MARK TOBEY: City Paintings

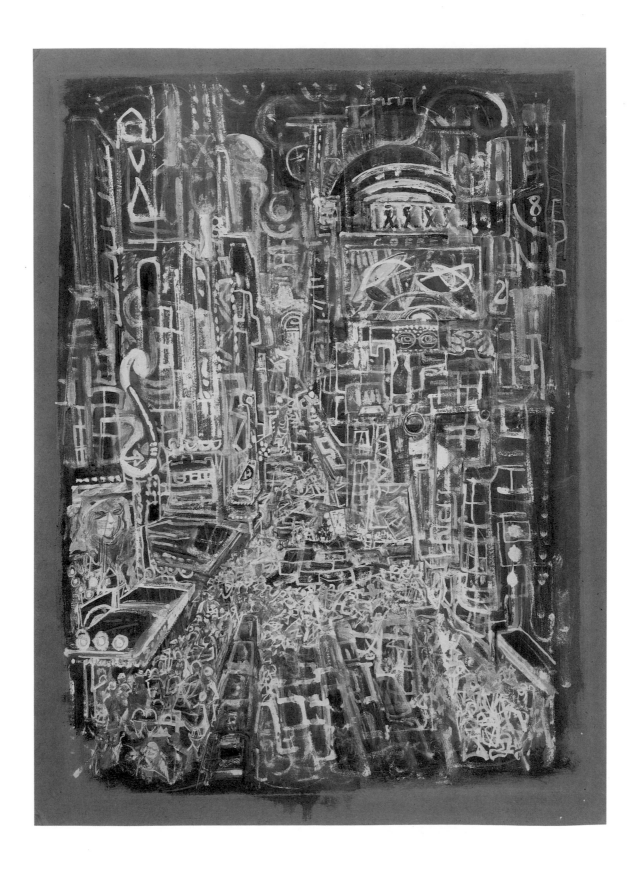

MARK TOBEY
City Paintings

Eliza E. Rathbone

National Gallery of Art, Washington 1984

This catalogue was produced by the Editors Office, National Gallery of Art, Washington. Printed by Eastern Press, New Haven, Connecticut
Set in Garamond by Hodges Typographers, Silver Spring, Maryland.
Cover and text papers are Warren Cameo Dull.
Edited by Paula M. Smiley.
Designed by Susan Lehmann.

Exhibition dates at the National Gallery of Art:
18 March to 17 June 1984

Cover: Mark Tobey, *New York*, 1944, National Gallery of Art, Gift of the Avalon Foundation, 1976. Cat. no. 19.

Frontispiece: Mark Tobey, *Broadway*, 1935, The Metropolitan Museum of Art, Arthur Hoppock Hearn Fund, 1942. Cat. no. 7.

Library of Congress Cataloging in Publication Data
Rathbone, Eliza E., 1948—
 Mark Tobey, city paintings.
 Catalogue of exhibition held at National Gallery of Art, 18 March to 17 June 1984.
 Bibliography: p.
 1. Tobey, Mark—Exhibitions. 2. Cities and towns in art—Exhibitions. I. National Gallery of Art (U.S.) II. Title.
ND237.T56A4 1983 759.13 83-27445
ISBN 0-89468-073-0
 (Rev.)

CONTENTS

7
FOREWORD
J. Carter Brown

8
LENDERS TO THE EXHIBITION

17
MARK TOBEY: CITY PAINTINGS

17
Tobey and the City as a Source

19
Early Years

23
The Trip to the Orient

26
White Writing and Paintings
Inspired by *Broadway*

38
Seattle

45
Elimination of the Figure

55
The Universal City

75
CATALOGUE

95
CHRONOLOGY AND SELECTED
EXHIBITION HISTORY

110
ABBREVIATIONS FOR LITERATURE
AND EXHIBITIONS

112
ACKNOWLEDGMENTS

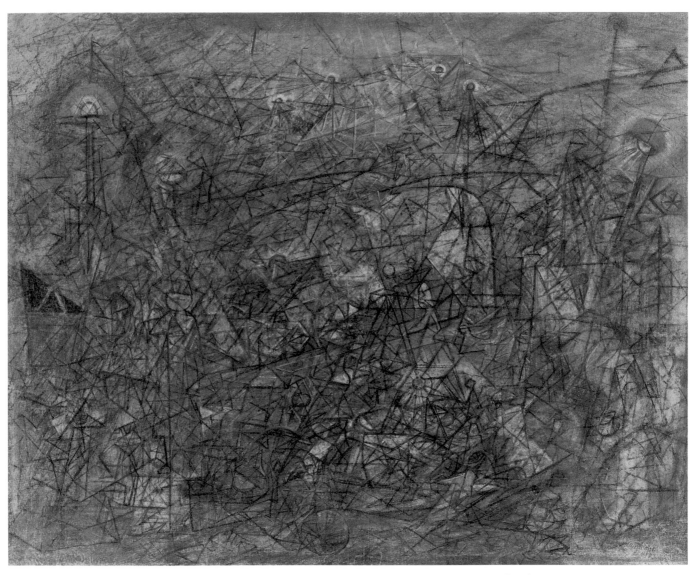

1. *Cirque d'hiver*, 1933 (cat. no. 1), Mr. and Mrs. Windsor Utley, Laguna Beach.

FOREWORD

The paintings of Mark Tobey are not easily accessible to the public, as a rule; a large percentage are in private collections, and those in museums are seldom on exhibition. Since they are usually executed on paper, in a water-soluble medium, they cannot be exposed to light for long periods of time. For this reason alone an exhibition of paintings by this American master is a welcome event.

Mark Tobey: City Paintings follows a series of exhibitions focusing on a particular aspect of an artist's work. Like *George Bellows: The Boxing Pictures* and *Picasso: The Saltimbanques,* the present exhibition highlights an outstanding work in the National Gallery collection. In 1976 the Gallery acquired, through the Avalon Foundation, *New York,* a major painting by Tobey of 1944. An outstanding work in his early white writing style, it also indicates the direction his later work was to take. It is both to put this painting in its true context in Tobey's oeuvre and to study his achievement through a particular thematic focus that this exhibition has been organized.

The theme of the city played a key role in the inspiration and development of Tobey's calligraphic style. Beginning with the painting *Broadway,* which he did immediately on his return to England in 1935 from a trip to the Orient, the exhibition traces the interaction of city themes with the evolution of the artist's style. Tobey's paintings of New York introduce the general theme of the city in his work, for the subject soon outstretched the confines of a particular locale to become a "universal city." The exhibition spans over three decades of Tobey's oeuvre and is designed to demonstrate the central and continuing importance of this theme to his expression. Included are many of Tobey's works of the thirties and forties, which have not been on public view for nearly a generation.

Mark Tobey: City Paintings was organized by Eliza E. Rathbone, assistant curator of twentieth-century art. Laura Coyle of the department of twentieth-century art assisted in many phases of the exhibition. Many other members of the staff have contributed their time and effort to the planning and realization of this project. To them all, and particularly to the lenders who have made this exhibition possible, we extend our grateful appreciation.

J. CARTER BROWN
Director

LENDERS TO THE EXHIBITION

Addison Gallery of American Art, Phillips Academy,
Andover, Massachusetts
Albright-Knox Art Gallery, Buffalo
Galerie Beyeler, Basel
Galerie Jeanne Bucher, Paris
Mrs. James H. Clark, Dallas
Mr. and Mrs. John M. Cooper, Bainbridge Island, Washington
Mrs. Joyce Lyon Dahl
The Dartington Hall Trust
The Detroit Institute of Arts
Mr. and Mrs. Paul Feldenheimer
Estate of Dr. Victor Hasselblad
Henry Art Gallery, University of Washington, Seattle
Dr. Solomon Katz, Seattle
Kunstmuseum, Kupferstichkabinett, Basel
The Metropolitan Museum of Art, New York
The University of Michigan Museum of Art
Munson-Williams-Proctor Institute, Utica, New York
Norton Gallery and School of Art, West Palm Beach, Florida
Galerie Pauli Lausanne
Portland Art Museum
San Francisco Museum of Modern Art
Seattle Art Museum
Mr. and Mrs. Windsor Utley
Wadsworth Atheneum, Hartford
Mrs. Max Weinstein
Willard Gallery, New York
Winston-Malbin Collection, New York
Private Collections

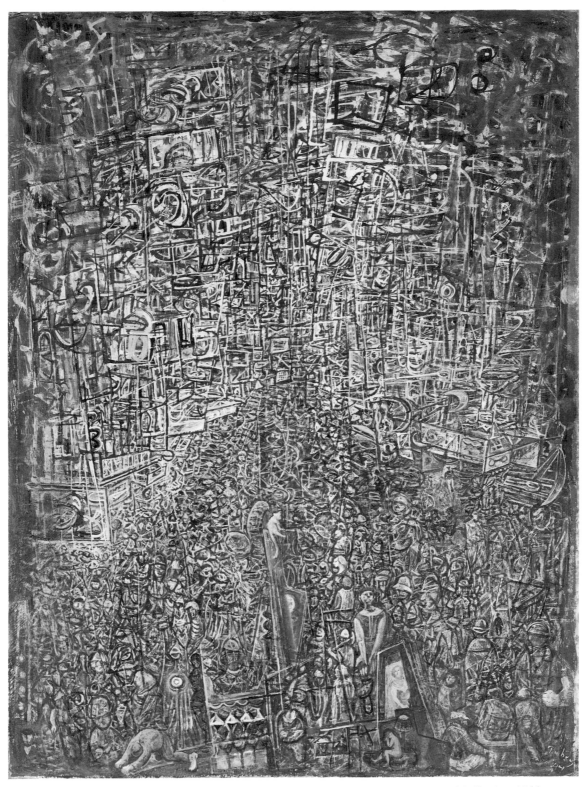

2. *Electric Night*, 1944 (cat. no. 22), The Seattle Art Museum, Eugene Fuller Memorial Collection, 1944.

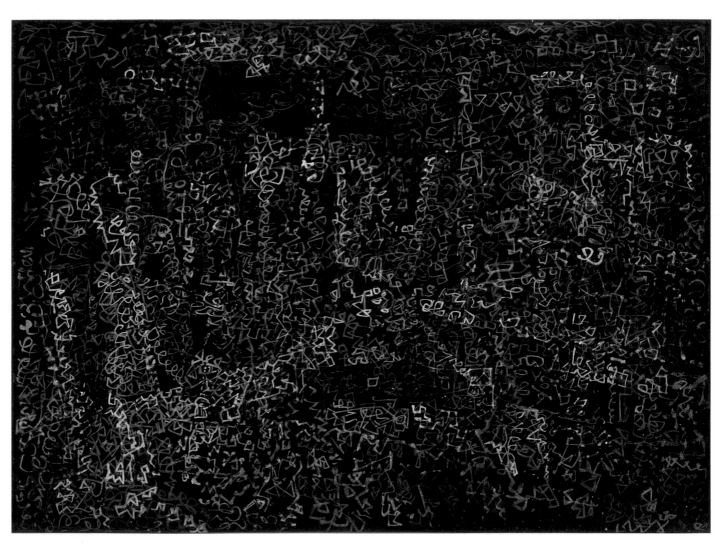

3. *Awakening Night*, 1949 (cat. no. 34), Munson-Williams-Proctor Institute, Utica, Edward W. Root Bequest, 1957.

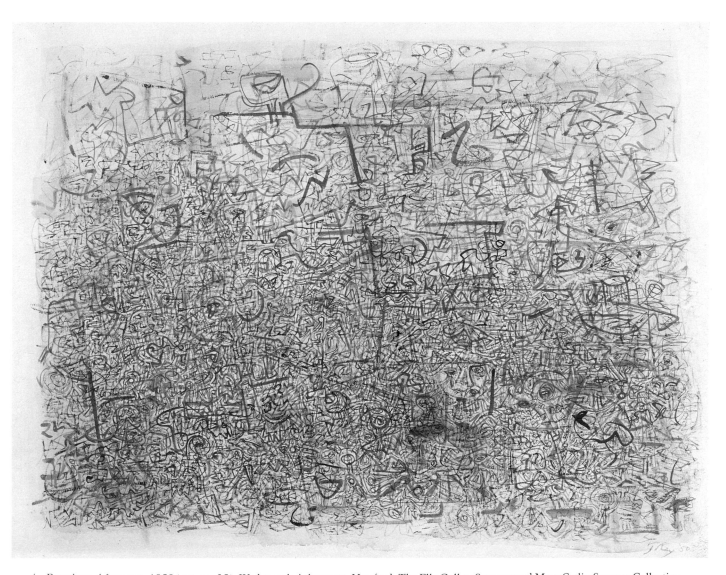

4. *Broadway Afternoon*, 1950 (cat. no. 35), Wadsworth Atheneum, Hartford, The Ella Gallup Sumner and Mary Catlin Sumner Collection.

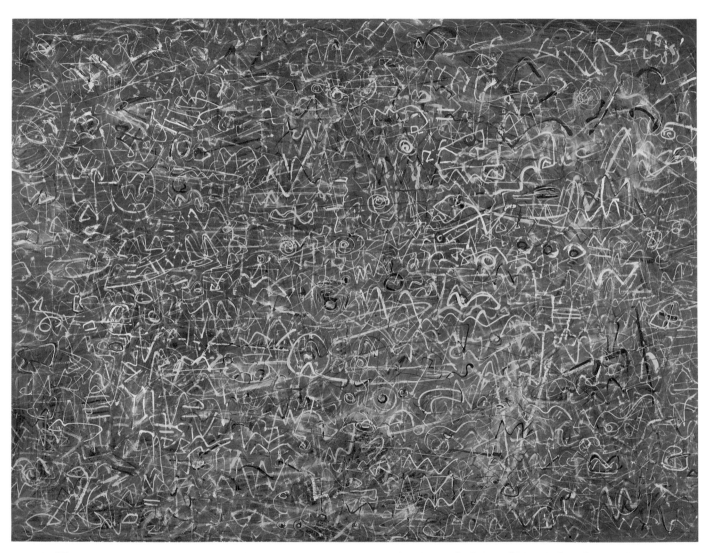

5. *Written over the Plains*, 1950 (cat. no. 36), San Francisco Museum of Modern Art, Gift of Mr. and Mrs. Ferdinand C. Smith, 1951.

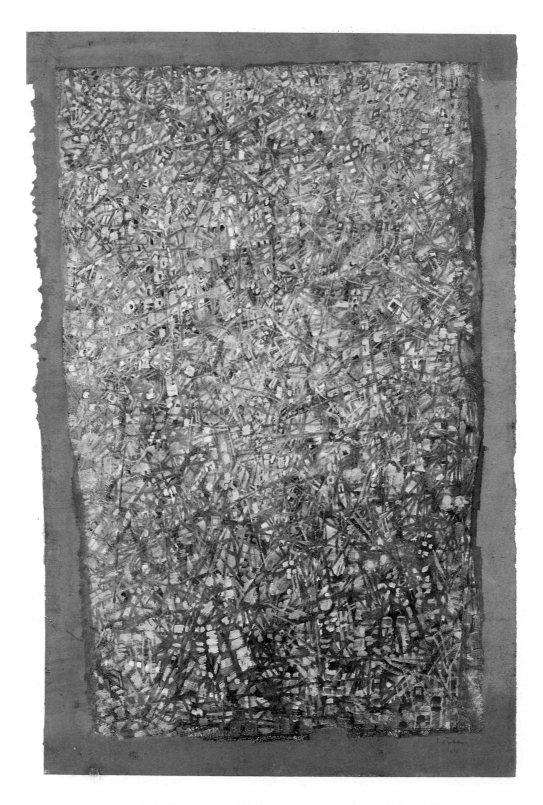

6. *Traffic I*, 1954 (cat. no. 41), Kunstmuseum, Kupferstichkabinett, Basel.

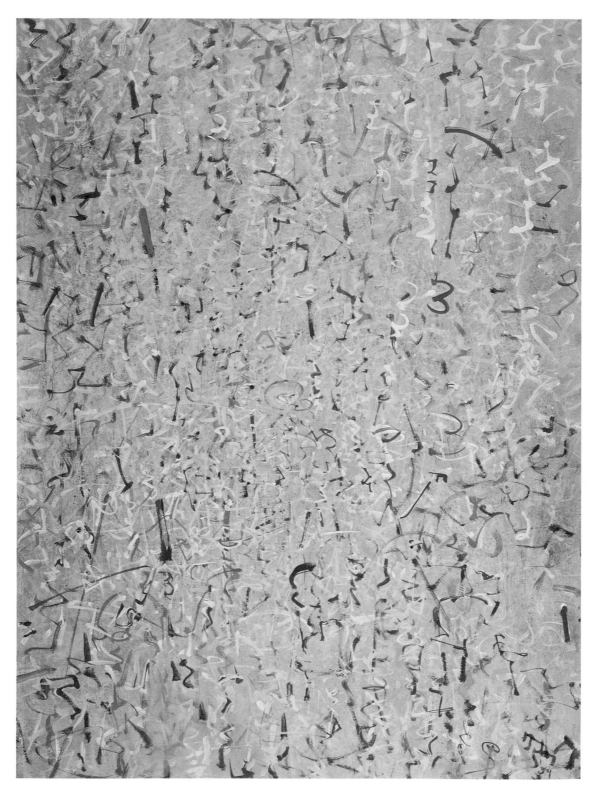

7. *The Avenue*, 1954 (cat. no. 40), Norton Gallery and School of Art, West Palm Beach.

14

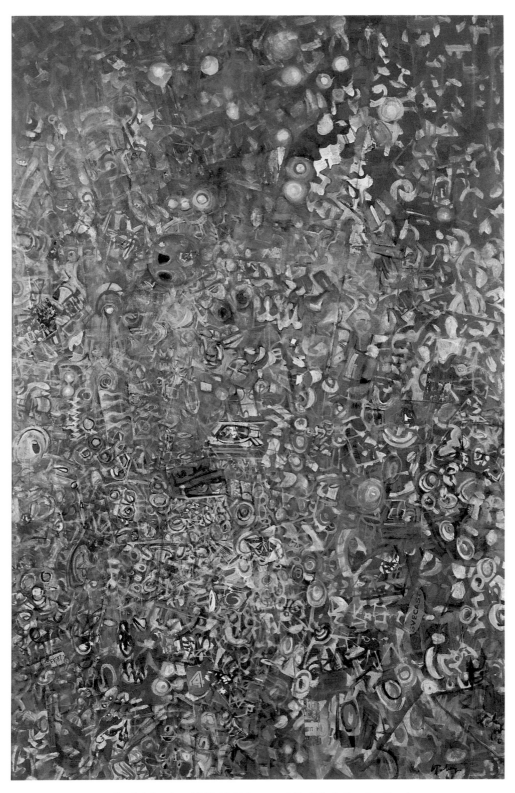

8. *Celebration*, 1965-1966 (cat. no. 58), Galerie Beyeler, Basel.

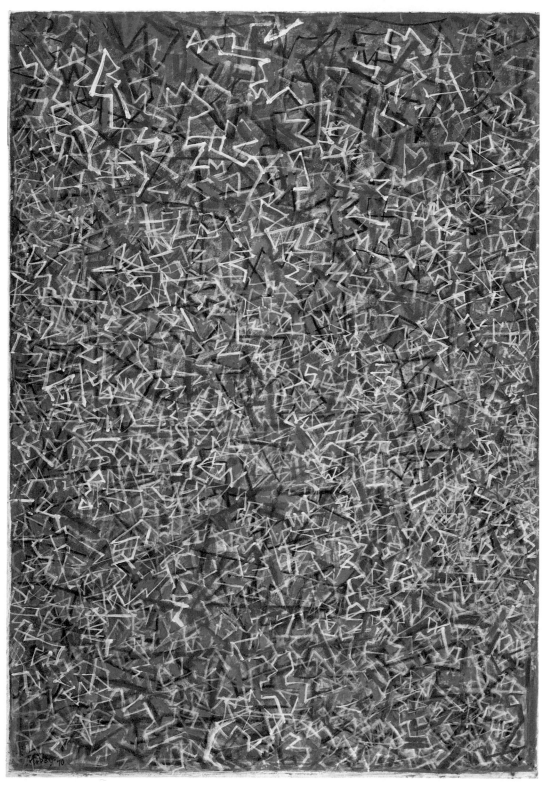

9. *Coming and Going*, 1970 (cat. no. 59), Albright-Knox Art Gallery, Buffalo, Charles Clifton Fund, 1970.

MARK TOBEY: CITY PAINTINGS

Eliza E. Rathbone

Mark Tobey is probably most known today for his mature work of the fifties and sixties, for which he is considered a delicate and refined abstractionist who anticipated Jackson Pollock's allover style—an artist of mystical bent, distinguished by his introduction of Oriental technique and aesthetic to the modern Western tradition. This image, however, ignores the complexity of the artist's sources and achievement. For Tobey was a man of many facets, all of which found expression in his art. To trace the richness of his sources and the way in which they emerge in his work demands a closer look at Tobey's work of the preceding decades of the thirties and the forties. These are the works that have not been seen in number since the Tobey retrospective at the Museum of Modern Art in 1962. It was in the earlier work of the forties that the range and diversity of Tobey's style was most marked and that the many concerns and stylistic threads of his later work were established. It is only through a close examination of these earlier paintings that we can interpret the richness of reference in the work of subsequent decades. For despite Tobey's self-confessed stylistic diversity and experimentation, the "zig-zag" of his development, as he put it, when reviewed with the advantage of a narrowed focus, his stylistic development may be seen to be surprisingly logical and consistent.

TOBEY AND THE CITY AS A SOURCE

Mark Tobey occupies a unique position in the history of American art—member of no school, follower of no master, largely self-taught, and entirely self-defined. Tobey's originality and independence have led to exceptional acclaim on the one hand and neglect on the other. After an adventurous youth spent in Chicago and New York, Tobey chose to live the rest of his life at a remove from the art scene, first in Seattle and later in Basel. From Seattle, he visited New York frequently to keep abreast of the scene, but he couldn't be persuaded to live there. He seemed to need the distance to distill his impressions and make them meaningful in terms of his own aesthetic. Similarly, when he went to live in Europe in 1960, he chose not to live in Paris but in Basel, a city of significant intellectual history but never an art capital. For Tobey's aesthetic did not emerge from group discussion; he shared no manifesto. He formulated his own artistic credo.

Yet he was not provincial; nor was he the retiring mystic he is often said to have been. Tobey's image as a mystic contemplating the mists and mountains of the Northwest, communing with nature, belies his real concerns as an artist. Indeed these generalizations were far more applicable to his fellow Northwest artist, Morris Graves. In 1953, a *Life* magazine article defined "Mystic Painters of the Northwest" as having a "mystical feeling toward life and the universe, their awareness of the overwhelming forces of nature and the influence of the Orient."[1] While these generalities are largely arguable in Tobey's case, he was not a painter of the overwhelming forces of nature but rather of the vitality and interrelatedness of natural forces, the unity of the whole, which he strove to understand scientifically as well as mystically. He did not live in idyllic isolation like Graves, but always in town. During the one period when he did live in the beautiful countryside of Devonshire (1931-1938), he painted almost no landscapes.[2] He really preferred visiting nature to living in it. The nature that fascinated him he could bring home in his pocket; he could find a universe in a single leaf or rock. The paintings that grew from this acquaintance became studies in the laws of natural formation—abstractions of natural forces. It was precisely because of this detached and conceptual approach to nature that Tobey did not find a dichotomy between the natural and urban worlds but rather parallels which frequently allowed him to treat the city metaphorically—as a living organism. Moreover, Tobey's early turn toward abstraction soon allowed him to transcend the particulars of a local scene in his painting. Thus his reputation as the leader of the Northwest School suggests a far

more regional role for his work than was in fact the case. As he himself once said, "I'm no more a Northwest painter than a cat."[3]

Just as Tobey's sources and intentions were international in scope, so was his influence. Indeed in the 1950s Mark Tobey was more known, acclaimed, and honored in Europe as the new leading painter than any other American artist. The first American since Whistler to win a grand prize at the Venice Biennale, he was also the first living American artist ever to be given a retrospective at the Louvre. At a time when he was considerably overshadowed in America by the New York School, he was hailed in Europe in 1955 as "Europe's great new discovery."[4] By 1958 his works at the Venice Biennale were said to "have helped to boost America's prestige abroad better than the more aggressive work of the younger painters at home."[5] And his 1961 retrospective in Paris was called "an outstanding retrospective exhibition . . . of marked significance since Tobey is considered by prominent artists of the School of Paris, as well as by established European art dealers, to be the foremost living American painter."[6]

Yet Tobey was (and is) treated as a side event to the mainstream of painting in this country. Despite these foreign accolades, on the occasion of the Mark Tobey retrospective at the Museum of Modern Art in New York in 1962, the press was notably silent. The curator, William Seitz, had to say that in America Tobey's status was "not yet secure."[7] Soon after Dore Ashton reported in *Das Kunstwerk,*

The inhospitable press reaction to the Mark Tobey exhibition at the Museum of Modern Art betrayed certain American prejudices. Critics showed a childish resentment of Tobey's preeminence abroad and snubbed him because he lived and worked away from New York.[8]

Tobey's early success abroad may be explained in part by the fact that his paintings were technically more conservative than the large and powerful canvases of Jackson Pollock, for example. From beginning to end, Tobey was a master of the brush. Any group of his paintings quickly reveals the breadth of expression he found in qualities of brushstroke. Tobey applied these seemingly traditional techniques, however, to an undeniably original and new vision—a vision which caused great excitement in Europe. His work also no doubt appealed to the French for its subtlety and refinement—characteristics not especially prized by the abstract expressionist group. While Tobey's painting anticipated the allover style of Jackson Pollock, his sources and intentions differed from those of the abstract expressionists in several fundamental respects.

Several sources which had significant bearing on Tobey's work distinguish him from his New York contemporaries: the Orient, his religion, and his continuing concern with the visible realities of the physical world. From the Orient he derived the "calligraphic impulse," as he called it, which became the essential ingredient of his style; from his religion he derived personal strength and vision, and a framework for his life and art; and from the visible world he derived ideas and stimuli for thinking and painting throughout his career. All three factors shaped Tobey's attitude to subject matter in his work. Unlike the abstract expressionists, he never abandoned referents in the outside world. Even if he did a painting far from its source of inspiration or titled a painting long after its completion, he deliberately provided the viewer with clues to the origin of the work in nature and its meaning. Sometimes a painting by Tobey appears so abstract that only the title reveals the artist's intention. Tobey's titles not only imply a visual source but often suggest a second level of meaning that lies more in the realm of spiritual and poetic metaphor.

While Tobey created an entirely new vision in painting, technically he drew on centuries of tradition, both Eastern and Western. He also retained references to the figure in his paintings, even in his mature work (for example *Celebration,* 1965, in this exhibition). By contrast, the human or figurative content of abstract expressionist painting was to be found *outside* the paint-

ing in an implied dialogue with the viewer. Thus large scale was an intrinsic part of the abstract expressionist aesthetic, while Tobey painted on a relatively small scale until the early 1960s. The abstract expressionists stressed the large form, the single and "unequivocal" totemic image, one that would identify with and reassert the flatness of the picture plane. By contrast, Tobey's concern was the relationship of many parts to the whole, the dynamic unity of the complex image. While the abstract expressionists sought to express the relationship of the mythical to the individual, Tobey sought to express the relationship of man to the universe, of religious thought to the modern world. In making deliberate reference to external reality, Tobey stands apart from the New York School and indeed seems closer in orientation to his real contemporaries like Stuart Davis and Georgia O'Keeffe. It is only when we consider that Tobey was almost a generation older than most of the abstract expressionists that we can appreciate the great break with the past, the giant step forward that he did take. This step is nowhere more clearly and dramatically chronicled than in Tobey's city paintings.

Tobey's evocations of the city reflect an enormous range of responses to the subject. He found the lights, human density, and the complexity of life in a city spellbinding. So too was the idea of this multiple organism abstractly conceived and stripped to its essentials as in his *City Punctuation* (1954) or *Lines of the City* (1945). Thus while in some paintings he reduced the subject to a meditation, in others he amplified it to incorporate all of humanity. Tobey not only found in the city an extraordinary range of subject matter and mood, but he also captured the spirit of a particular place. The paintings in the present exhibition span four decades and reflect virtually all the stylistic developments and thematic transformations of Tobey's mature work. We therefore find that a consideration of the city theme encompasses gems of colored light, like *Carnival* (1954), as well as large, resonant expanses like *Ghost Town* (1965), the trans-

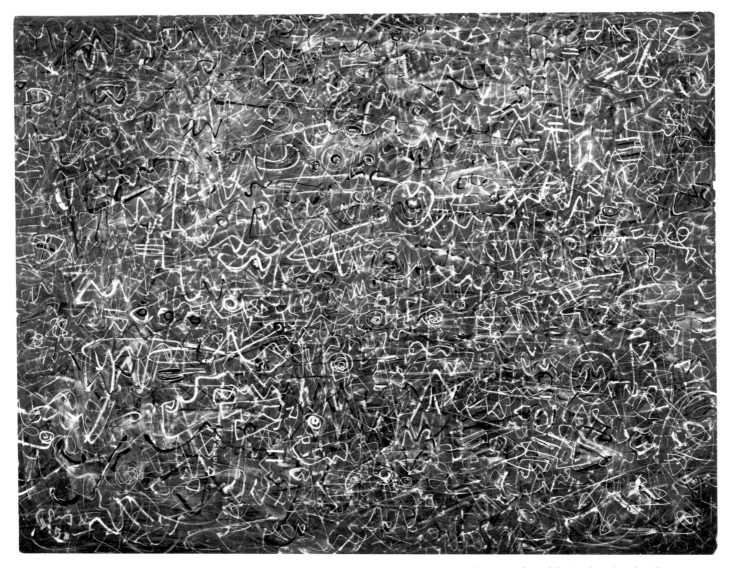

Cat. no. 36. *Written over the Plains*, 1950, San Francisco Museum of Modern Art, Gift of Mr. and Mrs. Ferdinand C. Smith (color plate 5).

cendant *New York* (1944), and the frenzied *Broadway Boogie* (1942). We can trace the theme from Tobey's initial absorption in the figure alone to its role in the emergence of his calligraphic style; from his dominant use of the figure in city scenes like *E Pluribus Unum* (1942-1943) or *Flow of the Night* (1943) to his dissolution of the figure into paintings of light like *New York* or *City Radiance* (both of 1944); and finally we can see his extension of the

subject from the specific city to the general in *Universal City* (1951) and eventually to the breadth of theme suggested by *Written over the Plains* (1950, cat. no. 36), *Multiple Mansions* (1954), *Battle of the Lights* (1956), or *Celebration* (1965-1966).

The development of the city theme in Tobey's work reveals the artist's enduring interest in the human figure and the fundamentally humanistic viewpoint of his work —a quality that was not lost when he dis-

solved the figure into his more abstract style of the fifties. Nor did he give up drawing the figure despite its diminishing appearance in his paintings over time. When he was in his seventies, living in Basel, he hired a model to draw from life. Indeed it is through this very love of the figure that Tobey came to translate the calligraphic impulse that he discovered in the Orient into an expression of the bustle of city streets. Conversely it is significant that it

was in city subjects (not subjects from nature) that this impulse first appeared. Thus the theme of the city played a key role in the inspiration and development of the calligraphic style, which guided his entire future oeuvre. White writing, as it was called, was the perfect means, as Tobey himself put it, to "paint the frenetic rhythms of the modern city, something I couldn't even approach with Renaissance techniques . . . through calligraphic line I was able to catch the restless pulse of our cities today."[9] Tobey's varied and successful use of this technique is reflected in a statement by Katharine Kuh, "No one in our century has celebrated the irridescense of modern cities more inventively than Tobey."[10]

EARLY YEARS

Born and raised a country boy, Mark Tobey never lost his love of nature, but he lived in cities most of his adult life. There he found the excitement and stimulation he needed and a subject he never tired of painting. For despite Tobey's occasional grumblings about city life, particularly as he grew older, his work attests to the profound stimulation he derived from it. Tobey first visited New York as a young man of twenty. Perhaps in part because of his rural upbringing, he was never to lose his fascination for that city with its throngs of people, its skyscrapers, its neon lights, and theaters.

Mark George Tobey was born in 1890 in Centreville, Wisconsin, the second son, and youngest of four children of George Baker Tobey and Emma Jane Cleveland. While he was a boy, the family lived in the small village of Trempeauleau, situated on the banks of the Trempeauleau River, which branches off the Mississippi River about 140 miles, as the crow flies, northwest of Madison. At the time Trempeauleau had about 600 inhabitants.[1] Tobey passed his youth in an era of horse-drawn carriages and gaslights and was a grown man by the time the automobile was more than a rarity. When he was sixteen the Tobey family

moved to Hammond, Indiana, not far from Chicago, and three years later to Chicago itself. This was Tobey's first taste of city life, and he never gave it up. For the next seventy-odd years he made his home with varying degrees of permanence (being a restless soul, he never seemed to think of any of them as too permanent) in Chicago, New York, Seattle, Paris, and Basel.

Tobey was an extremely gifted artist but slow to arrive at the mature style for which he is known. He enjoyed the challenge of a new idea or technique, admiring Picasso and Klee for the untiring invention of their work. Thus, although when he was twenty-seven, M. Knoedler & Co., Inc., in New York gave him a one-man show of twenty-three of his portraits, he didn't reach his real artistic maturity until he was in his early fifties.[2] Tobey never lost his interest in, or eye for, the uniqueness of a face. Despite his success in the vein of portraiture, however, it was the very next year, 1918, that he reputedly first had the desire to "smash form" in his art. It took him twenty years to pursue this ambition, his quest for a means of breaking up form leading him in many directions. Two discoveries in particular were to become essential factors in the means Tobey eventually evolved of breaking up form. Not surprisingly for Tobey, one was a matter of technique, while the other was a matter of spirit.

In 1918 Tobey discovered a religion that would provide the philosophical and artistic framework to shape the rest of his life. At a dinner party in New York, Tobey met a portrait painter, Juliet Thompson, who told him about the Bahai faith. He had been brought up a Congregationalist by devout parents. Perhaps feeling disillusioned by the First World War, in which Christian fought fellow Christian, he was attracted to this faith which maintained that all religions were manifestations along the way to one world faith that would bind all mankind in a spirit of unity and understanding. The Bahai religion was born in Persia in 1844, and its leader in 1918 was Abdul-Baha, the eldest son of his predecessor, Baha-Ullah.

The new religion had been introduced to this country only six years before, in 1912, when Abdul-Baha had toured America to spread the faith. On the invitation of Juliet Thompson, Tobey visited a Bahai camp in Maine and soon after converted.[3]

Tobey often repeated that there was no official Bahai art. Thus, although he did do paintings specifically on Bahai themes, he also made his religion such a fundamental part of his life and thought that its tenets are reflected to a greater or lesser degree in all his work. When asked how religion had influenced his work, Tobey said:

I've been influenced by the Bahai religion which believes there has been but one religion which renews itself under different names. The root of all religions, from the Bahai point of view, is based on the theory that man will gradually come to understand the unity of the world and the oneness of mankind. It teaches that all the prophets are one—that science and religion are the two great powers which must be balanced if man is to become mature. I feel my work has been influenced by these beliefs. I've tried to decentralize and interpenetrate so that all parts of a painting are of related value. Perhaps I've hoped even to penetrate perspective and bring the far near.[4]

In Bahai, Tobey found a spiritual reason to seek an artistic language that would reflect the discoveries of modern science. The principle of a pictorial unity of multiple parts that began to guide Tobey's art was partially formulated in direct response to the basic premises of his faith. For Tobey required not only an artistic but also a spiritual rationale for his painting. He was deeply committed to the meaning of his work. Where other artists have subscribed to a group doctrine or taken myths as a shared source of subject matter or an underlying framework, Tobey gradually formulated a whole system of beliefs, generally referred to as his "world view," for which he was to a large extent indebted to his religion.

Tobey's artistic development depended always on a balance of past and future, of science and religion. This ideal of equilibrium directly affected his work. He spent long hours in museums and galleries,

studying the art of earlier masters. The reverence for mankind professed by the Bahai religion is born out in Tobey's preoccupation with man. He believed that "every artist's problem today is 'what we will do with the human,'"[5] and his inclination to paint crowds of people arose from his concern for the multitudes that populate the world and the need for a universal consciousness. When asked what his sources for painting were, Tobey replied "Mine are the Orient, the Occident, science, religion, cities, space, and writing a picture."[6] Among his sources in the physical world, Tobey makes no mention of nature, landscape, or anything but cities as a source for his work. Indeed city life emerges as Tobey's most important subject: central to the development of his style, it also provided the subject matter which could most closely accommodate the religious content of his work.

Soon after Tobey went to Seattle in 1923, he met Teng Kuei, a Chinese student at the University of Washington, who taught him the principles of Chinese brushwork. Years later he recorded his joy upon discovering this technique, the very heart of which is movement and life.[7] Movement runs like a leitmotif throughout Tobey's work from his earliest days. In the work of other artists he has been keenly aware of qualities of energy, movement, vibration. Thus Tobey's interest in conveying movement in art and his ideal of technical virtuosity of brushstroke made him exceptionally responsive to the art of the Orient, where liveliness of line and brushstroke is paramount.

Tobey's choice of the city as a subject matter for painting was therefore a natural one—it was not only a subject he knew, but also it represented a microcosm of the world, a center of human energy, thereby encompassing his deepest concerns, both artistic and spiritual. As a painter of city life in America, Tobey was not alone but joined a young but thriving tradition. And indeed he was probably closer to this tradition than is generally recognized. Moreover, in his discovery of Oriental techniques and aesthetics, he found what other American art-

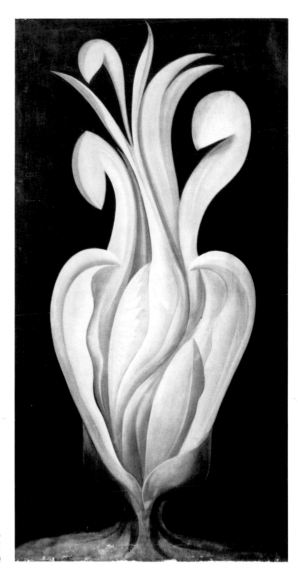

Fig. 1. Tobey, *Pink Flower*, 1928.
(Photo by Geoffrey Clements, courtesy of Willard Gallery, New York)

ists had discovered in New York not many years before. For the artistic climate of New York from about 1910 to 1930, when Tobey was a young artist living and visiting there, would also have sustained an interest in the Orient. Very little, if any, of Tobey's work of the twenties shows evidence of those lessons he took from Teng Kuei in Chinese brushwork. Similarly, those other American artists, whose work Tobey obviously admired at that time, were also influenced by Oriental principles, but, in their

work too, these ideas were absorbed into their individual styles and rarely resulted in overt orientalizing.

In 1920 Tobey demonstrated his openness to new approaches to art by joining the short-lived and experimental Inje-Inje movement, which proposed a return to simplicity in art, led by Holger Cahill. At this time Tobey must have met Alfred Maurer, who was also a member of the group. Perhaps through Maurer, Tobey met Marsden Hartley, who become an enthusiastic supporter

of Tobey's work.[8] Thus he was clearly aware of the work of the artists who exhibited at Alfred Stieglitz's galleries, 291, and later, An American Place. But of them all, it seems to have been Georgia O'Keeffe's paintings that had the greatest impact on him. A fellow native of Wisconsin, Tobey obviously found O'Keeffe's stark, open landscapes part of his own experience and painted a similarly empty landscape called *Middle West* (1929, Seattle Art Museum). His *Pink Flower* of 1928 (fig. 1), a larger-than-life painting of a single flower, organically abstracted, seems to confirm Tobey's awareness of this artist's work.

Just as Maurer had a Whistlerian phase and was aware of the relevance of Oriental ideas, so O'Keeffe, in an interview, confessed that the artists she most admired were the Chinese.[9] One man in particular brought an awareness of the Oriental aesthetic to these New York artists in the early years of this century: Arthur Wesley Dow. Dow's teaching triggered a fresh approach to the art of foreign cultures. For it was not the superficial and overtly exotic attributes of their art which he promoted but rather the fundamental principles.

The man who opened Dow's eyes to the lessons of Oriental art was the famous Orientalist and author of *Epochs of Chinese and Japanese Art,* Ernest F. Fenollosa (1853-1908), whom Dow met in 1891. Fenollosa, who adopted Oriental culture as if it were his own, championed it with such fervor that he is credited with restoring the pride of the Japanese in their heritage at a time when Japan was looking to the West, turning its back on its own past. In his book, *Composition,* which by 1931 was in its thirteenth edition, Dow stressed the primary importance of line and spacing in art; secondly *notan,* a Japanese word for "the massing of tones of different values;" and finally color, as the least important element, which was only to be added after the relationships of line and *notan* had been established.[10] In his book, Dow used examples from Whistler to illustrate *notan.* Tobey seems to have been aware of such abstract

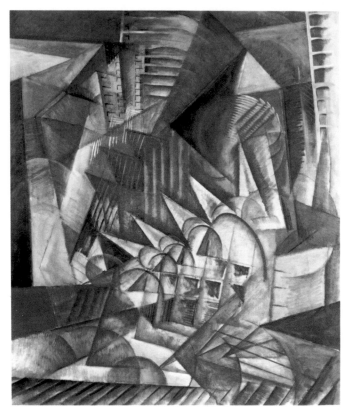

Fig. 2. Max Weber, *Rush Hour, New York*, 1915, National Gallery of Art, Washington, Gift of the Avalon Foundation.

principles of composition by 1928, if not earlier. For that year he made a visit to the Canadian artist Emily Carr, about which she reported:

He [Tobey] told me to pep my work up and get off the monotonous, even exaggerate light and shade, to watch rhythmic relations and reversals of detail, to make my canvas two-thirds half-tone, one third black and white.[11]

For Tobey also, color was always to be subordinate to a composition which depended first on line and tone. The crucial difference between *notan* and the Western tradition of chiaroscuro was its independence from the naturalistic description of light and shade, of objects and their cast shadows. *Notan* obeyed pictorial laws of composition rather than natural laws of observation. In 1962 Tobey said of *notan,*

"still today I think it is the most satisfactory thing to find in a painting."[12] Tobey shared with Fenollosa his interest in the Far East and the Oriental aesthetic, as well as the conviction that America was the place where East would meet West. Marin and O'Keeffe, despite their interest in Oriental art, continued to promote the sensual in art, a point of view generally held by the Stieglitz group at this time and antithetical to the Oriental approach to art. Tobey's desire to bring the East to the West led him to embrace Oriental culture on a deeper level than had been done by these artists before him.

What Tobey gleaned from Teng Kuei was an attitude that Max Weber, another student of Arthur Dow's, had already absorbed from Dow's teachings—that of a consciousness of art as "the possessing of

the spirit of things." "Nature inspires me with its living rhythm," Weber said.[13] The spirit of things that these American artists—O'Keeffe, Marin, Joseph Stella, Weber—had discovered as an Oriental principle was to find expression in their fascination with the city as a living organism. Rather than the genre approach to street scenes of the Ash Can School, these artists were concerned with the vitality, moods, and presence of the city itself. In their art, they expressed their reaction to the metropolis, their celebration of its energy, and its soaring buildings, monuments to man's invention and optimism. O'Keeffe and Stella celebrated the streamlined design of the Brooklyn Bridge. In other paintings by O'Keeffe, we find her emphasis on the austere geometry, the height and elegance of the city itself. Many photographers of the period, including Stieglitz, chose to present this aspect of the city. Like Marin and Stella, Weber turned his exposure to fauvism, cubism, and futurism into a peculiarly American idiom, as we find in his *Rush Hour, New York* (1915, fig. 2), a painting evoking the dynamism of New York and inevitably revealing futurist overtones.

Although the works that Tobey exhibited at Romany Marie's Café Gallery in New York in 1929 show little of his exposure to Chinese brushwork, they did reflect his interest in the Stieglitz stable of artists. That same year an exhibition of American art at the Bourgeois Galeries in New York was introduced with words that revealed the current interest among American artists in "'the life spirit' as the Chinese call it."[14] In adopting the spirit of Oriental art and applying it to entirely and explicitly American subjects, Tobey would follow directly in the tradition of recent American art. The crucial difference in his work was that, unlike these American artists, Tobey actually went to the Orient, and this trip changed the entire future course of his development. For although Tobey was interested in line, in movement, and in East-West connections before his trip to China and Japan in 1934, his experience in the Far East helped

him to crystallize, formulate, and express these concerns in an entirely new way. Few artists could have been as technically and philosophically oriented to benefit from an Asian sojourn as Tobey was by 1934.

THE TRIP TO THE ORIENT

It was early spring in 1934 when Tobey set off for the East with Bernard Leach, painter and ceramicist, who had come to teach at Dartington Hall, where he met Tobey in 1932. Tobey could hardly have wished for better company for such a trip, for Leach was born in Hong Kong and had been in Japan as a child. Leach had distinguished himself by the extent to which he, as a Westerner, adopted Eastern techniques and, equally important, emulated the spirit that lay behind them. The previous year he had been invited by his artisan friends to return

to Japan for a visit. The Elmhirsts, who owned and ran Dartington Hall, noting that the two had become friends, suggested that Leach take Tobey along.

Tobey and Leach sailed across the Mediterranean and, by way of Aden, to Colombo. From Colombo, the two journeyed on to Hong Kong, where they spent a week in Kowloon (mainland Hong Kong). There they both made ink drawings, which were Oriental in technique and in spirit but which reveal their different temperaments. Beside Leach's studies, Tobey's look bold and dynamic. While the potter was inclined to vary bird studies with broadly handled, open landscapes of Hong Kong Harbor, a drawing by Tobey of Kowloon (collection of Dr. Solomon Katz, Seattle), dominated by a mountain looming in the foreground, presents a dramatic juxtaposition of near and far, and we see the same sweep into the distance in a painting of the following year called *Seattle in the Snow* (cat. no. 5). *China*

Cat. no. 5. *Seattle in the Snow*, 1935, Mr. and Mrs. John M. Cooper.

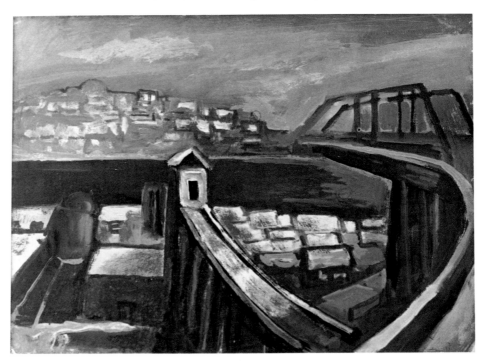

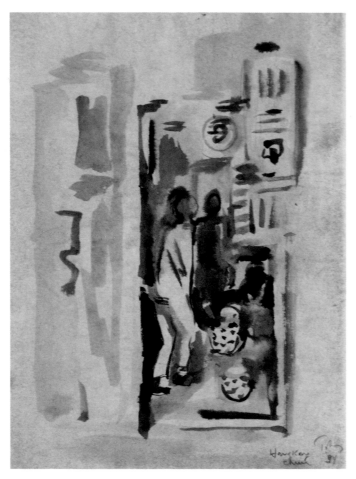

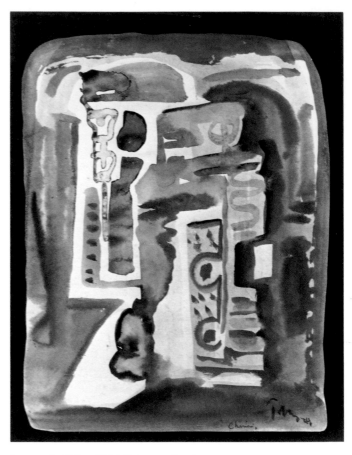

Cat. no. 2. *Shop Front, Hong Kong*, 1934, Dr. Solomon Katz. (Photo courtesy of Foster/White Gallery, Seattle)

Cat. no. 3. *China*, 1934, Private collection.

(cat. no. 3), on the other hand, emphasizes the two-dimensionality of its subject, revealing Tobey's strong inclination to fill and animate the surface. According to Leach, Tobey "was fascinated by the vertical signboards outside every shop—characters, black on white, red on gold; I [Leach] was absorbed by the beauty of the hand-made, brown-sailed junks."[1] The seemingly conceptual subject matter of *China* was probably inspired by the shop signs of Hong Kong or of Shanghai, where Leach and Tobey stopped next, a city which reminded Tobey of New York. As he noted in his journal, "Shanghai seems like New York—congested—and almost any kind of life, night

or otherwise, you want . . . there are dance halls and dance halls and traffic and neon signs especially red ones twisting and turning over everything."[2]

Both *China* and *Shop Front, Hong Kong* (cat. no. 2) were done in a method that Tobey had employed very successfully a year before at Dartington Hall, that of using pen or brush and ink on wet paper. Tobey relished such tests of technical facility and speed of execution. The result he wanted was the blurred line and atmospheric effect created by these softened contours. In both *Shop Front, Hong Kong* and *China* Tobey makes generalized reference to Chinese characters. In the drawing of the shop front,

a sign in characters hangs to the right of a lantern above the two figures inside the shop. This was just the first of many instances of Tobey's deliberately capturing the spirit, though not the letter, of Oriental calligraphy. It was in China that the subject of the city street captured his imagination, and these quick sketches constitute his first concentration on this subject matter.

When Leach and Tobey took a foggy trip by boat up the coast, through the East China Sea, they were met in Shanghai by Tobey's Chinese friend from Seattle, Teng Kuei. In Shanghai with Teng Kuei Tobey studied Chinese calligraphy (fig. 3). In the short period he spent there, Teng Kuei told him

Fig. 3. Tobey, Chinese calligraphy, 1934, Dartington Hall Trust, Devon. (Photo courtesy of Sotheby's, New York)

a Zen monastery. Leach had left him in Shanghai to go ahead to Japan on his own, and the two did not meet again until England. Tobey went alone to stay with the monks at a monastery thirty miles from Kyoto.[5] While Tobey had been intrigued by the bustle, the winding streets, the variety of people and their exotic ways in Shanghai, he was equally seduced by the purity and balance of the Japanese aesthetic. At the monastery he had the time and quiet to observe the smallest events in nature and to admire the directness and simplicity with which they were expressed in Japanese art.

The peace and simplicity of life at the monastery allowed him to observe the effects of weather and light on the humblest of nature's creations—grasses, seeds, lichen—which became of such paramount importance to his later work. In his journal Tobey wrote about the

Japanese vision which takes into account such [small] forms of life—gives them the dignity of a kakemona . . . it is this awareness to nature and everything she manifests which seems to characterize the Japanese spirit. An awareness of the smallest detail of her vastness as though the whole were contained therein and that from a leaf, an insect, a universe appeared.[6]

This last statement would prove to be extraordinarily prophetic of Tobey's later work.

Tobey rewrote, edited, and polished this particular selection of notes (quoted from above), publishing them years later in an article called "Reminiscence and Reverie" (*Magazine of Art,* 1951). Other notes he made in the Orient abound in visual impressions that were to be realized eventually in paint. It is important to recognize that it was not only his study of calligraphy that was to have such an impact on his art later on, but also many aspects of the Japanese aesthetic were to feed into or reconfirm his own aesthetic attitude.

Tobey's first stop after crossing the Pacific was San Francisco. There, responding immediately to his Japanese experience, he did a series of "the animal world under moonlight." In a drawing of a pair of toads

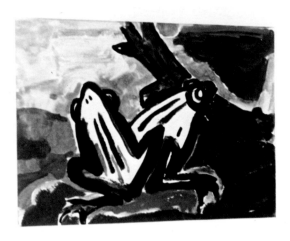

Fig. 4. Tobey, *Two Toads in Moonlight*, 1934, Dartington Hall Trust, Devon. (Photo courtesy of Sotheby's, New York)

(fig. 4), and another of three birds, the entire composition is executed with a few strokes of the brush, their boldly inked profiles lending importance to these small creatures. The landscape of the three birds is featureless, allowing them to be silhouetted, nothing between them and the moon. Tobey's animals reflect the "simplicity, directness, profundity" that he had observed firsthand in so many aspects of life in Japan.[7] These works were to make a great impression on Morris Graves. And it was not only their subject matter of animals in moonlight that he was to adopt, but more importantly their directness and simplicity of execution.[8]

We must assume it was also in July 1934, while staying in San Francisco, that Tobey painted the small watercolor now called *San Francisco Street* (cat. no. 4), immediately applying the response he had experienced to street life in Shanghai to the American equivalent. With a similar immediacy of handling, he painted this scene of the city whence he wrote to Dorothy Elmhirst:

Am in San Francisco—here ten days painting hard. . . . The town is incredibly beautiful—more

that he had produced calligraphy equal to three years of practice, and Tobey was sufficiently proud of his work sheets to take them back to Dartington Hall with him.[3] He later maintained, "it's impossible for any westerner to become a real calligraphist, because they would have to start at five under a master."[4] Yet his series of exercises reveal the concentration, depth, and accomplishment of his own study.

In the course of his trip, Tobey wrote poetry and recorded his impressions and observations. The journal he made of his Oriental sojourn reveals the deep impression that light made on Tobey, particularly night light—be it the light of the moon over the Indian Ocean, the sun setting over Shanghai, or the night lights of the city. Second only to light, we find in these notes Tobey's fascination with people and his acute eye for their mannerisms and characteristics. One feels that all of these experiences were stored in his visual memory to be drawn upon in later years, so vividly do they foreshadow the paintings that were to follow a decade later.

After China, Tobey traveled on to Japan, where he spent a month in early summer at

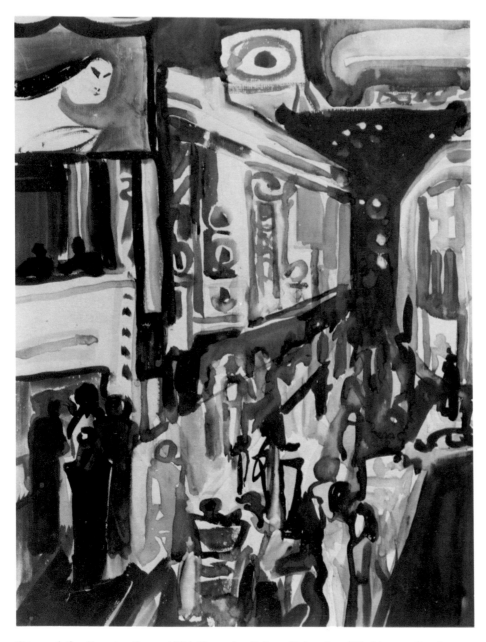

Cat. no. 4. *San Francisco Street*, 1934, Henry Art Gallery, University of Washington, Seattle, Margaret Callahan Memorial Collection, Gift of Brian T. Callahan.

town at night. Sections of the composition are blocked in with a dark brown wash, and figures, mostly in gray, move along the street. Tobey has reserved the brightest colors for the orange, red, and yellow lights of windows and illuminated signs. A large-scale Oriental face looks down on the scene from the upper left, and many vertical signs along the left side of the street suggest calligraphy. The yellow and untouched white of the paper here seem to glow from behind the red and orange signage. Many circles also suggest Japanese lanterns illuminating the street. Probably the artist's first depiction of a city street with a sharply receding perspective, this was a composition he would return to for years to come. Indeed this small painting serves as a transitional work from his drawings done in China to the now famous *Broadway* he painted a year later in England. It has qualities of both. Moreover, despite the contrast in subject between *San Francisco Street* and the contemporaneous animal series, his simple and direct handling of opaque watercolor in both paintings sets this group of works apart from the rest of Tobey's oeuvre. Tobey was later to combine the keen observation of the former with the vivid imagination of the latter in such paintings as *Broadway Boogie* (1942) and *Electric Night* (1944).

WHITE WRITING AND PAINTINGS INSPIRED BY *BROADWAY*

While *Broadway* shares some aspects of *San Francisco Street,* the difference between the two works depends on several intervening discoveries on Tobey's part, one of which was the spontaneous little painting, which he later called *Broadway Norm* (cat. no. 6) and which, while not a great work in itself, opened doors to his future development and marks a turning point in his work. It was on his return to England in the fall of 1935 that Tobey painted this small work in tempera on cardboard, consisting of a mesh of white lines and a few forms in blue on a darker ground. Only afterward was it titled

so than any other I have ever seen anywhere. . . . I feel strangely in space since returning . . . somehow more complete than ever, more concentrated and more quiet.[9]

In this small street scene, Tobey came as close as he could to his Oriental experi-

ence by choosing to paint San Franciso's Chinatown. For despite the artist's generalizing of forms in this crowded scene, one's immediate impression of this work so close stylistically to the drawings done in China, is that it must be San Francisco's China-

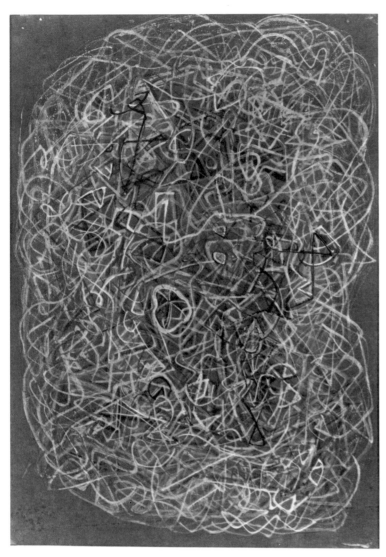

Cat. no. 6. *Broadway Norm*, 1935, Carol Ely Harper.

tangle of white lines and a crowd of people and bright lights, he probably would never have painted *Broadway* as he did. *Broadway Norm,* however, was something of a freak instance, an anomaly, in Tobey's work, which he saw no reason to pursue in itself but which triggered his first expression of abstracted movement.

There were, however, not only Oriental but also American roots to Tobey's calligraphic style. And this aspect of the American tradition was presumably absorbed by him subconsciously as well as consciously. During his intermittent periods in New York from January 1935 until the following October when he returned to England, Tobey could hardly have been unaware of the unprecedented acclaim given to the work of John Marin. That winter Marin's work was exhibited at the Museum of Modern Art, at the Whitney, and at Stieglitz's gallery, An American Place.[3] He was on the cover of the *American Magazine of Art* of February 1935 and was also featured in both the October and November issues of that year. Indeed Marsden Hartley, whom Tobey had visited in Mexico in 1931, could well have drawn Marin's work to Tobey's attention. Although Marin had exhibited many times in New York, an exhibition there in 1928 had provoked considerable controversy, and it was Hartley who came to his defense. Hartley, who knew Marin from 291, had by this time moved away from personal, emotional expression in his painting, but he continued to praise the work of Marin, and in the catalogue of the Marin exhibition at the Museum of Modern Art in 1936, he compared Marin's work to Sung painted scrolls in their "surety of observation, and surety of brushstroke."[4]

Before the Ash Can School in the early years of this century, artists had never so keenly observed or recorded the street scenes of Manhattan. The artists who revolved around Stieglitz—Marin, Stella, Weber, O'Keeffe—were equally fascinated with their city but turned from the often charming and figure-oriented views of the Ash Can School to themes larger in scope and

Broadway Norm, when he "realized that it was Broadway, with all the people caught in the lights." What was new and distinctive about this painting was the absolute and continuous linear spontaneity with which it was executed, and, significantly, the artist's choice of white for the calligraphy. Some nights later, Tobey painted *Broadway,* and two days later, a painting called *The 1920s (Welcome Hero).*[1] What eventually came to be known as "white writing" ap-

peared in Tobey's art. Although inspired by Oriental calligraphy, *Broadway Norm* represents an instance in Tobey's work that is close to automatic writing, a surrealist technique whereby the artist draws freely, or "automatically," and then finds his images in what he has drawn. Tobey was certainly familiar with surrealism. In 1929 he was even touted as the artist who put America back on the surrealist map.[2] And indeed had he not made the association between a

more impersonal in subject, such as the Brooklyn Bridge and Broadway. Their work expressed an enthusiasm for, and involvement in, these symbols of urban dynamism. During his earlier years in New York Tobey had been so thoroughly seduced by the figure that he had always taken his subjects from cabaret and burlesque. His notes on the teeming humanity in the streets of Shanghai were the first indication of his fascination with a city subject that would become central to his work.

While Marin's paintings were more subjective and expressionist—less conceptual—than Tobey's, Marin's choice of the city to express an integrated whole of vital forces provides the clearest precedent in American art to Tobey's city paintings. This excitement with the city as a subject was, as we have seen, not untypical of other members of Marin's generation, but it is in his work that we find the feeling of the city expressed in the interacting energies of the buildings, cars, and people.

Marin's first paintings in which he expressed primarily his *felt* response to his subject were a series of fourteen watercolors of New York City, which were included in his one-man show at 291 in 1913. For this exhibition the artist wrote a statement "for those who may need help of an explanation." The artist's words in many respects adumbrate the attitude Tobey was to take toward depicting the city in the thirties and forties. It begins:

Shall we consider the life of a great city as confined simply to the people and animals on its streets and its buildings? Are the buildings themselves dead? We have been told somewhere that a work of art is a thing alive. You cannot create a work of art unless the things you behold respond to something within you. Therefore, if these buildings move me, they too must have life. Thus the whole city is alive; buildings, people, all are alive; and the more they move me the more I feel them to be alive.[5]

When and where Tobey first encountered Marin's work is pure speculation. A selection of the watercolors by Marin shown at 291 in 1913 were subsequently included in

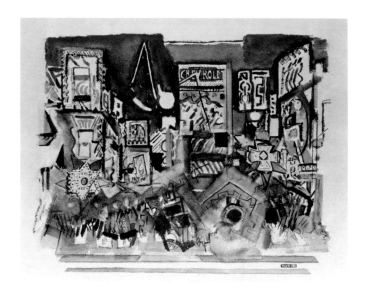

Fig. 5. John Marin, *Broadway (Night)*, 1929, watercolor, 21⅜ x 26⅜ in., The Metropolitan Museum of Art, New York, The Alfred Stieglitz Collection.

Fig. 6. John Marin, *Street Crossing, New York*, 1928, watercolor on paper, 26⅛ x 21⅜ in., The Phillips Collection, Washington.

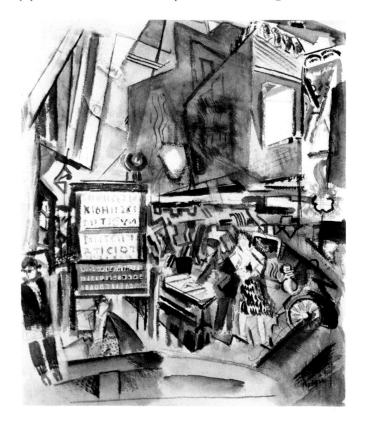

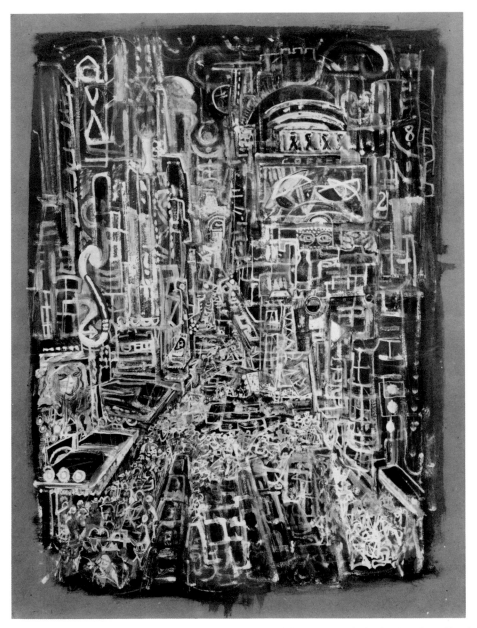

Cat. no. 7. *Broadway*, 1935, The Metropolitan Museum of Art, New York, Arthur H. Hearn Fund, 1942 (frontispiece).

American Place. The artist's celebrity climaxed in the mid-thirties with the series of articles appearing on Marin in the *Magazine of Art* in 1935 and the Museum of Modern Art's major retrospective in 1936. Although Tobey was not in New York at the time of the retrospective at the Museum of Modern Art, it is unlikely that he would have missed an article in the June 1935 issue of the *Magazine of Art,* entitled "Phases of Calligraphy," in which E. M. Benson related the calligraphic aspects of many cultures to one another and illustrated one aspect of his argument with a watercolor by Marin entitled *Broadway* of 1929 (fig. 5). In America, on his way back to England from the Orient, where he had been an intensive student of calligraphy, and setting foot on American soil for the first time in three years, Tobey would naturally have been eager to catch up on the scene at home and most especially to read an article about the calligraphic in art. Tobey probably also had firsthand experience of another New York painting by Marin when he visited the Phillips Collection in Washington in June 1935. The museum had recently acquired (in 1931) a watercolor of 1928 called *Street Crossing, New York* (fig. 6). There is no question that some of the suggestive shorthand Marin used here is very like Tobey's generalized handling of architectural ornament and street signs in *Broadway.* And a monograph on Marin, by E. M. Benson, was published in 1935 reproducing both *Broadway* and *Street Crossing, New York.*[7] In any case Marin's *Broadway* bears some striking resemblances to Tobey's *Broadway,* while the contrasts between the two highlight the originality of Tobey's style.

Like Marin's *Broadway*, Tobey's *Broadway* (cat. no. 7) was a purely conceptual work, painted as it was far removed from its city of inspiration in the quiet of Devonshire. This reliance on a retentive memory led quite naturally in the work of both artists to a distillation of their experience and a personal and subjective recording of the subject. Both artists allowed an irregular border within the edges of the paper on which they

the Armory Show, and, although Tobey was not in New York at that time, he did see the Armory Show in Chicago. Tobey's work of 1913 reflects no impact that Marin's work might have had on him. But Marin's New York paintings were controversial enough at the time that they may at least have caught his attention. That Tobey knew Marin's work by the 1920s is almost beyond doubt. Marin's paintings were shown annually in New York at Stieglitz's 291 gallery, and subsequently at its successor, An

were working, giving the surface itself greater presence, and executed the lively scene with calligraphic strokes in a rectilinear framework of buildings and signs. In both works these signs and street signals, not legibly but suggestively depicted, enhance the frontal treatment of the scene. Both artists have used underlying washes of color, and their palettes are notably similar, the dominant hues being red, blue, and yellow, with some green. These colors are more muted in the case of Tobey's painting, largely due to the reddish ground he used. Lights, sometimes dotted, always brilliant, illuminate both paintings through the use of white. While in Marin's view of Broadway the white passages are untouched paper and the dynamism is largely conveyed by the zig-zag strokes across the bottom of the composition, in the Tobey no part of the surface is untouched, and the white calligraphy, painted in over some portions of the image, largely accounts for the dynamism of the scene. Marin's work is thinly painted and has a lucidity due to its spareness of paint, but Tobey built his composition in layers. The white, which initially appears to be on top, in fact is largely painted over with thin washes of blue and yellow. (Indeed almost all the blue and yellow pigment has been added after the white writing.) The receding avenue creates a strong perspectival element, which is only counteracted by the calligraphic handling of the crowd, the central focus of Tobey's work. In the Marin, by contrast, the planar quality dominates, and the figures are only vaguely suggested across the bottom foreground. There is no strong recession into depth. Where Tobey's work is cumulative and linear, Marin's is reductive and planar.

Marin expresses his own subjective reaction to the city. While Tobey's *Broadway* may look "expressionist," in that the frenetic quality of the crowd is conveyed by a rapid, involved movement of the brush, Tobey's line was inspired by the agitated bustle and jostle of figures walking down the avenue. As his line moves back in space, it becomes less descriptive of figures and more identified

with their paths of movement. What is distinctive about Tobey's line is its expressionist agitation and angularity—characteristics of calligraphy, which Tobey adopted in spirit, but without imitating the appearance of calligraphy. The white writing of *Broadway,* as in *Broadway Norm,* seems to represent both the activity of the people bustling along Broadway and, at the same time, the web in which they are entangled by virtue of their aggregate energies. Marin never makes the analogy so immediately conveyed by Tobey of the interacting energies of lights and people.

In an interview with William Seitz, Tobey recalled his fascination with light and the magnetic attraction it exerts on all living creatures. In the monastery in Japan, awake in his room at night, the lights burning, he watched the moths striking against the window, recording, "countless in number they seek an entrance to the light."[8] Earlier, when he lived in Paris from 1925 to 1926, he recalls,

I used to go and look at light with people going into it and coming out of it. It made a light focus . . . they wanted light. . . . Those foci of light are highly magnetic. Like a bee going in and out of a hive; no matter how far away a flower is and they go there and bring it back. . . . People, everything, flowers, trees have to have light; more or less, there are always variations on this—some can get along with very little light, some can live in the depths of the ocean with no light and then they create a light for themselves.[9]

By using white for both the lights and the people in the light, Tobey suggests a symbiotic relationship between them. White, as an intense, highly charged color (we think of white heat) suited his purposes. Tobey probably saw rubbings of Chinese rock inscriptions which present the inverse of black on white, and indeed he at one time owned a screen of such a rubbing (fig. 7). Moreover, the fact that Broadway was called The Great White Way no doubt in part accounts for his interpretation of his spontaneous little work as *Broadway Norm.* His interest in light as a focal point to which people gravitate and around which movement

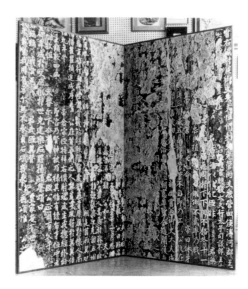

Fig. 7. Screen with rubbing of Chinese rock inscription, once in the collection of Mark Tobey (c. 1930s-1940s), Henry Gallery Archives, University of Washington, Seattle.

centers led him quite naturally to analogies with religious symbolism, but he did not paint any works that specifically reflect this association until the following decade.

Nevertheless, the idea of people "caught in the lights" or, as Tobey has also put it, "caught in the mesh of their net," reflects his own ambiguous attitude toward the city and one aspect of the Bahai view of the self-seeking and conflicting energies of a city such as New York. His fascination with city life, and especially New York, was mingled with rejection; in as much as he needed the stimulus of New York, he needed to retreat to the Northwest. Tobey's words about the city seem to echo those of Baha-Ullah:

They that are intoxicated by self-conceit have interposed themselves between it and the Divine and Infallible Physician. Witness how they have entangled all men, themselves included, in the mesh of their devices.[10]

In a letter of about 1935 from London, Tobey wrote to Kenneth Callahan that his painting *Broadway,* "astonished me as much as anyone else. Such a feeling of Hell under

a lacy design—delicate as a [Watteau?] in spirit but madness."[11]

Tobey himself attributed the rapid linear notation of *Broadway Norm* to his study of Oriental calligraphy. Certainly an Oriental would not find the translation of writing into painting a difficult concept, since in the Orient writing and painting are treated as two aspects of the same art. As Hyatt Mayor has explained in an article on writing and painting in China, "since they write and paint with the same ink, brushes, and brushstrokes, writing and painting almost fuse into one art."[12] In China writing is admired for its character and energy. An analogy with human activity is evident in their criterion that good writing is made up of "bone and muscle."[13] Rather than exact drawings, like Egyptian hieroglyphics, calligraphic drawings can be considered action sketches to the extent that they are classified by speed, both of execution and, consequently, of appearance, into standing, walking, and running scripts. In *Broadway*, line is not an abstraction of a thing seen so much as an expression of an activity; it does not describe, but is.

"Draw bamboos for ten years," says the Zen artist, "Become a bamboo. Then forget all about bamboos when you draw."[14] Such a concept is reflected in *Broadway Norm* and in *Broadway*, as well as in Tobey's own words, "Of course when I did Broadway I did it because I loved it, because I had experienced it. It was in my bones but I could paint it best when I was farthest from it."[15] In San Francisco Tobey had painted a pastoral vision of the pull of the moon; then, surrounded by the Devonshire countryside, he painted the magnetic attraction of city lights. It was thus through his experience in the Orient that he arrived at an expression of a concern of many of his contemporary artists and writers: the labyrinth of men's lives and the labyrinth of the unconscious, of the mind.

In choosing to paint Broadway, Marin and Tobey selected the topical city subject of the day. Broadway was in its heyday in the twenties and thirties. Brooks Atkinson

Fig. 8. Tobey, *The 1920s (Welcome Hero)*, 1935, tempera, 26 x 19 in., destroyed by fire.

writes of what he calls the "Paradox of the Thirties," after Broadway had been hard hit by the Crash of 1929, "Although the nation seemed to be falling apart and money was scarce on Broadway, the theatre was in top form. No wonder John Mason Brown referred to that perplexing period as 'these full lean years.'"[16] A description of Broadway in the thirties conveys the atmosphere at that time of this center of night life. By nightfall if not earlier those blocks all the way from 34th to 49th Street were probably the busiest pedestrian section of the city.

Whether Broadway was beautiful or ugly was beside the point. Broadway was never intended to be beautiful. All Broadway had ever hoped for was that people should feel livelier when they plunged into its "tonic light-bath" as Stephen Graham called it. Night was its natural hour. By day, many of the lights were turned on impatiently as if the proprietors could not wait for the sun to get out of the way. Nature was in large part eliminated from this vast clangorous bazaar. Even on clear nights, the stars were outdazzled by the great flare of light that leaped from Broadway, as if a supernatural furnace door had been opened. If you hunted long enough over the building tops, sometimes you could see a pale moon moving through its lonely orbit in the sky. Like a discarded mistress, it kept its distance. It looked reproachful and humiliated.[17]

Only two days after painting *Broadway*, Tobey painted another work in the same

vein, which he called *The 1920s* or *Welcome Hero* (fig. 8). The "white writing" here bears less resemblance to calligraphy than in *Broadway.* It is the essential impetus, the speed and intensity of execution, that Tobey retained and that provided a language so suited to the New York of the twenties, of "sirens, dynamic lights, brilliant parades and returning heroes. An age of confusion and stepped-up rhythms," as Tobey recalled.[18] And we are reminded of the advent of the moving picture in the 1920s, here reflected in the jerky, agitated movement of the crowd bustling down the avenue, a cinematographic conception that prefigures Tobey's future use of the moving focus in his work. The whole painting is animated with the theme due to the rupturing of the spatial dimensions of solid and void, and in this respect is reminiscent of Marin's fractured handling of such massive edifices as the Woolworth building. Rather than a predominance of horizontal and vertical for solid buildings in contrast to a calligraphic description of moving crowds, as in *Broadway,* here people, and faces even, seem to emerge from the buildings themselves, which careen and rock with the same vibration as the advancing throng. The painting bears an uncanny resemblance to Ensor's *Entry of Christ into Brussels.* Tobey only saw this painting, however, many years later and, in 1962, remarked to William Seitz, in reference to the Ensor, "it goes back too far on the top for me but then that's nothing. That's his time."[19] In *Welcome Hero* Tobey brings the eye repeatedly back to the surface by filling the entire space with activity. In both paintings, the artist's composition begins with a central avenue, or vista, into depth, which provides focus and defines the space and movement. Yet, as in Ensor's famous work, the movement is not back into depth but rather forward out of depth. What was new in Tobey's painting was the dichotomy of the illusion of pictorial recession versus the presence of the pictorial surface, where all the movement comes into play. Many aspects of *Broadway* foreshadow Tobey's later work: its composition,

Cat. no. 1. *Cirque d'hiver*, 1933, Mr. and Mrs. Windsor Utley, Laguna Beach (color plate 1).

rapidity of brushstroke, and the rhythmic and continuous line linking the disparate elements—in this case figures—of the composition together.

Tobey described the experience of painting *Broadway* and *Welcome Hero* as

the most revolutionary sensations I have ever had in art, because while one part of me was creating these two works, another was trying to hold me back. The old and the new were in battle. It may be difficult for one who doesn't paint to visualize the ordeal an artist goes through when his angle of vision is being shifted.[20]

And it was perhaps for this very reason that Tobey did not draw much on this breakthrough for some years. He described it as a frightening experience, and yet, he remembered, "I was free. I could make them go this way and I could shoot things up...."[21]

While Tobey is generally assumed to have become a line artist subsequent to and because of his trip to the Orient, at least one work that predates his Oriental sojourn

provides clear evidence of an earlier interest in the kind of linear mode that Tobey would not explore fully until the early 1940s. This painting, *Cirque d'hiver* (1933, cat. no. 1), consists of a predominantly rose and blue ground on which straight, fine black lines create a mesh out of which rise several poles crowned with beacons. Despite hints of the human figure, this study in line is exceptional in the extent to which it anticipates a linear style that only emerged as a guiding principle in his work almost a decade later. The particular event that inspired this painting is unknown, but the work is not only a stylistic keystone but also a thematic one. For it is one of the group of circus paintings that Tobey did in the early 1930s. In such paintings as *Death of a Clown* (1931, fig. 9) we find a wild scene filled with the kind of figures that eventually crowd into Tobey's city streets and evolve into one very strong aspect of his city vision, that of celebration and carnival—a con-

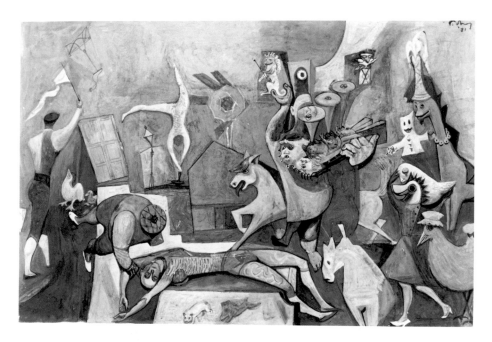

Fig. 9. Tobey, *Death of a Clown*, 1931, Mr. and Mrs. Windsor Utley, Laguna Beach. (Photo courtesy of The Seattle Art Museum)

temporary view of the *comédie humaine.* While all the other circus paintings of this period are far more graphically descriptive of a circus and its performers than *Cirque d'hiver,* the group of works as a whole introduces the theme of the circus—one which, with variations, recurs throughout Tobey's oeuvre as an aspect of his city paintings and also emerges frequently in related subjects in their own right, in works such as *Carnival* (1954) and *Celebration* (1965). In his city paintings of the early 1940s, like *Broadway Boogie,* Broadway itself, rather than its many theaters, has become the stage. The crowd is filled with circuslike characters. Tobey often painted the kind of celebrations that draw together the inhabitants of a place both physically and emotionally. And unlike his early city paintings of San Francisco and Broadway, by the time he painted *Broadway Boogie* (1942) and *Broadway Melody* (1945), he had transformed the conflicting energies of rush hour to the shared ones of an event partaking of the spirit of a circus.

The title *Cirque d'hiver* and the strongly linear style of this painting suggest an acquaintance with the work of Paul Klee, particularly such fanciful scenes as *Music for the Annual Fair, Magic Theater,* or *Carnival in the Mountains* (all of 1924-1925), which Klee did in response to the tales of E. T. A. Hoffmann.[22] Tobey may have seen works like these during his travels in Europe in the twenties and thirties, or perhaps reproduced in art periodicals and books. It is not only its fine linear composition that is reminiscent of Klee, but also the way in which one ground is laid over another to create a varied surface and atmospheric space, in which the linear activity occurs. This is one of the earliest instances in Tobey's work of such a practice. Throughout Tobey's oeuvre we find many parallels with the art of Klee. While we know that Tobey responded warmly to Klee's work, we do not know how early he was aware of it. He may have seen paintings by Klee in New York in 1930 at the large retrospective mounted by the Museum of Modern Art.

He also could have seen works by Klee in London in the thirties. Nor was Klee unknown to Seattle by this time. There, the Henry Gallery (of the University of Washington) included works by Klee in an exhibition of German watercolors in 1937. (Any exhibition held at the Henry Gallery was well attended by Seattle's art community, since it was one of the very few galleries to exhibit modern European art.) Moreover, Klee's work was readily embraced by other Northwest artists. Guy Anderson had a major Klee, which was an inspiration to him, and works by Klee were included in the private collections of Zoe Dusanne and Nancy Wilson Ross, both of whom Tobey knew.

Tobey continued to experiment with line during the thirties and early forties, but he did not resume the subject of Broadway and the crowded avenue until some time after his return to Seattle from England in 1938. We can find a number of explanations for his delayed pursuit of what would become such an important subject to him. For he was not only soon preoccupied with getting himself on the Works Progress Administration program, but it also appears that he did not really know what he had hit upon in his art until others began to respond to it. When Marion Willard came to Seattle in 1939, she saw work by Graves and by Tobey for the first time in a WPA exhibition and immediately wanted to see more. She bought several works by Graves but only one by Tobey—*Broadway.* Moreover, by 1940, Graves had already begun to employ very successfully and to his own purpose the white writing he had seen in Tobey's work. Tobey himself, on unpacking in Seattle his works done in England, must have realized the magic of the white calligraphy in them; how it springs to the eye and imparts dynamism to the image. In 1941 Tobey began again where he had begun before, with an exceptionally tall and narrow painting of San Francisco (cat. no. 8), which, by its format, accentuates the cavernous depth of the city street. The following year, he returned to the subject of Broadway. It seems

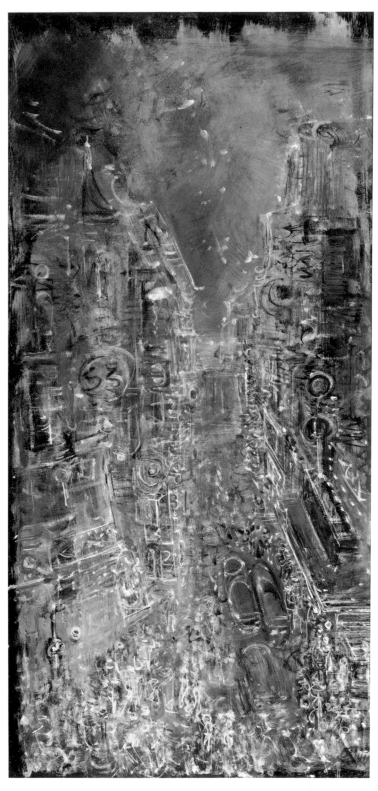

Cat. no. 8. *San Francisco Street*, 1941, Detroit Institute of Arts.

likely that he was encouraged by the fact that Marion Willard had bought his *Broadway* of 1935 and planned to enter it later that year in the *Artists for Victory* exhibition at The Metropolitan Museum of Art, where it indeed won sixth prize and entered the Metropolitan's collection. Perhaps Tobey simply felt the desire on his return to this country to revert to specifically American themes. Or perhaps he was responding to a strong sense of the interdependence of men's lives that wartime inescapably impresses upon us. In any case, the years 1942 to 1945 saw a series of paintings on this theme.

It is the jubilant painting *The 1920s (Welcome Hero)* more than *Broadway* that is recalled by *Broadway Boogie* of 1942 (cat. no. 10). For the wild array of figures Tobey presumably drew upon the many sketches made from his visits to New York nightclubs. Tobey found the city demanded some form of abstraction to convey the audible, as well as the visual, bombardment of the city, as here expressed in random words or the screech of a series of E's. Here, unlike the earlier *Broadway,* Tobey frees words from any concrete location to emerge as part of the sensory overload of the subject as a whole. A superficially cubist device, Tobey's use of words, however, does not have the formal or mechanical frontality and flatness of the words and letters in cubist paintings. Rather, they contribute to the expressionist dynamic of the painting in a manner more akin to the pictorial use of words practiced by the Italian futurists. Again, however, the futurists used various type faces where Tobey uses a calligraphic stroke or brushed-in capitals, thus aligning his treatment as much with the art of John Marin, or indeed with the Oriental easy marriage of writing and drawing. The painting is not made up of flat planes but pockets of depth. An interweaving calligraphy results in a many-layered shallow space, in which the nearly monochromatic buildings seem to have disintegrated altogether. One is first struck by the tremendous energy this work conveys, by its sense of an overwhelming density of activity, a sensory overload to

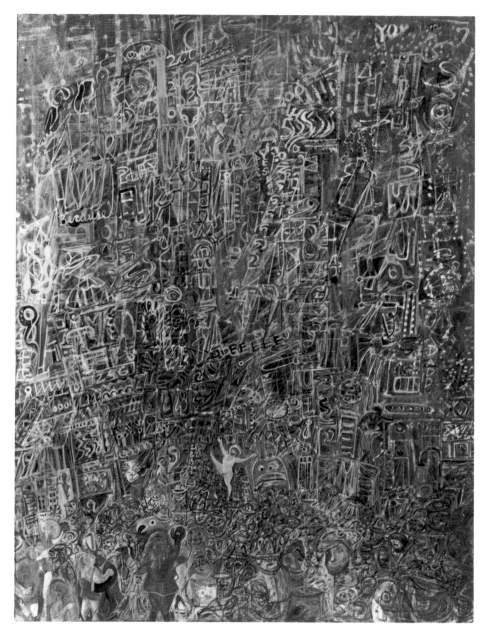

Cat. no. 10. *Broadway Boogie*, 1942, Mrs. Max Weinstein. (Photo courtesy of The Seattle Art Museum)

a means of suggesting lights which soon inspired a whole series of city abstractions. The speed of execution suggested by these passages adds to the energy of the whole image, belying the fact that it must have been built up over some time. Spatial recession is suggested in the lower portion of the composition in the diminishing size of the figures in the crowd, but the upper portion returns the eye to the surface, to a written veil of calligraphic notation, giving the whole work a cohesive unity. The ground is made up of layers of muted tones, shades of pink, gray, and beige, the linear mesh on top offering little contrast, in gray, brown, ochre, and white. Tobey later claimed, "Like the early cubists, I couldn't use much color at this point as the problems were difficult enough without this additional one."[23] And indeed Tobey's city paintings of the early 1940s almost uniformly lean toward a monochromatic palette. As in all Tobey's paintings, however, the longer one looks at it, the more the colors emerge.

The return of the burlesque figures which Tobey had studied in the twenties signals a return to the human figure in general in Tobey's work, which was to dominate one vein of city paintings in the 1940s. However, the figure to predominate was to be that of the workman, or the common man, rather than the performer, reflecting Tobey's response to the concern for the common man that had begun in the 1930s in America, specifically under the aegis of the Works Progress Administration. Some of the city paintings which grew out of *Broadway*, like *Flow of the Night* (1943, cat. no. 15) and *Electric Night* (1944, cat. no. 22) are not New York scenes but Seattle at night, and they expressly reflect the mood of wartime. Of this period, Tobey recalled:

But then when the crowds came, there were so many people I began to paint crowds, because they flooded the markets, and they flooded the streets, and they worked all night. That's when I made all the crowd pictures you know. And then of course it gave me a chance for interlacing of small forms also. This abstract sort of agitation

eyes and ears. The overall effect is at once exciting and disturbing. More faces and words emerge the more one looks at it: figures with animal heads, birdmen, a boxer, a pig, dancing couples, a disembodied ear, figures in windows. In one section, the lin-

ear energy is inspired and carried through by the shapes of a series of hats. Along the right side of the composition, the brushstrokes are reminiscent of *Broadway*. Circles, triangles, and many white dots and dashes run down this section of the painting,

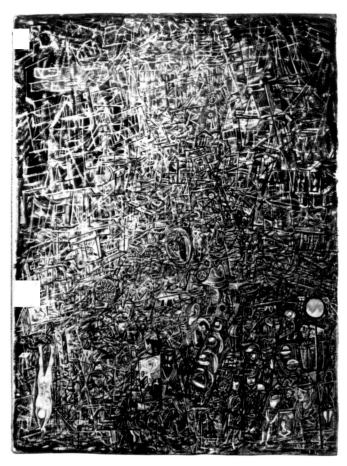

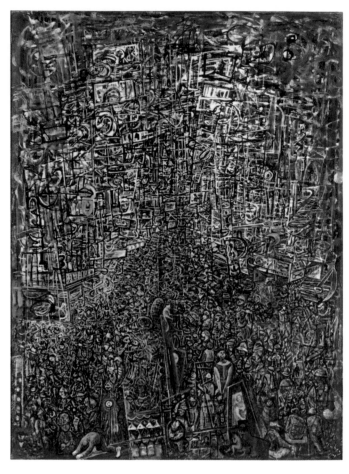

Cat. no. 15. *Flow of the Night*, 1943, The Portland Art Museum, Helen Thurston Ayer Fund.

Cat. no. 22. *Electric Night*, 1944, The Seattle Art Museum, Eugene Fuller Memorial Collection (color plate 2).

of points in space and so on and so forth. This gave me a chance to do the same thing with figures.[24]

In *Flow of the Night*, the avenue-type composition, more marked here than in *Broadway Boogie* of a year earlier, is accentuated by a line of men in the center moving back into depth. As in *Broadway Boogie,* a large ear appears in the center of the composition, and figures, large and small scale, are intermingled, regardless of spatial position. In addition, interior and exterior views, glimpses into bedrooms, and intimate views through windows, are interwoven in this space made up equally of both. A figure in bed can be seen on the right and another in

the lower center of the scene. Other elements juxtaposed like a lamppost and a nude man standing on his hands give the whole picture a density of activity and suggest that anything and everything goes on in a city at night. Layers of time and place are compressed here to express the simultaneity of lives and events in the city. White, beige, gray, and black calligraphy cover the virtually black ground of this nearly monochromatic painting, only modified by two brief passages of red and a little beige toward the upper left. The freely brushed strokes in the upper corners turn in on themselves or fade out, in classic cubist style, rather than going off the sheet. *Electric Night*, in the

same vein, of the following year, is more tightly composed, still more dense and detailed, and considerably brighter in palette. Here Tobey gives us his most thoroughly integrated and cohesive interpretation of this compositional scheme. Using both line and tone, the painting carries the viewer's eye from the foreground figures back to a central perspective vanishing point; but the eye is immediately retrieved from this distance to return to the surface through the lighter structure of the upper portion of the composition.

The progression from the cursive to the rectilinear, from an organic to a more structured space, that we see in this series of city

Cat. no. 25. *Broadway Melody*, 1945, The University of Michigan Museum of Art, Gift of Mr. and Mrs. Roger L. Stevens.

paintings also characterized Tobey's non-figurative paintings of these years, culminating in the structural refinement and purity of idea we find in *New York* (1944). Thus Tobey worked back and forth between series, from the densely crowded avenue scenes to the abstracted, distilled essence of the city.

Having reached this order and refinement of his theme, the following year (1945), Tobey loosened up his style again to paint the last of this series of city scenes that grew directly out of *Broadway*. Similarly combining figurative and abstract imagery in a central avenue composition, *Broadway Melody* (cat. no. 25) not only reverts to the specific locale of *Broadway Boogie*, but also to the mood of this earlier painting. The title *Broadway Melody* may well refer to a musical film of the twenties by that name, for popular music was almost as much a love of Tobey's as classical. A friend of the artist noted, "Many popular songs of his past seemed to evoke painterly ideas for him, he had a wide knowledge of them and the popular stage and movie music and song."[25] The novelized version of the film *The Broadway Melody* begins with a description of Broadway, with an emphasis on the cacophony of this part of town equal to that evoked by Tobey in this work:

Blending with the traffic cops' whistles, the grinding of brakes, the blaring of horns, the shuffle of feet, the clanging of motormen's gongs, the muffled subway's roar, the newsboys' cryptic shouts, the scalpers' ballyhoo, then, are the tunes of the moment—the best sellers of the tin-pan industry. Such is the Broadway Melody. . . . "Broadway Melody," the theme song of a forthcoming musical revue, named for it . . . is a jazzy syncope, split-beat against time and rhythm.[26]

The same year Tobey did a work that combined the abstract and figurative strains of his city paintings to date. *Partitions of the City* (cat. no. 24), quite a colorful work, is built up in layers using a varied brushstroke, from dry brush to wet, thick strokes to thin. Faces, or parts of faces, emerge but recede just as easily into the whole image, like a trick of memory. A man in profile

Cat. no. 24. *Partitions of the City*, 1945, Munson-Williams-Proctor Institute, Utica, Edward W. Root Bequest.

SEATTLE

Seattle was a young city in which cultural life was just emerging when Tobey arrived there in the twenties. But by the time he returned there from England in 1938, a small group involved in the arts was progressing by leaps and bounds. The Cornish Institute, founded in 1914, had contributed significantly to the life of the arts in the city, and half of Seattle's symphony orchestra was eventually culled from this school. In 1933 the Seattle Art Museum opened, and, thanks to Dr. Richard Fuller, a fine collection of Asian art could be seen there. If a "Northwest School" existed, it necessarily surpassed the boundaries of "regionalism," for by the 1930s an awareness of and interest in the Orient was germane to the West Coast in a way it would never be to the East. Even the climate and geography of the region is not unlike that of Japan. The mists and rain that enshroud Seattle most of the winter months often obscure Mt. Rainier, which, like Mt. Fuji, raises its volcanic profile not far away. Seattle was also near the heart of Northwest Indian territory. The city's proximity to both Asian and American Indian cultures allowed its artists to anticipate the growing interest among New York artists in both indigenous and Far Eastern, as well as European, art.

By the time Tobey felt he was ready to use color in his painting, he had lived in the Northwest long enough for the softening and muting effects of the climate to have permeated to his inner eye and given him a sense for the subtle harmony of tertiary hues. The winters are mild, it hardly ever snows, but the constant mist and rain coming up off the sound promote a luxuriant growth of fir trees and envelop the city. Tobey responded to all these aspects of his surroundings, and his painting, however abstract in style or universal in intention, reflects his years spent in this part of the world. Such an indirect reflection of the artist's locale he once described to his students:

may be found in the bottom left corner, and we can discern a female profile at the bottom center of the composition. The whole structure appears to shift and change. In this series of paintings inspired by *Broadway*, we find Tobey's constant concern with the fate of man. Gradually, however, although his concerns remain fundamentally un-changed, the role of the figure in his work diminishes in his need to pursue the abstract potential of his style.

There is no abstract art. You must always start with *something.* Afterwards you can remove all traces of reality. There's no danger then, anyway, because the idea of the object will have left an indelible mark. It is what started the artist off, excited his ideas, and stirred up his emotions. Man is the instrument of nature, whether he likes it or not. I didn't copy the light of the Dieppe cliffs, nor did I pay any special attention. I was simply *soaked in it.* [1]

Tobey's ability in the twenties and thirties to paint in totally different styles simultaneously began to give way in the forties, and a more consistent style emerged. In these paintings his initial adoption of cubist principles seems more fully subsumed to allow a more personal expression to emerge, and it is these works of the early forties that reflect the liberating use to which Tobey put his understanding of cubism. With regard to cubism, he remarked:

those fellows painted light—they took light and they congealed it to planes. So they had a light plane and they had a dark plane. They had medium planes but they were working in notan: black, white, and gray. [2]

Thus Tobey found mirrored in cubism the truth of certain aspects of Oriental composition. In speaking of cubism and *notan* in the same breath, he reveals the easy marriage of Eastern and Western sources that underlies his work. For inasmuch as the calligraphic impulse freed Tobey from the representation of solid forms, so both cubist and Oriental approaches to space (of no single vantage point) liberated him from the tradition of one-point perspective. The two together provided him with the means to treat his surface as a plane with any number of facets, creating multiple shallow pockets of depth while maintaining a unifying surface handling by means of which the whole mood of his work was eventually to be transmitted.

From painting to painting at this time Tobey would seem to vacillate between the figure or object and its abandonment for the pure and more conceptual use of line. His Western heritage of the painting of volumes in space conflicted with the love of line he developed after his visit to the Orient.

Fig. 10. Tobey, *Rummage*, 1941, The Seattle Art Museum, Eugene Fuller Memorial Collection.

This was particularly true in the case of subjects with which he had immediate experience, like the Pike Place Market in Seattle. Yet Tobey's development of a multiple viewpoint may have been inspired by this particular place, just as Picasso came to terms with some issues in the early evolution of cubism while visiting the hill town of Horta de Ebro in 1909. For Seattle's Pike Place Market is a multilevel maze of stalls, small shops, and open counters, overlooking the waterfront. Tobey said, "For me every day in the market was a fiesta." [3] Although he had been attracted to the market and made drawings there during his first period in Seattle in the 1920s and immediately on his return in 1938, it was during the years 1940 and 1942 that he did his

greatest number of studies of market scenes and types. Right there in the midst of the throngs and the colorful array of fruits and vegetables, he made his sketches. In brown or black ink on a pad of ordinary notepaper measuring 8⅜ x 5⅜ inches, he recorded the myriad activities of the market. Often the line, fluent and spontaneous, looks as if his pen had scarcely left the paper. On returning home, he would rely on his keen observation and visual memory to add colors, in tempera, which might differentiate the figures in a crowd or add light and depth to an interior. Here again, Tobey was stimulated by the necessarily rapid notation of moving figures.

Tobey's sketches can be considered preparatory to the larger and more complex paint-

ings of the subject only in that through them he gained familiarity with this scene. Tobey observed the life of the market at its opening, its peak moments, and at the end of the day when the garbage pickers would come to scavenge. He did not hesitate to explore the market from every angle. His unorthodox vantage points convey the haphazard and organic structure of the market and its multilevel maze of stalls. It is just such a multitude of impressions of myriad objects and activities that inspired Tobey's painting called *Rummage* (fig. 10).

Certainly, however, the idea of a multiple viewpoint had also been employed before, indeed years earlier by Stuart Davis, in his *Multiple Views* (1918), and multiple views were typical of WPA murals. Tobey was very likely affected by these works in his choice of subject matter as well as composition. Many of Seattle's foremost artists participated in the WPA program. In their search for specifically American subject matter, they were influenced by the concerns of the regionalist movement and its reversion to America's own realist tradition. The American scene, and specifically the worker, provided the social content of many WPA paintings. Like Morris Graves, who painted Seattle's Hooverville, and Kenneth Callahan, who chose to depict workmen and lumberjacks, Tobey made many studies of the down-and-out. But in contrast to Callahan, whose figures were mostly mythologized and Michelangelesque, Tobey continued to celebrate the dignity of the common man, introducing neither sentimental nor heroic overtones. Like Tobey, Graves and Callahan also sought a universal message, but while they tended to express such ideas through fantasy and visions, Tobey was able to find his theme of life, the brotherhood of man, even heavenly aspiration, in marketplace as well as metropolis. Those who frequent the Pike Place Market, as well as those who sell their goods there, come from all over the globe—Japanese, Italian, Scandinavian, German. As a microcosm of international exchange, this was an inevitable subject for Tobey.

Fig. 11. Tobey, *Interior of the Studio*, 1937, National Gallery of Art, Washington, Gift of Ambrose and Viola Patterson.

Rummage and the paintings that follow depend also on Tobey's cubist experiments in his still lifes of the late 1930s and early 1940s. The struggle to maintain the figure or object and yet allow a certain rhythm and surface freedom to emerge and unify the composition is one of the key elements behind Tobey's work of the early 1940s and begins to appear in the thirties in such works as *Interior of the Studio* (1937, fig. 11), painted at Dartington Hall. On his return to Seattle, no doubt stimulated by the presence of such visiting artists as Amedée Ozenfant (in 1938 and 1939) he showed his continuing interest in the formal possibilities of cubism in another series of still lifes.[4] Tobey may also have been affected by Ozenfant's attitude toward art, for Ozenfant believed the artist must concern himself with the modern world. While Tobey had already demonstrated his own like concern (in *Broadway* for example) he was also given

to more conceptual and religious subject matter in painting, and it may have been partly due to reinforcement from Ozenfant that he resumed his choice of subjects from the modern world—indeed subjects that most aggressively reflected the times in which he lived—in his work of the early forties. It is likely that Ozenfant conveyed to the Northwest artists the excitement over America and particularly New York that both he and his compatriot in exile, Fernand Léger, had felt on coming to this country.

Tobey manipulated his understanding of cubism to many purposes, sometimes incorporating stylistic features from other periods and artists. He had special admiration for El Greco, and once "described . . . a method of composing based partly on ideas he had developed from El Greco which involved simplifying volumes and defining them through highlighting their edges."[5] Such a painting is *Two Men* (1941, cat. no.

9), one of the most interesting of Tobey's paintings of workmen—of which he did many in Seattle in the early forties. Here Tobey has started to facet the volumes, and, by highlighting the edges with white, he simultaneously created a fragmented linear network on the surface of the painting. With white the artist picked out the prominent features of each man's face—cheekbone, nose, and brow. With considerable economy of means, he created two very different characters. Each wears his own peculiar style of hat. Tobey loved hats. They become a central motif in some of his Seattle market works, and he even did one painting which consists of virtually nothing but hats (collection of Morrie Alhadeff, Seattle).

The faceted volumes of *Two Men* attest to the logical integrity of the evolution of Tobey's white writing. Here we see the linear network of highlights just beginning to take on a pictorial independence from the volumes they pick out. Soon the volumes were to drop away, as Tobey eliminated everything but the structure or the light element, the essence of his subject. He once explained:

People say I called my painting "white writing." I didn't. Somebody else did. I was interested in an idea—why couldn't structures be in white? Why did they always have to be in black? I painted them in white because I thought structures could be, should be light. What I was fundamentally interested in at the time was light.[6]

Thus Tobey developed a concept of white for structure from his use of white as highlighting, that is, touching or delineating with white those parts of his subject that are prominent. In a face it is the bone structure that catches the light, and it is this underlying structure revealed by light that is, of course, the distinguishing and unchanging aspect of a face or any other subject. Thus white writing had no single source but emerged rather from the natural convergence of several sources.

We can see the extent to which Tobey's white writing differs fundamentally from that of Morris Graves, who took the idea from Tobey but turned it to very different

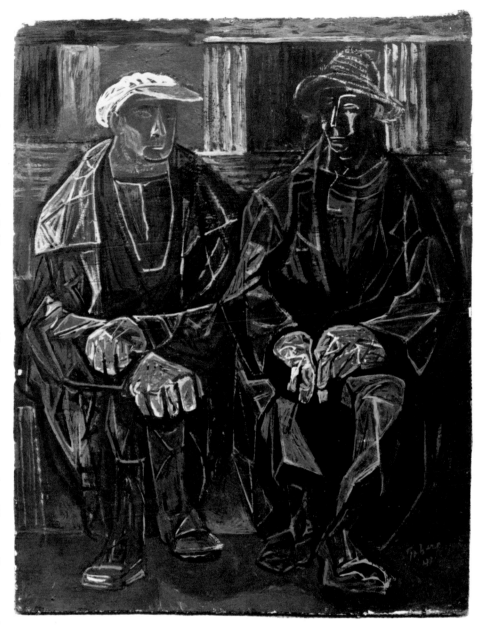

Cat. no. 9. *Two Men*, 1941, The Portland Art Museum, Helen Thurston Ayer Fund.

effect. In Graves' *Surf and Birds* (1940, Phillips Collection) a strongly gestural white line, echoing the calligraphic energy of Tobey's *Broadway*, suggests the surf. Soon, like Tobey, Graves created white mazes symbolizing light, but he used this web of lines exclusively to suggest moonlight—a

light which in his work seems most often to symbolize a state of consciousness. It creates a transcendent realm. For Tobey white writing embodies both the central idea and underlying structure of a work. While Tobey first used this linear language in a painting inspired by a crowded city avenue, Graves,

having seen Tobey's first efforts in this style, related them immediately (according to his own account) to the play of light refracted from water in a barrel onto his ceiling—a sight that apparently made a lasting visual impression on him.[7] For Graves white writing was a literal means of creating a body of light. For Tobey it is the asbtract and dynamic essence of his subject.

Although from a New York perspective it was natural to group these two artists together under the vaguely understood term, Northwest School, any close comparison demonstrates that the contrasts between the two artists outweigh their points of kinship. While Graves was virtually uninterested in the human figure,[8] Tobey loved the figure and continued to imply it even in his abstract work. Ironically it was a painting by Tobey which Marion Willard did not choose to take to New York on her visit in 1939 that provided a significant point of departure for Graves. Tobey's *Modal Tide*, which won the Baker Memorial Award in the Northwest annual exhibition of 1940

at the Seattle Art Museum, was one of the sources for Graves' *Beach under Gloom* of 1943, in which a shore bird confronts mountainlike waves of the sea.[9] Graves carried much further than Tobey the idea of animals under the pull of the moon that Tobey had begun to paint in San Francisco in 1934. Many of these works by Tobey were first exhibited at the end of that year at the Seattle Art Museum, and it is likely that Graves saw them there. In about 1939/1940, after visiting Tobey in his Seattle studio, he embarked on the series of paintings for which he is best known, such as *Bird in the Moonlight* (1940) and *Moon Mad Crow in the Surf* (1943). While in Tobey's *Modal Tide* the rhythm itself is the subject of the work, as the title indeed suggests, Graves was almost always inclined to pit a lonely bird against these forces of nature. Later, in his *Spring with Machine Age Noise* (1957) what emerges is the jarring contrast of the delicate blossoms and the relative violence of the "machine age." Graves' sympathies lie with the flowers.

Tobey, on the other hand, rarely states such antitheses in a painting or suggests the threatened frailty of living things. More often he expresses the dynamic interdependence of vital energies, whether it be the effect of the elements on plants or living creatures or that of city lights on people. Graves has been generous in his praise of Tobey and once remarked on seeing a group of his works that their quality derived from Tobey's drive and long years of self-remonstration, "not good enough."[10] Graves and Tobey remained friends, off and on, for a number of years (fig. 12).

The vitality of such a young but growing city and the size of Seattle, which was cozy compared to New York, both appealed to Tobey and at times frustrated him. Until the 1940s the *Seattle Post Intelligencer* was apt to devote an inordinate amount of space to gossip. And until local artists like Kenneth Callahan began to write its art column, it reflected an astonishingly backward understanding of contemporary art and most especially of its local artists.[11] Although Tobey was already well respected in Seattle's art community by the 1930s, Callahan, in reviewing Tobey's first show at the Seattle Art Museum, had to defend his work to a hostile general audience. Yet, as the region's leading artist, Tobey was virtually unchallenged and built a small but fashionable clientele over the years.

Tobey taught off and on, formally and informally, most of his years in Seattle. A man of tremendous conviction and commanding presence, he had a real following among his students. His unorthodox method of instruction was designed to make the students find their own individual form of expression. Tobey strongly believed that the spirit that animated the work was important, rather than the technique. A discussion of color theory could lead to music and philosophy. Tobey was a teacher by nature; some said he was always teaching, whether in or out of class. He has been described by his students as "so spontaneous, so direct, so vivid," and as a "volcanic personality, very articulate."[12]

Fig. 12. Marion Willard, Morris Graves, Mark Tobey, and Graves' dog, Edith, at the home of Graves, Woodway Park, Edmonds, Washington, August 1949. (Photo by Mary Randlett)

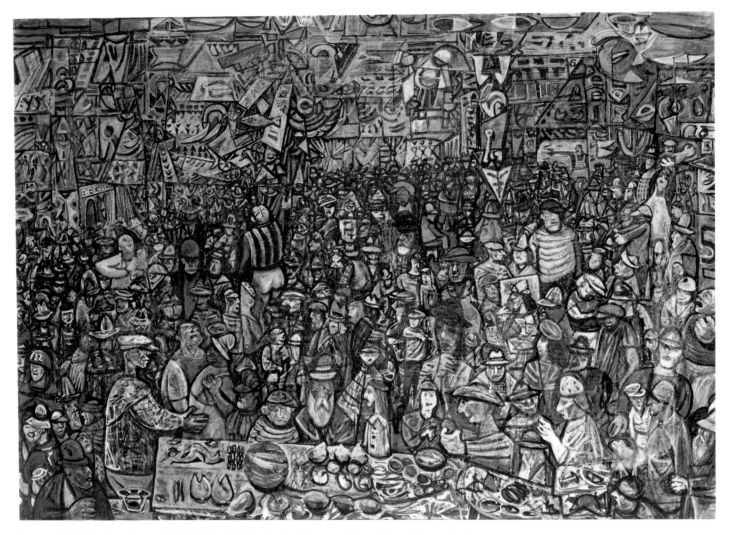

Cat. no. 14. *E Pluribus Unum*, 1942-1943, The Seattle Art Museum, Gift of Mrs. Thomas D. Stimson.

Tobey's city paintings of Seattle speak of the immediate human experience he had there, in marked contrast to his paintings of New York City. In the Seattle works he continued to paint the figure although he had already eliminated it entirely from a contemporaneous series of New York paintings. While these distinct series reveal parallels in stylistic development during the years 1942-1945, they also are distinguished by the extent to which they reflect their different locales.

E Pluribus Unum (1942-1943, cat. no.

14), appears in many respects to be a summation of Tobey's market studies. One of the most densely and fully worked of the Seattle scenes that Tobey painted, it is also one of the most colorful. Of these overall market views, most are more sketchy in handling and grisaille in palette (*Sale, The Gathering, Remigration*), but, like *E Pluribus Unum*, they are all similarly horizontal compositions in contrast to the vertical format that, in keeping with the verticality of the subject, Tobey usually chose for New York paintings. Like Tobey's other market scenes,

it reflects the more regionalist vein in which he approached such subjects. These works provide the most extreme contrast to the contemporaneous abstract paintings inspired by New York. While the impersonal essence of the metropolis made eliminating the figure inevitable, the immediacy of the Pike Place Market made figures the central element. Yet he found abstraction in both. Of Pike Place, he said, "It has color and movement—a release from mechanization."[13] Moreover, in the generalized shapes occupying the background of this painting,

Tobey appears to refer to such abstract artists exhibited at this time in New York as Joaquin Torres-Garcia. Arranged as they are in irregular compartments, they might be compared to the pictographic language of such works by Torres-Garcia as *Composition* of 1932 (acquired by the Museum of Modern Art, New York, in 1942).[14] Tobey's similarly generalized shapes, however, were painted one over another, which in combination with their flat design creates shallow pockets of depth, in contrast to Torres-Garcia, whose symbols are each separate and pictorially flat. We also find in Tobey's shapes an affinity to the Indian art of the Northwest, with which he had a growing acquaintance. He not only had collected some pieces but also did several paintings derived from his knowledge of Indian art.[15] And in this respect his interest coincided with that of the New York School artists in the art of the American Indian. Thus Tobey took inspiration from various sources but never copied.

In *E Pluribus Unum*, a diverse crowd mingles. The disparity in scale of the figures allows the eye to peruse the maze of faces deep into the background and be brought forward again by the larger figures and, in doing so, gives the illusion of many different centers of activity in the same pictorial space as well as creating a space to look both down on and into. One experiences the painting as one would such a crowd, certain faces standing out more than others in the mind's eye. Tobey later remarked, "I was interested then in having things big and then very small and then big and then contraction—expansion—contraction."[16]

Tobey attached considerable importance to titles of paintings, and *E Pluribus Unum* is no exception. In this case, however, the painting was titled by his Swedish friend Pehr Hallsten, a language scholar who was keen on Latin. The motto, "E Pluribus Unum," or "out of the many [states], one" found on United States coins, means in effect, out of diversity, unity. Not only does it seem to refer to the diversity of people

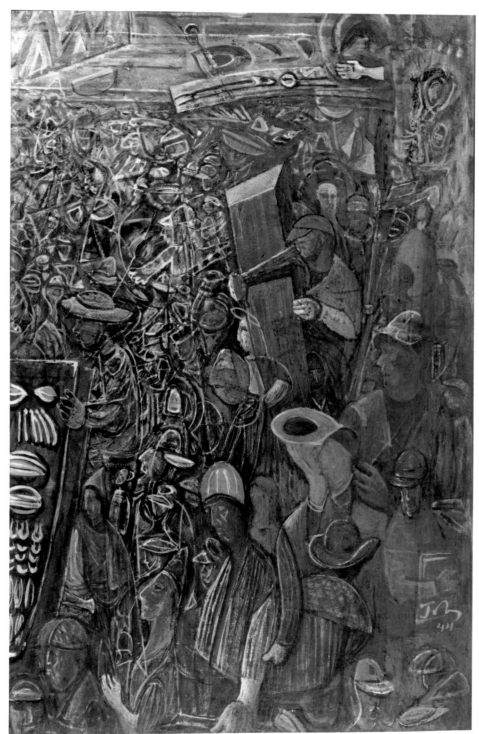

Cat. no. 17. *Market Scene*, 1944, The Seattle Art Museum, Gift of Mrs. Albert Enders.

assembled at the Pike Place Market (a virtual microcosm of the "melting pot" of the United States), but also the fact that the motto is found on coins may be an indirect reference to the painting's commercial subject matter. The exchanges that take place in a market place exemplify the interdependence of human lives—a constant preoccupation of Tobey. Though white is used again here as a means of structural highlighting, dark lines, like stained glass tracery, both separate and bind together the individual figures.

Tobey continued to paint the Pike Place Market for another two years, some canvases more clearly related to his city street scenes than others. While variations of scale and activity are abruptly juxtaposed in *Market Scene* (1944, cat. no. 17), the figures, as in *E Pluribus Unum*, are bound in a tight network of interrelationships. Soft tones of blue-gray, beige, crimson, golden-brown are used for faces, jackets, hats, objects. *Market Scene* reveals a further step toward linear abstraction. In this very small painting, enlarged by a mottled mauve-brown painted frame, which Tobey must have made himself, the shapes of hats and shoulders become abstracted forms, which, gathering their own linear momentum, carry on into the background to suggest the continuation of the crowd. Tobey's seeming *horror vacui* conveys the very essence of a public market where one is perpetually surrounded and jostled by others. It is this quality of line that begins to assume a certain autonomy, with curving rhythms descriptive of the throngs rather than the individuals, which brings this painting into the same realm as *Electric Night* of the same year. Although discussed separately on the basis of theme, these paintings of the early 1940s inevitably relate in form as well as in content.

Inasmuch as the regionalists expressed nostalgic attachment to local types and scenes, so Tobey felt strongly about the preservation of the Pike Place Market. When it was threatened with destruction as an outmoded institution, he voiced his distress over "impersonal modernism" or what he mockingly referred to as "urbane renewal." In 1964, Tobey wrote, "The Market will always be within me . . . it has been for me a refuge, an oasis, a most human growth, the heart and soul of Seattle."[17]

While modern technology had in some respects its allure for Tobey, the market place exerted an appeal precisely for its lack of the impersonal quality he deplored in modern architecture and the results of mechanization. Thus he would never have shared with Thomas Hart Benton the feeling that the "great cities are dead. They offer nothing but coffins for living and thinking." Tobey found his theme of life, humanity, even heavenly aspiration, in both market and metropolis. His city subjects of the forties, despite their universal themes of mankind, communications, and light, are related (more than his subjects from nature) to a specific location. Seattle is known for Pike Place just as New York is known for Broadway, its skyscrapers, and its lights.

ELIMINATION OF THE FIGURE

While it was the crowds of the city that first inspired Tobey's calligraphic abstraction, the full realization of this technique required him to give up the figure. For despite his preoccupation with the specific individual and mankind as a whole, Tobey's desire to smash form was simultaneously leading him in quite another direction. He would always return to the figure, however, and even sometimes turned the technique of sumi flung ink—an almost unavoidably abstract medium—to figurative ends. Moreover, where the figure is no longer present in Tobey's work, it is often still implied. That Tobey felt torn is clear from his own statements, "Yet I had to do it. And I had a hard time— out of my love of figures—I had a hard time to not carry that along, because I liked figures."[1] Indeed the same ambivalence and vacillation between abstract and figurative work characterized other artists of this period. Arshile Gorky never relinquished figuration although he disguised his subject. Jackson Pollock reverted to figuration in his last years, and Rothko once stated, "It was with utmost reluctance that I found the figure could not serve my purposes."[2] This reluctance was a natural one for artists who shared a fundamental interest in expressing human concerns in their art. In 1951, when the issue was in the air and keenly felt, Tobey said, "Every artist's problem today is 'what will we do with the human.'"[3]

As for other artists, however, the elimination of the figure opened for Tobey the door to a richness of implication and association that had not previously been possible in his work. Indeed it was a crucial turning point, after which line, which had bound figures together and given a rhythmic unity to a figurative composition, became invested with the subject matter itself. Tobey discovered the range of expression in line alone.

Tobey had long been interested in the most abstract of the arts—music. As early as the twenties he had a piano in his studio in Seattle, and he had no sooner arrived at Dartington Hall in England than he had a piano sent down from London. But it wasn't until the early forties that he began to study music in earnest, and it may be more than coincidence that it was at this very time that his abstract linear style began to emerge.[4] Music became almost as important to Tobey as painting, but rather than being a competing interest, it was a complementary one. The white writing, which had emerged in his work from a desire to express movement, was now to be further informed by his perpetual preoccupation with rhythm. Tobey later made a statement revealing the close relationship of music to his painting:

When I play the piano for several hours, everything is clarified in my visual imagination afterwards. Everything that exists, every human being is a vibration.[5]

While some artists have found in color a correspondence to musical timbre or instru-

Fig. 13. Tobey, *Mural* (one of eighteen panels), 1939, gouache and oil enamel paint on muslin, The Seattle Art Museum, Gift of Dr. and Mrs. Richard E. Fuller.

ments, Tobey found in line a correspondence to musical tempo. It was the tempo of a work that would give it its mood and qualify its subject. The correlation he found between music and painting fertilized his sense of repetition and variation in painting, where he fused time and space into one visual entity.

It is very likely that Tobey's discovery of the possibilities of such a correspondence was prompted by a commission he received in 1939 to paint a mural for the music room of Mrs. John Baillargeon in Seattle.[6] While we can trace his first inspiration for the project in a drawing of David and the harp,[7] he soon abandoned this static conception, and, referring to an abstract composition he painted in the twenties called *Garden Rhythms* (conveniently located in the Baillargeon collection), he painted a mural based on movements and rhythms found in nature. The forms in the mural

build to a crescendo, subside, recoil, and extend again like the movement of waves or the formation of shells (fig. 13). Soon after, Tobey began to paint other abstract works in which line and movement predominate.

Tobey's preoccupation with rhythm and vibration led to paintings dealing with neither suspended forms in space nor a completely surface emphasis, but with an interpenetration of solid and void—an indeterminate space, breathing life and motion. Of a painting of 1942, *Drift of Summer* (fig. 14), a work made up of a multitude of fine lines, he stated:

Since I try to make my paintings organic, I feel that there is a relation with nature. In "Drift of Summer" for instance, I wanted to experience through the medium of paint a feeling of the movement of grass and floating seeds. To achieve the rhythmic impact of such I had to build the body of painting by multitudinous lines.[8]

and

I want vibration in it so that's why it takes so long to build this up; because I want it to have air pockets. . . . Before I get to the actual painting I have to build up a mass of line.[9]

Drift of Summer bears a striking resemblance to a painting of the same year called *Transition to Forms* (fig. 15), a painting which with its many layers of fine lines suggests movement, a state of flux. The total disintegration of form in this work conveys its subject of life in the process of becoming—before form. It was both an intellectual concept and a new technical challenge that led to these densely linear works. Tobey would return to this subject of transformation two years later with a painting called *Crystallization*.

In his emphasis on growth and transformation, Tobey's abstractions bring to mind the underlying principles of Paul Klee's art, and we might suspect that Tobey's return to a language of pure line was boosted by a renewed exposure to the work of Klee. In 1941, the year after Klee's death, the Museum of Modern Art in New York held a memorial exhibition of his work—a large show which traveled to San Francisco, where Tobey might well have seen it. The Neumann-Willard Gallery had a Klee show in 1939, and the Buchholz Gallery, which sometimes shared exhibitions with the adjacent Willard Gallery, showed Klee's work in 1939, 1940, and 1943. In 1944 Tobey, visiting New York, wrote to Kenneth Callahan, "12 Klees at Valentin's which was about the best show I have seen."[10] Clement Greenberg, in writing about the late thirties and early forties, described the art scene in New York, "Almost everybody, whether conscious of it or not, was learning from Klee, who provided the best key to Cubism as a flexible, 'all-purpose' canon of style."[11] Indeed Klee's art provided a frame of reference for the New York critics who first recognized Tobey's work in the early 1940s.

Tobey's affinities to Klee run much deeper than mere stylistic influence. Indeed, their affinities as artists may sometimes result from a kinship of attitude as much as

Fig. 14. Tobey, *Drift of Summer*, 1942, tempera, present location unknown. (Photo by Adolph Studley)

Fig. 15. Tobey, *Transition to Forms*, 1942, tempera, destroyed by fire. (Photo by Adolph Studley)

from direct visual sources. A sense of history, of the relevance of ancient civilizations, informs their art, and a sense of the temporal quality of line guides their expression. Both were teachers who found that teaching clarified their own thought and expression; both were fascinated by all kinds of symbols and scripts; and both were musicians and composers, obsessed by the notion of time and the quality of movement, to a degree that a description of the work of one presents a striking parallel to that of the other.[12] Moreover it comes as nearly a shock to read in Klee's diary an entry of 1905 that precisely presages Tobey's white writing:

[Klee] one day tried scratching a blackened sheet of glass with a needle. "The medium," he writes, "was no longer the black line, but the white. White energy against a nocturnal background beautifully illustrates the saying: Let there be light."[13]

Tobey responded to the infinite variety of Klee's creative imagination. Klee's dictum, "Art does not reproduce the visible, it renders visible" is echoed in Tobey's words, "The artist no longer copies nature. . . . He is interested in what he feels about it."[14] The creative process of both artists was based on intuition, a process that Tobey compared to music.

I often think of Chopin when I work. From time to time I have ideas, sometimes I don't have any at all. Ideas come to me in the course of my creative work. A composer, once he has as his point of departure a series of sounds he can compose an entire symphony.[15]

Like Klee, Tobey felt most comfortable working on a small scale. The paintings of both artists are often considered "intimate" and spring from an intimate acquaintance with nature, with the world of minute forms, which Tobey recorded having discovered in Japan. When he took up white writing again in the early forties, he applied it to a variety of subjects, some of which

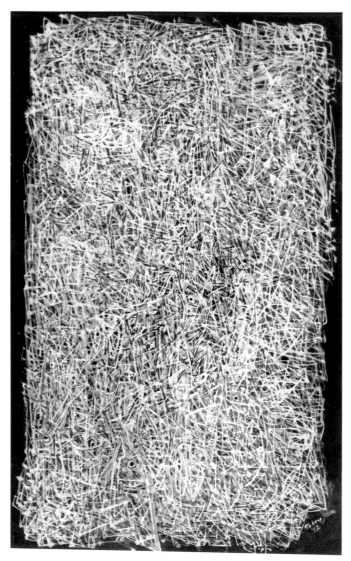

Fig. 17. Paul Klee, *In the Grass*, 1930, oil on canvas, 16⅜ x 20¾ in., The Sidney and Harriet Janis Collection, Museum of Modern Art, New York.

Fig. 16. Tobey, *In the Marsh*, 1942, tempera, present location unknown. (Photo by Adolph Studley)

seem to echo his experience in the Orient where he learned to recognize the "small world underfoot."

The subject matter of Tobey's *Drift of Summer,* grasses and seeds, relates this painting closely to a work done probably slightly earlier in the same year, called *In the Marsh* (fig. 16). It would not be surprising if Tobey had known a painting by Paul Klee called *In the Grass* (fig. 17), at that time in the Sidney Janis collection, but al-

ready much exhibited, including in the Klee memorial exhibition.[16] In Klee's work this grassy world, defined by its uniform ground color, is populated by faces and leaves all emerging from the same language of fine lines. Similarly in Tobey's dense web of a world in *In the Marsh*, one fish after another may be picked out of the maze of lines.[17]

From Tobey's *In the Marsh* to *White Night* (cat. no. 12), we find a sequence of

development from a multidirectional, or, in the case of *Drift of Summer,* even a turbulent linear composition, to one consisting of more singly directed strokes achieving greater rhythmic effect, building up toward the upper right corner whence beams of light appear to emanate. Indeed Tobey transferred his vision of nature almost directly into his city paintings. It was not only a technical consolidation of means in his work of this period but also a poetic and

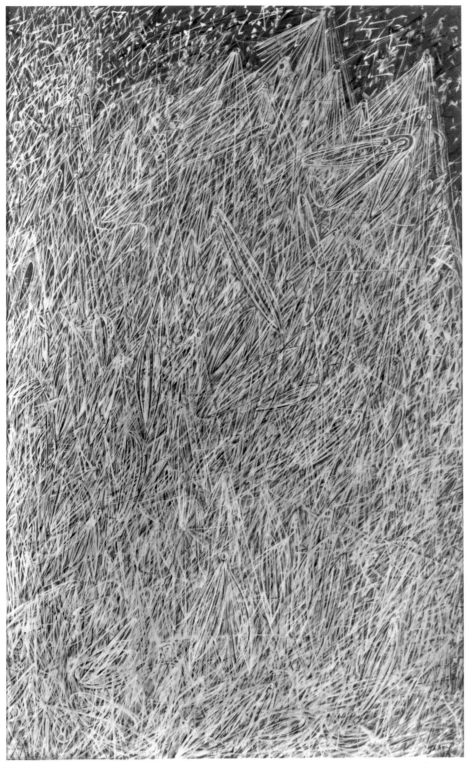

Cat. no. 12. *White Night*, 1942, The Seattle Art Museum, Gift of Mrs. Berthe Poncy Jacobson.

metaphorical vision of the world that enabled this transition. As he said in reference to his white writing:

For a long time I had wanted to unite cities and city-life in my work. At last I now felt that I had found a technical approach which enabled me to capture what I was specifically interested in. Lights, threading traffic, the river of humanity . . . chartered and flowing through and around its self-imposed limitations not unlike chlorophyll flowing through the canals in a leaf.[18]

The striking similarity between a painting of 1944 called *Crystallization* (cat. no. 18), derived from the earlier *Transition to Forms*, and Tobey's *New York,* also of 1944, reveals that what began as a study in the minute became a study in infinite light. Here lies the seed of Tobey's "world view" that emerged a decade later and was distinguished by its sense of intimacy. In addition to their compositional similarity, the outstanding quality that relates *Crystallization* to *New York* is the luminosity of these works. Tobey used no conventional method of creating pictorial light in *Crystallization;* virtually monochrome in palette, it hardly relies on color for this effect. Yet the painting emanates light. Executed mostly in white on a brown ground, the painting is densely worked, producing a soft, chalky impression. The strokes do not go off the surface, but turn in on themselves, away from the edges, creating an effect of infinite, but contained, expansion.

It was the *Burning of the Ships* by one of the greatest masters of light, Joseph Mallord William Turner (1775-1851), which Tobey saw in the Tate Gallery in 1938, that set him to thinking about what he called "dimensionless dimension." He found that Turner dissolved everything into light.[19] He later remarked that he found in Turner a principle espoused by the Chinese and Japanese, that of looking and not seeing but experiencing. While in Tobey's work nature is never the awesome force that overwhelms a scene in a Turner, the rhythms and intensity of his best work leave one feeling more in touch with the primal forces of nature, of having experienced a funda-

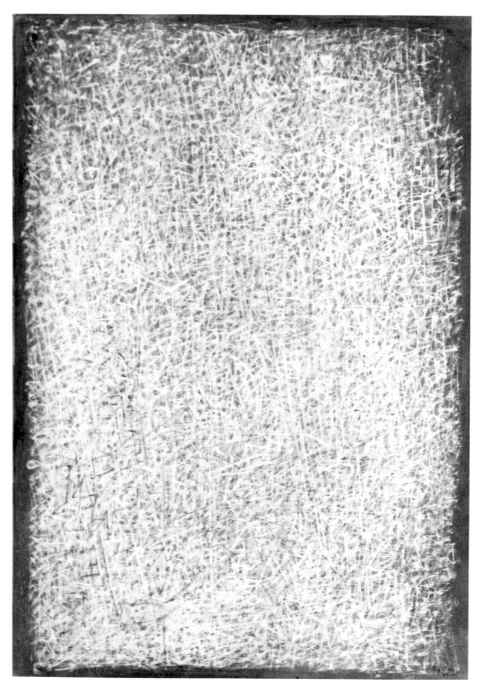

Cat. no. 18. *Crystallization*, 1944, Mrs. James H. Clark, Dallas.

mental source of life. Although Tobey also admired the paintings of Edward Hopper for their mood and feeling, it was the very lack of specificity in Turner's late work and in his own that allows the feeling and experiencing to supersede the seeing.

I wanted a picture that one felt more than one looked at. . . . The Chinese always talked about this feeling that exudes from a painting, you know; and I for a long time wanted something to come slowly to you. This thing has to be established between the painting and you. You can go up to it, looks like the dullest thing on earth as though no color at all. And you stand there a while and that color will come out to you.[20]

Often, at close and prolonged examination, a seemingly monochromatic work by Tobey will reveal its colors. Tobey emulated the state of contemplation in which an Oriental received a work of art, the intention of which, like Tobey's, was to enhance his perception of the universe. In Tobey's work of the fifties, color emerged more and more to accent rhythms and create the entire mood of the painting. *New York* (cat. no. 19), however, consists of a multitude of white lines on a muted gray ground. The reduction of his palette to variants of gray, an approach Tobey used often to clarify formal pictorial relations, is eminently suited to the subject of the city at night, when the brilliance of electric lights forces the dull stone into monochromatic obscurity. That which is seen from a distance, through atmosphere, tends to lose contrasts and distinctions of color. Moreover the winter mists of Seattle and Devonshire no doubt contributed to Tobey's sensitivity to such subtle tonal relations. Considerably larger than any of the other works in this vein, *New York* must be considered the summation of this type of white writing abstraction. Of *New York*, he wrote to Marion Willard,

I have always felt that "New York," your "New York" was my major painting of the whole white writing series . . . the other paintings are varying attempts at a type of modern beauty I only find in the delicate structures of airplane beacons and electrical transformers and all that wonderful slender architecture connected with a current so potent and mysterious.[21]

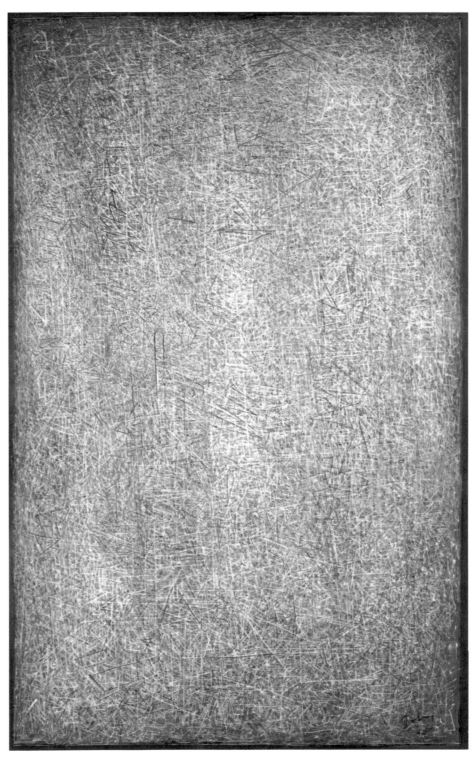

Cat. no. 19. *New York*, 1944, National Gallery of Art, Washington, Gift of the Avalon Foundation, 1976 (cover illustration).

Tobey's *New York* seems to represent the point at which he was closest stylistically and conceptually to American precisionist painters like Charles Sheeler, who created paintings of extraordinary formal purity from industrial city subjects. Their emphasis on clarity and precision led to an elimination of extraneous detail and an idealized view of the modern industrial world. Yet Tobey's world, idealized too, remains more romantic in concept. Indeed the comparison points up the contrast, for Tobey would have been the last to romanticize the mechanical world, where he found not beauty but rather a threat to human concerns. Instead Tobey sought elements of the real world to express something intangible. In many of these more abstract city paintings, like *New York*, the dominant subject matter — an intangible one — is light.

Light, which symbolizes in many cultures a supernatural presence or divine illumination, might well be considered the primary theme of Tobey's painting, and from the earliest years of his abstract work, it carries with it many metaphorical associations. For Tobey light is a source of energy and life. It is, moreover, a "unifying idea," to use Tobey's own words, because it draws people, as well as all other living things, to it. He himself has described light as "a unifying idea which flows through the compartmented units of life, bringing a dynamic to men's minds ever expanding their energies toward a larger relativity."[22] And it is precisely because he thought of and used light conceptually that his approach could embrace the religious symbolism of light as a source of spiritual revelation. This metaphorical way of looking at the world soon enabled Tobey to express Bahai ideals simultaneously in his paintings of city subjects. Indeed Bahai texts and teachings would have naturally encouraged such an approach to artistic expression of the faith, as we find, for example, in *City Radiance* (cat. no. 20).

While in *New York* the endless darting exchange of energies fills the canvas overall with almost uniform intensity, the lights of

Cat. no. 20. *City Radiance*, 1944, Private collection, Zurich. (Photo by Adolph Studley)

City Radiance are contained so that one is aware of the vast night sky above and beyond. The luminous beams criss-cross, and their points of intersection suggest stars. Tobey's use of white representing a multitude of light sources, on a dark ground, creates the impression of immeasurable depth. Indeed Tobey seems here to have penetrated perspective and brought the far near. The restraint of both color and handling in these paintings also contributes to a loss of physicality and lends to both works an otherworldly effect. While Tobey lived his faith and all his paintings express Bahai ideals to one degree or another, certain paintings seem more deliberately an expression of the Bahai faith than others. In *City Radiance* the title alone suggests that Tobey found and hoped to convey a Bahai association within the subject of the city. Not only is the upward, soaring structure of *City Radiance* reminiscent of Tobey's *Gothic* of 1943, a composition based on the structure of the Gothic cathedral, but also here the lights of the city acquire a celestial quality, lights and stars becoming one, a marriage of earthly and celestial, of science and religion.[23] *City Radiance* becomes a spiritual expression in twentieth-century terms of the vertical heavenward thrust of a Gothic arch and reflects the Bahai vision of "This Radiant Century," made radiant by modern invention, to which a whole chapter of the writings of Abdul-Baha is devoted.[24]

City Radiance belonged for many years to Lyonel Feininger. It was not only the mystical quality but also the affinity to music in Tobey's work to which Feininger responded. Like Tobey, he was a musician. Moreover, like Tobey, Feininger was for some years better received abroad than in his native country. Tobey and Feininger met in the early forties. A deep and lasting friendship ensued.[25] Feininger has been described by those who knew him as refined, gentle, saintly. Tobey's senior by nineteen years, he was for the younger artist a stabilizing influence, someone who could give him peace of mind and support the direction to which he was committed as an artist. Indeed, when

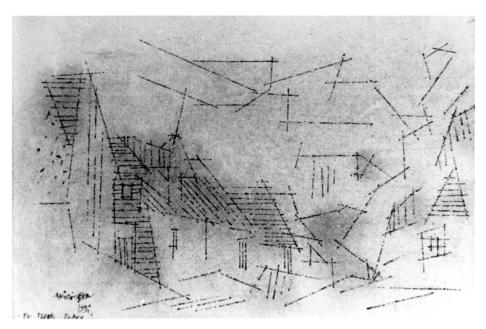

Fig. 18. Lyonel Feininger, *Untitled*, ink and watercolor, 1951, once in the collection of Mark Tobey. (Photo by John H. Livingstone, courtesy of Arthur Dahl)

we compare the work of the two artists in the mid-forties, it seems that Feininger's work itself reinforced Tobey's development of his refined form of linear expression. Feininger once remarked to Seliger that Tobey made him feel primitive by comparison, so refined and sophisticated did he consider Tobey to be.[26] Tobey owned some Feininger watercolors of which he was particularly fond (fig. 18). After Tobey began to exhibit in New York, principally at the Willard Gallery, Feininger became a sensitive interpreter of his work. When Feininger died in 1956, it was a devastating loss for Tobey.

On the occasion of Tobey's first show at the Willard Gallery, Clement Greenberg wrote of "the intensity, subtlety, and directness with which Tobey registers and transmits emotion usually considered too tenuous to be made the matter of any art other than music."[27] He had opened his review remarking that the exhibition "deserved the most special notice." No critic, however, wrote as sensitively of Tobey's work as

Lyonel Feininger. For the catalogue of a one-man show in 1945-1946, which opened in Portland, Julia and Lyonel Feininger together contributed these words:

Tobey himself speaks of his latest works as "white writing," but it is the handwriting of the painter, a painter who, for the tales he has to tell in his pictures has created a new convention of his own, one not yet included in the history of painting. . . . Like poetry and music, his pictures have the time element, they unfold their contents gradually. With an active imagination they have to be approached, read, and their symbols interpreted. They reveal their tenor if one listens with the inner ear, "the ear of the heart," as Jean Paul calls it.[28]

Tobey's stylistic development unfolded intuitively. In twentieth-century art, particularly in the case of an artist who arrived at a form of abstraction, we tend to expect the artist to proceed in logical steps toward the simplification or purification of his vision, or the elaboration or refinement of his grand design. If we look for such a progression in Tobey's work, we will be stymied. As he

himself said, his development has been a zig-zag. He would return to an idea he hadn't worked on for years, picking up again where he left off, or digress from a given theme to explore various byways before getting back on track. Tobey sometimes bought back works that he considered "seed" paintings, which he wanted to draw on again. Though his vision was constant, his ways of expressing it revealed his love of experiment. Such a series of paintings are those that spring from city paintings like *Broadway* and *Broadway Boogie*, but which consist of almost nothing but dots of light in a night sky. One of the first of these paintings is *Times Square* (cat. no. 23), probably done in 1944, a work that led to the more loosely constructed painting called *Transcontinental* (1946, cat. no. 29). What is extraordinary in these works of uniform surface treatment and little color variation is the articulation of the space the artist has nonetheless achieved. The eye, perusing the surface of *Times Square,* comes across an open window or door. A man leans against a door jamb in the bottom center of the composition. Tobey then moves from this invented impression of a specific place to a work much broader in its reference; *Transcontinental* suggests the experience he himself had so often of crossing the country by train. Again for him the seemingly limitless expanse of this land was magically evoked by the night lights illuminating the way, a sign of man's communications crisscrossing the country. In this small work Tobey intimates a vast scale, and the painting seems to express his own words about, "America, my land with its great East-West parallels, with its shooting-up towers and space-eating lights—millions of them in the vast night sky."[29] In June 1947 Tobey wrote to Marion Willard:

Don't know how much longer I can keep on white-writing as it's too nervous a style—too exacting for a nervous man.[30]

Tobey's work never lost its intensity, but white writing, which had served as the language for a great variety of paintings, was to

Cat. no. 23. *Times Square*, 1944, Private collection. (Photo courtesy of Sotheby's, New York)

During the decade of the forties, Tobey's vision of the city expanded from the particular locales of Broadway in New York and Pike Place in Seattle to less specific evocations of the urban experience. Simultaneously he explored broader visual fields made possible by the concept of the aerial view, as we find, for example, in *Transcontinental* (1946) and some years later in *Aerial City* (1950). In tandem with this expanded field, Tobey was becoming increasingly concerned in the fifties with the universal content of his work. He became interested in scientific laws of dynamics and natural formation, and this pursuit enriched his exploration of a pictorial field with no fixed vantage point, which led, by implication, to a more abstract image. Moreover, at this time he intensified his interest in Oriental art and thought, to which he felt committed both aesthetically and philosophically, in his search for a universal artistic expression. Throughout, Tobey's concern with universal content is fundamentally attributable to his religious belief, but it also reflects the artistic climate of the period.

By the late 1940s the seeds of internationalism, which had been sown in this country in the early years of the century in a growing awareness of the art of other cultures, had blossomed into a universal ideal to be achieved through somewhat different means. The emphasis had shifted from one of gleaning methods and ideas from the art of other cultures to one of seeking the inner and fundamental core of reality and thereby arriving at a message which was necessarily universal. Robert Motherwell expressed this idea in a statement for the catalogue of the exhibition, *Fourteen Americans*, held at the Museum of Modern Art in 1946:

Among other ends, modern art is related to the ideal of internationalism. . . . One is to know that art is not national, that to be merely an American or a French artist is to be nothing: to fail to overcome one's initial environment is never to

become only one aspect of a continually evolving expression in which black as well as white and a rich spectrum of color came into their own.

In the Baillargeon murals, Tobey seems to have put into paint quite literally Ernest Fenollosa's concept of art as kind of a spatial music. Like nature's own process of transformation, the rhythmic forms unfold. Lawrence Alloway's words on Tobey's work are as relevant to his studies of city lights

or natural formations as they are to his interest in ancient scripts or a Gothic cathedral: "Layers of time, rather than a fragmentation of the present, underlie his pictures."[31]

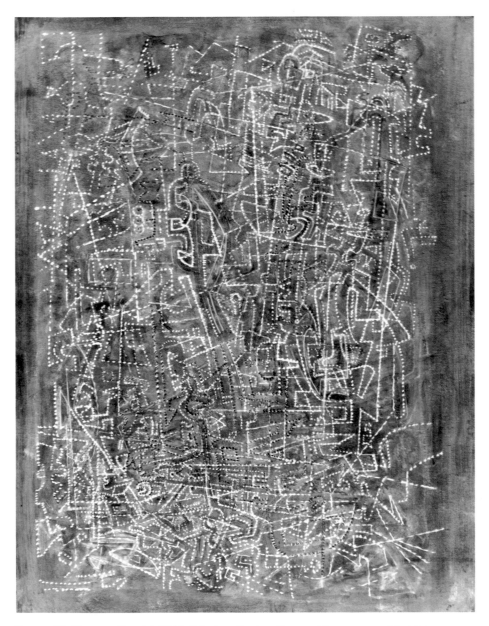

Cat. no. 29. *Transcontinental*, 1946, Private collection, Europe. (Photo courtesy of Sotheby's, New York)

While Tobey too sought the underlying structure of reality, the statement he submitted for the catalogue of the same exhibition, in stressing the importance of the universal, points out America's geographical position between Europe and Asia, revealing his own conviction that America has for too long looked only to Europe and must now look to Asia as well.

Our ground today is not so much the national or the regional ground as it is the understanding of this single earth. The earth has been round for some time now, but not in man's relations to man nor in the understanding of the arts of each as a part of the roundness. As usual we have occupied ourselves too much with the outer, the objective, at the expense of the inner world wherein the true roundness lies. . . .

Ours is a universal time and the significances of such a time all point to the need for the universalizing of the consciousness and the conscience of man. It is in the awareness of this that our future depends. . . . America more than any other country is placed geographically to lead in this understanding, and if from past methods of behavior she has constantly looked toward Europe, today she must assume her position, Janus-faced, toward Asia, for in not too long a time the waves of the Orient shall wash heavily upon her shores.

All this is deeply related with her growth in the arts, particularly upon the Pacific slopes. Of this I am aware. Naturally my work will reflect such a condition and so it is not surprising to me when an Oriental responds to a painting of mine as well as an American or a European.[2]

Just as the conflicts of World War I lent conviction to Tobey's faith in the Bahai movement, so he realized the extent to which the events of World War II impressed upon the Western world the unavoidable necessity of recognizing the Far East.

The universal oneness espoused by the Bahai faith refers not only to the unity of mankind but also to the requisite interdependence of nature, science, art, and religion. When William Seitz asked Tobey in 1962 if he regarded himself as a religious painter, Tobey responded:

Well, I don't. . . . it's something I always wanted to be, or did, always want to be a religious painter.

reach the human. Still we cannot become international by willing it, or by following a foreign pattern. This state of mind arises instead from following the nature of true reality . . . mobilizing one's means in relation to an insight into the structure of reality. With such insight, nationalities become accidental appearances; and no rendering of the appearance of reality can move us like a revelation of its structure. Thus when we say that one of the ideals of modern art has been internationalism, it is not meant in the sense of a slogan, of a super-chauvinism; but as a natural consequence of dealing with reality on a certain level.

That's true. And I made many attempts at it, but in a very irreligious age it isn't easy. This is a scientific age, the whole accent is then on science.[3]

His answer, however, belies the extent to which science and religion are uniquely married in his art. To the Bahai, man's greatest gift, and that which makes him superior to the rest of nature, is the gift of an intellectual and inquiring mind.

God has conferred upon and added to man a distinctive power, the faculty of creation, the acquisition of higher knowledge, the greatest virtue of which is scientific enlightenment.[4]

Thus in the Bahai view, science is not only applauded but must go hand in hand with religion if religion is to progress. The two complementary paths of enlightenment are interdependent.

Tobey's avenue to dealing with the fundamental structure of reality was clearly enhanced at this time by his interest in science, in which he found confirmation of his own inner vision. He read constantly about science, philosophy, and nature. In 1949, following his participation in the Western Round Table on Modern Art (a forum consisting of representatives of art, architecture, and music), Tobey read *Science and the Modern World* by Alfred North Whitehead, the English mathematician-scientist-philosopher.[5] The extent to which Tobey coordinated Whitehead's theories with those of Bahai illustrates both the philosophical nature of Whitehead's writing and the scientifically enlightened views of the Bahai faith. Whitehead was convinced of the need for a philosophy which would encompass both science and religion. He distinguishes modern scientific knowledge from that of the past, "[today] its home is the whole world,"[6] and, like the Bahai, considers the relation between science and religion critical to the future of the world.[7]

Some specific passages in Whitehead's book must have reinforced and given added impetus to the abstract development of Tobey's painting. In his chapter on relativity he writes, "The new relativity associates

space and time with an intimacy not hitherto contemplated."[8] Tobey had already intuitively given expression to the revolutionary principles of space and time discovered by Albert Einstein. In the series of New York paintings that began with *Broadway* in 1935, we find a striking parallel to Einstein's words,

False our old conception of space, false the time we've fabricated. Light is propagated in a straight line, and the mass of bodies is a kind of rubber band.[9]

Whitehead presents a detailed exposition of the fact that our traditional perception of the world in terms of finite objects at a distinct moment in time is no more real than that of a continuous present in which hitherto unknown forces are in a constant state of flux.

An event is the grasping into unity of a pattern of aspects. . . . The pattern is spacialized in a whole duration for the benefit of the event into whose essence the pattern enters.

Notice that the pattern requires a duration involving a definite lapse of time. . . . Thus a duration is spacialized; and by "spacialized" is meant that the duration is the field for the realized pattern constituting the character of the event.[10]

Tobey's ability to penetrate to the underlying structure, the directions and forces of a subject or situation, had first emerged in his work of the thirties in his focus on physical dynamism and light, but by the mid-forties, this dynamic structure was usually incorporated in his pictorial sense of pattern, as rhythm, as repetition, and as variation, uniquely attuned to a musical sensibility.

As line itself became the vehicle of Tobey's subject matter, it became susceptible to the scientific theories of writers like Whitehead. In works like *Awakening Night* (1949, cat. no. 34) and *Traffic* (1954, cat. no. 41), the quality of the artist's line evokes the subject matter of the work. *Awakening Night* is executed with a stroke that suggests the immediate and multiplying chain reaction of lights coming on in a city at night. First one, then another, till the eye

cannot keep up, and in minutes the city has come alive with lights. Tobey's line, quick and continuous, evokes the magic of this daily occurrence—an occurrence which has a duration in time and has been "spacialized," in Whitehead's term, on the canvas. The resulting "pattern" constitutes "the character of the event." Tobey is said to have executed this painting in a single afternoon so as not to lose the rhythmic impulse. In *Traffic*, by contrast, the artist employs short, square strokes and dabs, criss-crossing over the surface with the start-and-stop motion of traffic in the city. Through the use of a golden orange ground over the first gray ground, he gives the work a luminosity complemented by the predominantly red, blue, and yellow palette suggesting traffic lights. The work conveys the activity caused by, but without any reference to, a multitude of individual human lives. Even in those city paintings where the human figure is unmentioned, the emphasis in Tobey's work remains throughout on human energies, channeled and directed as they may be by the architectural structures of the city. And in every case, the activity evoked suggests a duration in time. Movement and rhythm in art had concerned Tobey for years, and his study of music, as well as his readings in science, seems to have helped him find a pictorial language to realize those aims. His subjects—crowds, lights, stars, microcosms of seeds and grasses—consisted of multiple parts, conducive to an art of cumulative effect.

In 1953, Tobey "refound" Sigfried Giedion's *Space, Time, and Architecture*.[11] It is not surprising that he found Giedion's book worth rereading, as the views of this writer supported his own on many counts. Giedion's concept of space-time was central to Tobey's work and underlies the analogies he made with music. Through his studies of nature's forms and processes, Tobey arrived at a marriage of inner and outer, at a pictorial language of new dimensions, a language through which he gave visual expression to Giedion's view of time and history:

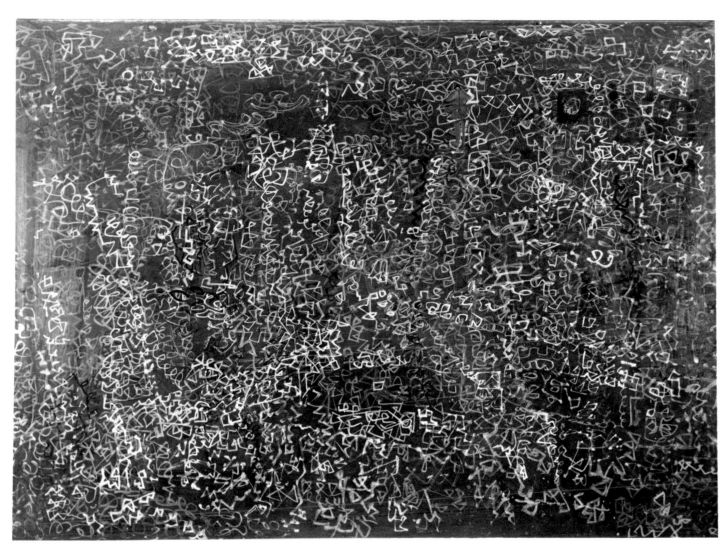

Cat. no. 34. *Awakening Night*, 1949, Munson-Williams-Proctor Institute, Utica, Edward W. Root Bequest (color plate 3).

This living from day to day, from hour to hour, with no feeling for relationships, does not merely lack dignity; it is neither natural nor human. It leads to a perception of events as isolated points rather than as part of a process with dimensions reaching out into history. The demand for a closer contact with history is the natural outcome of this condition. To have a closer contact with history: in other words to carry on our lives in a wider time-dimension.[12]

Giedion's idea that science and art must go hand in hand and his demand for conti-nuity with the past and for a universal outlook support the ideals of the Bahai faith and are echoed in Tobey's writing as well as in his painting. Bahai, Whitehead, Giedion, all present a scope of vision that could only be realized in paint through a comprehension of elemental structures. According to Giedion, science outdistanced art in the nineteenth century; thinking and feeling were separated with the sudden and rapid rise in scientific and technological discovery. In the 1930s Giedion felt a tendency in the direction of unity. The concept of space-time arrived at in both science and the arts, independently yet simultaneously, in the early years of this century is viewed by Giedion as an indication of a common culture. His strong sense of the interdisciplinary in all periods of history (whether recognizable in the present or only in retrospect) leads him to conclude that the artist, equipped with an understanding of the past, must nevertheless be a part of the present and express feelings elicited by the contem-

57

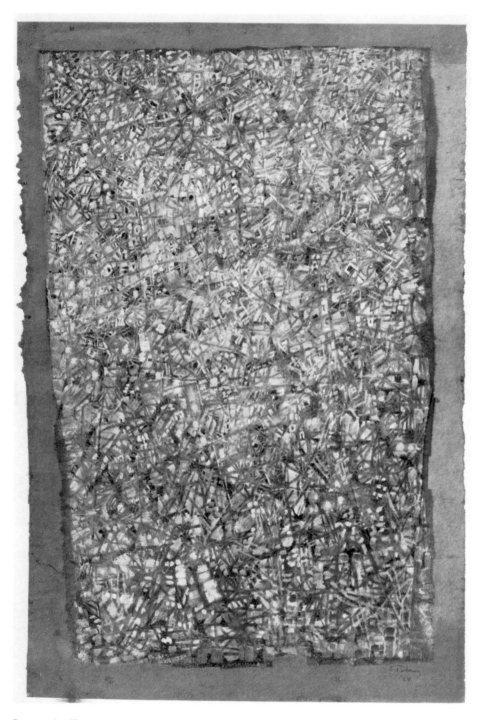

Cat. no. 41. *Traffic I*, 1954, Kunstmuseum, Kupferstichkabinett, Basel (color plate 6).

porary world. What more suitable means of expressing the concept of space-time in terms of twentieth-century scientific discovery than an aerial view.

The bird's-eye view has opened up to us whole new aspects of the world. Such new modes of perception carry with them new feelings, which the artist must formulate.[13]

Aerial City (1950, cat. no 37), though devoid of any hint of the figurative, has, when compared with the relative rectilinearity of *Lines of the City* (cat. no. 27) of five years before, a calligraphic irregularity of brushstroke. Black on a light ground rather than white on a dark ground, it looks forward to Tobey's sumis of 1957 and reveals his freedom from the white writing convention he had abided by during most of the forties. Unlike Georgia O'Keeffe, whose *Sky Above Clouds* series resulted from frequent plane travel, Tobey painted aerial views long before he had actually seen one from the air.[14] When he finally flew for the first time in 1962, he was disappointed in what he saw. Although his restlessness caused him to travel a great deal, he had an aversion to cars and planes. He would cross America by train, the Atlantic by boat. While an understanding of the unprecedented intercommunication and dynamism resulting from the speed of travel today was central to his work, his dislike of the inhuman machine in all its manifestations gave rise to a lyrical and conceptual expression of these interactions. Thus his aerial view is only related in the most simplistic sense to an actual view looking down from a plane.

Like *Transcontinental*, which presumes a view from above, *Aerial City* also grew naturally out of the multiple focus Tobey had established in his work of the forties. Once he had abandoned perspective and embraced the notion of an allover field of painting, it was a small and logical step to the aerial view.[15] The vast difference between photographs taken from the air and Tobey's concept reveals how refined, unified, and harmonious the latter.

Increasingly in the decade of the fifties, Tobey explored an inner vision encompass-

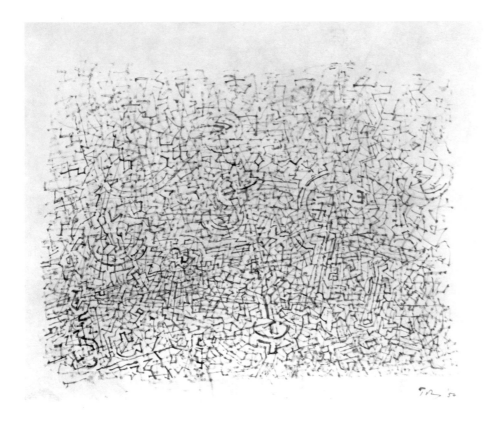

Cat. no. 37. *Aerial City*, 1950, Private collection. (Photo courtesy of Museum of Modern Art, New York)

Cat. no. 27 (below). *Lines of the City*, 1945, Addison Gallery of American Art, Phillips Academy, Andover, Massachusetts, Bequest of Edward W. Root.

ing both the vast and the minute, the very far and the very near, in which he could identify the essential natures of both. Where, in the thirties, he had enjoyed plunging the eye into depth in drawings like *Seattle in the Snow*, in the forties he began to place increasing emphasis on the surface, eventually merging near and far in the fifties when he combined telescopic and microscopic visions in a single canvas. In February of 1954, Tobey was reading *This Flowering Earth* by Donald Culross Peattie, of which he wrote, "It's my kind of book I find and quite inspiring and suggestive of paintings."[16] Peattie writes of the oneness of life, filling the reader with awe for the world of plants, the basis of all living things, and points out as universal truth:

The laws governing the most primitive and microscopic of special cases, are law unto oak and king. The powers in the one-celled, drive all cells.[17]

Thus the idea of temporal processes unfolding in space could equally be applied to the small and near-at-hand and to growth and movement on a world scale. For underlying both the vast and the minute is a common structure, and it was in his pursuit of this essence that Tobey was to bring to its most consummate statement his concept of the universal in art. During this period he spoke of the telescope and the microscope and their importance to the vision of today.[18] In drawing less on the outside world, he drew more on his own work, carrying his themes and compositions of the previous decade a step further into abstraction, but always retaining a reference to the visible reality. *Universal City* (1951, cat. no. 38) emerged from earlier paintings of specific city scenes, married to the concept of the aerial view. Brilliantly colorful and varied

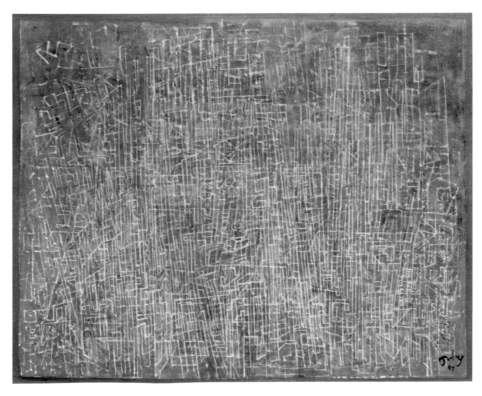

in brushstroke, the central crescendo of concentrated "characters" recalls Tobey's earliest New York paintings of an avenue jammed with activity, yet it also looks forward to paintings like *The Avenue* (1954, cat. no. 40), in which a more over-all composition of calligraphic elements evokes the throngs. *Universal City* is alive, in Tobey's words, with "Oriental fragments as characters which twist and turn drifting into Western zones, forever speaking of the unity of man's spirit."[19] Thus while retaining a basis in outer reality, the painting has been transformed into a vision that has its own geography. It is an expression of Tobey's faith, as a Bahai, in the world unity to come. As Tobey himself stated in *Tiger's Eye* in 1948, in words that reflect his translation of his faith into abstract pictorial terms, "The great universal day when all the pieces have to function as a whole."[20]

A natural consequence of the abandonment of the representational is the emphasis given to technique, color, medium, and the power of these alone (rather than that of an image) to elicit a response in the viewer. The abandonment of the figure is at least partially responsible for the explosion of a great variety and vitality of technique in Tobey's work of the fifties. At this time Tobey's experimenting is evident, for example, in *Carnival* (1954, cat. no. 45), a brilliant small work evoking Chinese paper dragons or cascading fireworks, in which he used an atomizer to apply the first layer of pigment.[21] Using this instrument he would blow ink or diluted tempera onto the surface as a beginning ground. He nearly always worked on tinted paper or laid in a ground first. Charles Seliger has recorded,

Mark talked a good deal about painting and I became aware of his concept of color—the use of a ground color—in a sense a background and then in counter movement use other colors to float them across the universal field.[22]

The unity of all life finds its counterpart for Tobey on the canvas. Since the 1940s, Tobey's technique had been developing away from building a painting to realizing a work in a single session. Indeed if inter-

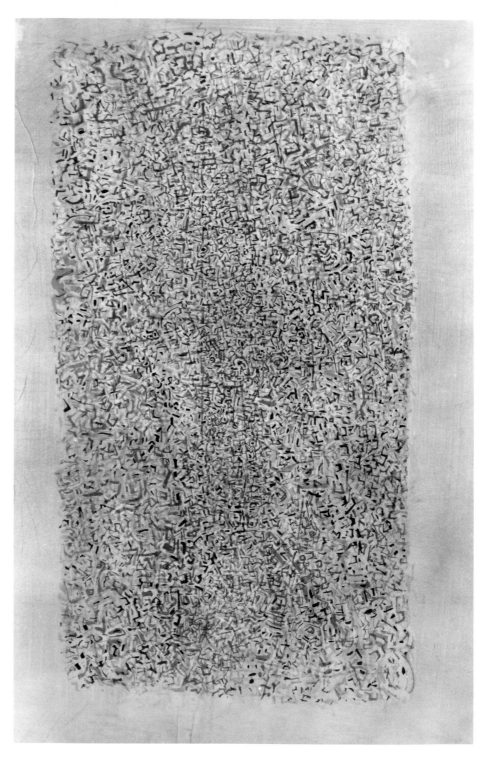

Cat. no. 38. *Universal City*, 1951, The Seattle Art Museum, Gift of Mr. and Mrs. Dan Johnson.

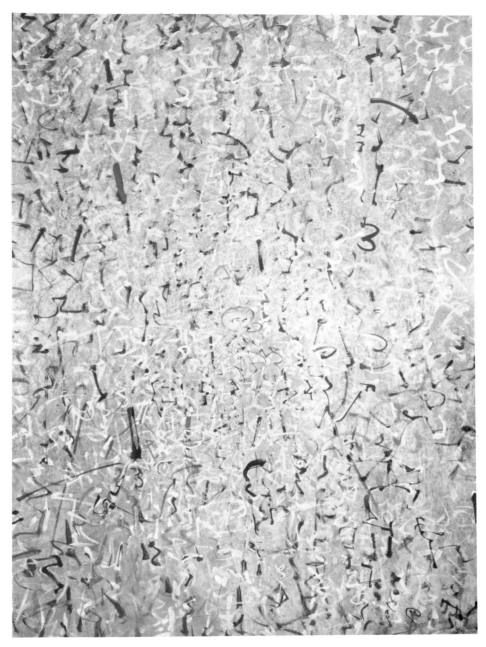

Cat. no. 40. *The Avenue*, 1954, Norton Gallery and School of Art, West Palm Beach (color plate 7). (Photo by Lee Brian)

rupted from his trancelike state of painting, he would often have difficulty recapturing the mood and rhythm of the work at hand. His interest in Oriental thought, which intensified in the fifties, seems to have encouraged this more spontaneous approach to painting. While much of Tobey's work of the fifties does not suggest any specific acquaintance with Chinese or Japanese sources, the directness and immediacy of handling reflect the spirit, a certain loss of conscious effort, that Tobey admired in Oriental art. He was inspired by Eugen Herrigel's *Zen in the Art of Archery,* which he read soon after it was published in 1953, and he was so enthusiastic about it that he presented friends of his with copies of the book.[23] Later he gave Charles Seliger *The Book of Tea.*[24] He read D. T. Suzuki's *Zen and Japanese Culture* and quoted passages to friends. In a letter to an artist friend, Ulfert Wilke, of some years later but nonetheless pertinent to his approach to painting in 1954, he wrote:

I have no system—I never know when I can paint; I just have to arouse myself—get into a state and forget all things if possible to make a union with what I am doing and the less I think of it—the paintings and myself, the better the result. There is a famous Zen or Tao verse—in translation thus:
Behind the technique, know
that there is the spirit (ri)
It is dawning now;
open the screen,
and lo, the moonlight is
shining in.
I think this poem and Zen and the art of archery is all one needs to know and go ahead and paint—and paint and paint and let out and then judge—if possible. This poem comes from Suzuki's *Zen and Japanese Culture.*[25]

As Tobey's style became increasingly abstract, it could draw more and more on the basic principles of music and of Oriental calligraphy. In paintings like *Traffic* and *The Avenue*, the artist's line is a metaphor for the subject. It expresses it directly. Tobey usually listened to music while painting. He loved Bach, Scarlatti, Mozart, Chopin, and Debussy. (Much of his own music is

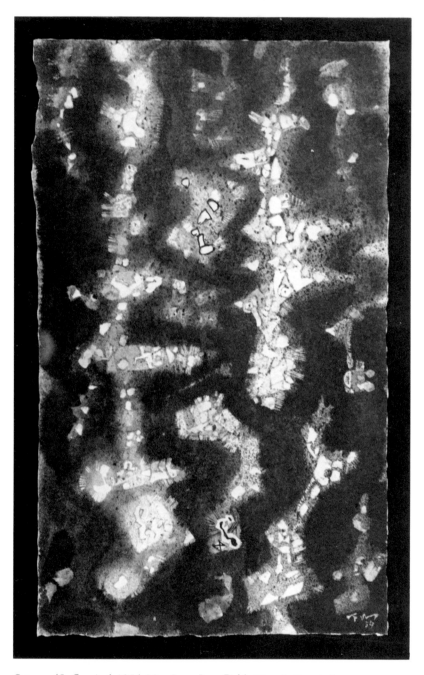

Cat. no. 45. *Carnival*, 1954, Mrs. Joyce Lyon Dahl. (Photo by Beverly A. Okada, courtesy of Foster/White Gallery, Seattle)

Fig. 19. Tobey striking a dance pose in his house in Basel, 1970. (Photo by Kurt Wyss, Basel)

closer to Debussy and to Rameau than to any other composer.) Indeed some paintings have the quality of a direct and spontaneous expression of his response to the music. He was sometimes observed breaking into a little dance while he was painting, and his brush danced on the canvas (fig. 19).[26] Tobey believed that a painting could give off only as much energy as the artist put into it. His direct linear expression of the life of his subject is reminiscent of that of an Oriental calligraphy artist. Chiang Yee, an authority on Chinese calligraphy, writes,

It is not unprofitable to compare calligraphy with dancing. The calligraphy of a great master is . . . an adventure in movement very similar to good dancing. . . . A satisfying piece of it [calligraphy] can be executed only by a scholar of marked personality, and preferably one with poetical, literary and musical tastes.[27]

All of these Mark Tobey brought to his painting.

Tobey spent very little of 1954 and 1955 in Seattle. Indeed during the 1950s he

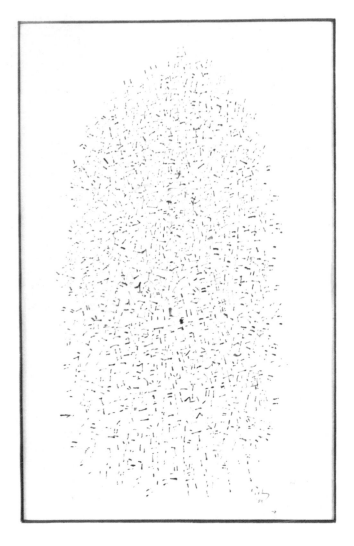

Cat. no. 43. *City Punctuation*, 1954, Galerie Jeanne Bucher, Paris. (Photo by Luc Joubert)

Fig. 20 (below). Paul Klee, *Egypt in Ruins*, 1924, watercolor, 4⁹⁄₁₆ x 11⅜ in., Collection Angela Rosengart, Lucerne.

stayed several months of nearly every year in New York. In 1954 Tobey left Seattle with no specific plan to return. From February to June of that year, he took up residence in New York. After some travels during the summer, by October he settled in Paris, where he lived until the following June. In both cities Tobey had small quarters in which to work: in New York on Irving Place, where he was living, and in Paris, in a room of his pension, the Hôtel-Pension Metropole, near the Etoile. Consequently Tobey's works of this period are mostly small in size, but they are nevertheless among his best. This was a time of extreme concentration and productivity for Tobey. He sometimes worked in his studio for eight hours without stopping. He often worked at a table, with his paper lying flat, allowing him to rotate the surface as he worked on it, and it may be because of this forced circumstance that his compositions became increasingly free from gravity and the suggestion of a ground plane.[28]

Some of the works he did in New York are meditations on his city experience, like one series called *Lights* and another called *New York*, while a contemporaneous group of paintings, which he referred to as *Meditations*, reveal his ability to transcend completely the immediate subject matter of the city. Tobey wrote, in 1958,

We hear some artists speak today of the *act of painting*, but a State of Mind is the first preparation and from this the action proceeds. Peace of Mind is another ideal, perhaps the ideal state to be sought for in the painting and certainly preparatory to the act.[29]

It is exactly such peace of mind that must have preceded the Meditation series, for they induce a state of quiet contemplation. A revealing counterecho to *Broadway*, done in the quiet of Devon, he created these

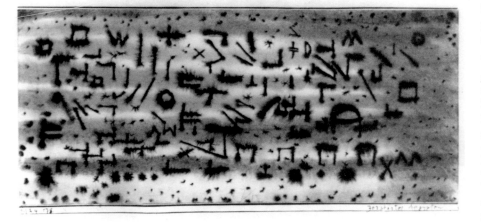

meditations, an inner vision of the evanescent and ineffable workings of the mind, in the midst of that very teeming and frenetic city that had been the subject of the earlier work. Yet some of Tobey's paintings of the city of 1954 equally suggest, by their very minimal rendering and their restraint in handling, this meditative distance on the subject of the city. *City Punctuation*, for example (cat. no. 43), consists of little more than many fine short marks in black tempera, some patches of white scattered throughout, and a few strokes of red. Its very delicacy bespeaks its transformation into a thought, an idea far removed from observed reality. Again, Tobey's work finds a parallel in that of Klee, most notably in several works he did in 1924, such as *Collection of Signs* and *Egypt in Ruins* (fig. 20). *City Punctuation* is reminiscent of the words Tobey himself used that same year to describe Feininger's paintings of the city:

The buildings of Manhattan rise resplendent carrying within their magic structures the calligraphic black lines of window ledge and pane.[30]

Perhaps in reaction to the large number of small paintings Tobey was producing at this time, or perhaps in response to the overwhelming impression of the New York School, with their large canvases and thick use of paint, both Michel Tapié, acting briefly and informally as Tobey's dealer in Paris, and Marion Willard in New York began in 1954 to request bigger paintings from Tobey. This annoyed the artist who had no respect for size in and of itself. He knew his paintings already had an internal sense of scale that far exceeded their dimensions. Nevertheless, disinclined as he was to follow others or try to please a public, the idea of painting larger than he ever had before (with the exception of much earlier pre-white writing works or murals) was a challenge he could not ignore. In January of 1955 he wrote from Paris to Otto Seligman, his friend and dealer in Seattle, "I feel I would like to paint a few large paintings—say 6' x 8'—but I want some quiet nest to do it. But how—where—when."[31] And in April, "Willard

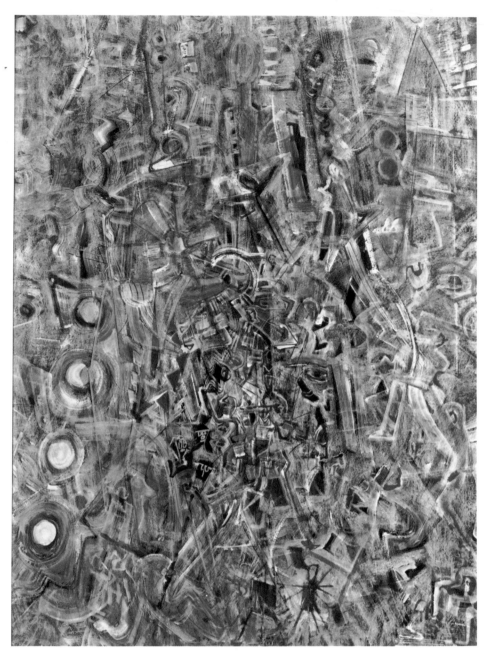

Cat. no. 39. *Festival*, 1953, The Seattle Art Museum, Gift of Mr. and Mrs. Bagley Wright.

writes for large paintings—I can't paint in hotel rooms."[32] And finally in the summer of 1955, "All my work looks too little to me now."[33] Gradually Tobey did try larger paintings, using bigger brushes and a broader brushstroke. Tobey's readiness to accept the challenge of large paintings was probably abetted by the tremendous acclaim he received in Europe in the fifties. In 1953 he had painted the approximately 2½ x 3 foot *Festival* (cat. no. 39); three years later the similarly large-scale *Battle of the Lights*

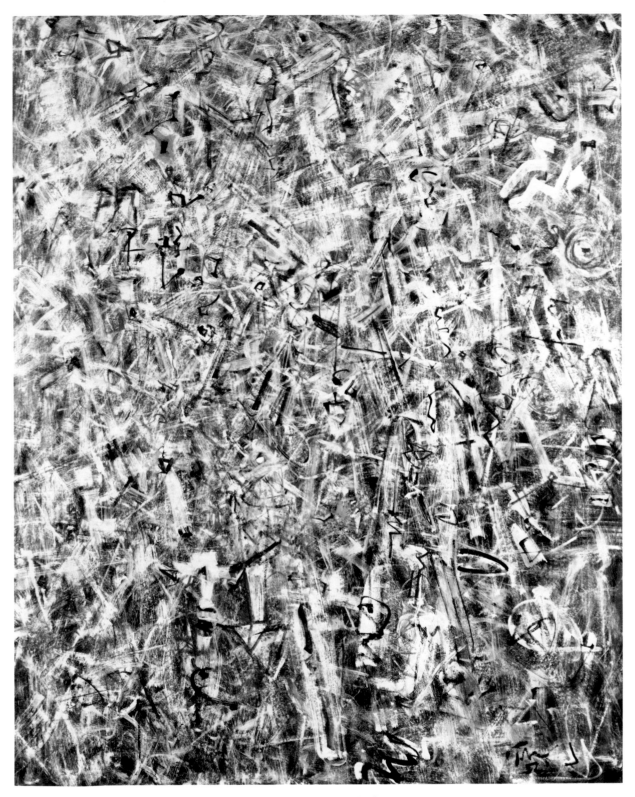

Cat. no. 48. *Battle of the Lights*, 1956, Winston-Malbin Collection, New York. (Photo by Geoffrey Clements)

(cat. no. 48) followed. While *Festival* still echoes the basic avenue composition that began with *Broadway*, its breadth of handling adumbrates such paintings as *Battle of the Lights*, in which all traces of the avenue composition are gone and the sense of sprung energy is almost palpable.

While the increased size of Tobey's canvases, which invited the more frequent use of oil paint, could superficially align him more closely with the abstract expressionist aesthetic, the approach to the world reflected in his work remained fundamentally different from that of these New York artists. For while their work demanded a large format to fulfill their extension of man as the measure in their art, Tobey's vision, despite his humanist attitude, was directed toward the cosmos—a world view beyond the individual. Following the Oriental concept that man must "get out of the way" in order for a work of art to be born, Tobey's art is only self-reflective in its immediacy of brushstrokes—never in the content to which the viewer's attention is drawn.

After a trip to London, Tobey had returned to Paris briefly and then embarked on the *New Amsterdam* at Cherbourg on 22 June 1955, bound for New York. Despite his success in Paris and an invitation from Marion Willard to stay in New York, he felt drawn to return to Seattle. There, Tobey saw more and more of his Japanese friends, Takizaki, George Tsutakawa, and Paul Horiuchi (fig. 21). He would often have dinner with them and talk about the Orient and about art. His interest in the Orient had waxed, not waned, and he even entertained the possibility of making another trip to Japan. After observing the artists Tsutakawa and Horiuchi at work in their studios, he asked if he could try using sumi ink and brushes himself. Tobey's sumi paintings are a brief chapter in his oeuvre. He did them only during March and April of 1957 and stopped as suddenly as he had begun. The sumis were as much an experiment in artistic means as an expression of Tobey's espousal of Oriental concepts. Not only did he abandon color for black and

Fig. 21. Takizaki, Horiuchi, and Tobey, in Tobey's studio, mid-1950s. (Mark Tobey Papers, Archives of American Art, Smithsonian Institution)

white, but he abandoned himself, and control, as never before. The request for big paintings had eventually resulted in a series of large canvases in 1956 (for example, *Battle of the Lights*, mentioned above, and *White Journey*, 44¾ x 35¼ in., collection of Ernst Beyeler, Basel). Miss Willard had followed that suggestion with some criticism that Tobey's work could profit from greater freedom and vitality of execution. The sumis were a means to both ends. Some are as large as *White Journey*, about three feet by almost four feet, and, although more control is involved than appears, the spontaneity and risks involved must have been liberating. As Tobey expressed it later to a friend, "I've had my fling."[34]

The attitude of the abstract expressionists toward a painting as an object with a life of its own, as the outcome of the artist's encounter with the canvas, involving, above

all, improvisation, had been compared in 1954 to Oriental attitudes. Alfred Frankfurter suggested that an appreciation of Oriental processes was an important influence.[35] None of the abstract expressionists, however, except perhaps Motherwell, comes nearly as close to Oriental method and technique as Tobey did in his sumis. Nevertheless all those New York artists had employed much freer gesture and looser handling of their medium than Tobey ever had before. Tobey now entered the ring where chance and accident were paramount. But the concept the abstract expressionists had inherited originally from surrealist automatism had come to Tobey directly from the Orient. Sumis cannot be reworked or painted over. Tobey threw away as many as he kept. For the abstract expressionists, on the other hand, the initial "accident" more often than not provided the

basis, the raw material to work with and possibly to be submerged entirely in the finished work.

In many of Tobey's sumis the force of flung ink or the brushstroke exceeds the border, enhancing the quality of energy. Here, Tobey respects the principles of the Japanese sumi artist.

A Japanese artist will frequently ignore the boundaries of the paper upon which he paints by beginning his stroke upon the *mosen* and continuing it on the paper. . . . This produces the sentiment or impression of great strength of stroke. It animates the work.

And in this energetic kind of painting, if drops of *sumi* accidently fall from the brush upon the painting they are regarded as giving additional energy to it. Similarly if the stroke on the trunk or branch of a tree shows many thin hair lines where the intention was that the line should be solid, this also is regarded as an additional evidence of stroke energy and is always highly prized.[36]

All these qualities, highly regarded in Japan, appear in Tobey's sumis. Tobey himself explained, "Perhaps painting that way I freed myself or thought I did. Perhaps I wanted to paint without too much thought . . . it's difficult to be faster than thought."[37]

One of the strengths of Tobey's sumis is their variety: some truly flung, some done with a fat sumi brush, and an unusual and telling series of heads. Even in what could be viewed as his furthest venture from the representational, he could not resist finding the subject with which his art began, the human face. Moreover, while many of the sumis are simply numbered, some have been given such descriptive titles as *Thundering Plains*. The example in this exhibition, *Suburban Hill* (cat. no. 50), by contrast, is a relatively subdued work which reflects Tobey's continuing delight in the image of night lights. Here, in contrast to his earlier work, the white of the lights, which fairly twinkle in this predominantly black landscape, is the untouched paper.

Thus in the midst of the emergence of delicate color harmonies in some of his smallest and finest works, the black and white, large and free, expression of the

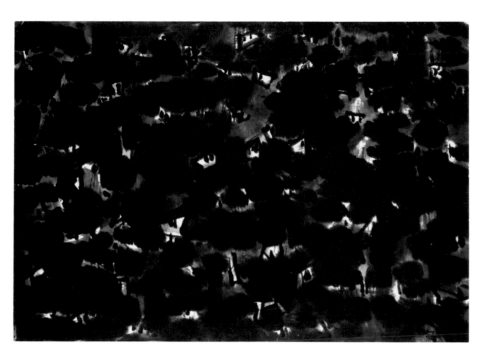

Cat. no. 50. *Suburban Hill*, 1957, Private collection, Zurich. (Photo courtesy of Galerie Beyeler, Basel)

sumis exploded. Tobey's Japanese friend in Seattle, Takizaki, had provided an inspiring exchange, just as Teng Kuei had years before. Tobey considered his sumis of historical importance. Indeed at this time he seemed particularly aware of his own art-historical position. Perhaps in part provoked by the death of Feininger the year before, which moved him deeply, he began to assess his own contribution. Typically, he was self-critical and felt he "must strike new ground."[38] The sumis were one foray into the unknown. Despite the favorable reviews they received when shown at the Willard Gallery at the end of 1957, however, Tobey did not return to the technique.

The following year, on the occasion of the Venice Biennale in 1958, where he became the first American artist since Whistler to win a grand prize, the knowledge that Rothko's paintings were also to be included made him particularly conscious of his own insatiable urge to experiment. He wrote to Marion Willard, "I think he [Rothko] is the

very best of all the boys in New York City. It will be hard for me to see all my differences along side his continuity."[39] In 1945 he had said, "I am accused of too much experimentation but what else should I do when all other factors of man are in the same condition? I thrust forward into space as science and the rest do."[40] As he had Feininger, Tobey admired Rothko for his continuity. Yet it was Tobey who won the first prize at the Biennale in 1958. And it is exactly by virtue of his ceaseless experimentation, for which he felt an affinity with Klee, and admiration for Picasso, that his work can be compared to Marin's in the 1930s and to Pollock's (a generation younger) in the 1940s. He lived the Bahai ideal of progressive revelation. Through all his experimentation, a continuity of spirit pervades his work.

I have never wished to continue in any particular style. The path has been a zig-zag — in and out of old cultures, seeking new horizons — mediating and reviewing for a better position to see. . . .

67

Pure abstraction for me would be a painting where one finds no correspondence to life—an impossibility for me. I have sought a unified world in my work and used a movable vortex to achieve it.[41]

In 1960 Tobey moved to Basel, where he settled for the rest of his life. There he painted many major works of his oeuvre including his masterpiece, *Sagittarius Red* (1963, Kunstmuseum, Basel). Executed in oil, ink, and crayon on canvas, the painting measures nearly seven by thirteen feet. Tobey's house on the Saint Albanvorstadt, which had five floors, afforded him a large room to use as a studio. He often worked on big canvases, trying new techniques. In *Celebration* (cat. no. 58), which he began in 1965 and completed in 1966, he mixed oil and collage. Like so many of Tobey's compositions this one too evidences the dynamic of combined compression and expansion. The work is most densely composed in the lower center from which energy appears to radiate outward and upward. Painted layer upon layer, the work features circular forms throughout, predominating at the top, where, often luminous, they suggest lights, balloons, buoyancy, ascension. Out of the suggested throng, one imagines figures and faces though none is specifically described. The artist's palette, subtle but bright, consists of red, blue, pale olive green, and many shades of white on a mauve-gray ground. There is enormous variety of brushstroke. Cut-out papers stuck on top read: "Svecast," "4," "Fight," "StafsjoBruck," and there are cut-outs of crowd scenes. Tobey's incorporation of more than one language in these collage elements suggests the universal tone he intended to give to the painting. StafsjoBruck, for example, is a Swedish place name. The overall effect of the painting is that of looking down on a crowd bearing banners. And indeed even in the relatively small, quiet, and quaint town of Basel, Tobey responded to the moments that animated it and brought the lives of the inhabitants together. The major one of these events was Fastnacht, Basel's annual pagan ritual

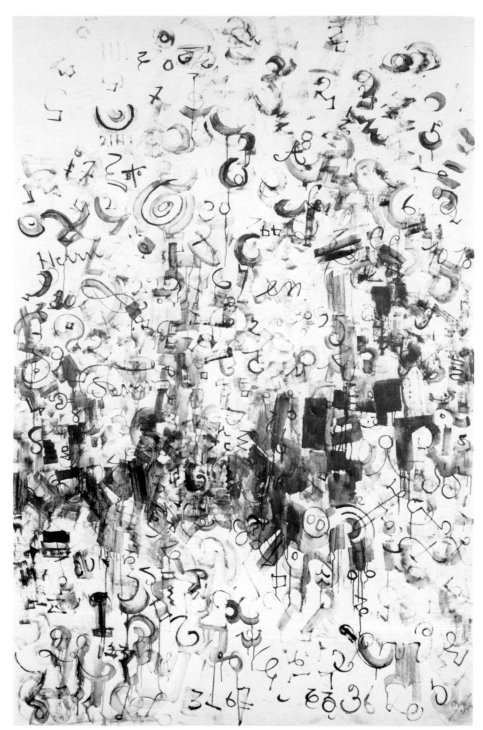

Cat. no. 56. *Ghost Town*, 1965, Willard Gallery, New York. (Photo by Geoffrey Clements)

which goes on for three days without interruption. A few of Tobey's works from his years in Basel, like *Celebration*, surely refer to this wild and colorful event. Tobey would typically complain of the noise and then be riveted at his window by the masked and costumed throngs dancing down the narrow streets playing pipes and drums.[42] Just as Broadway was where one found night life in New York so Fastnacht represents the height of night life in this ancient Swiss town.

In most of Tobey's paintings from this period, however, he pared his subject down to its abstract essence as we find in *Ghost Town*, *Breathing City*, and *Coming and Going*. Indeed few other paintings of the sixties relate specifically to city themes. Though he continued to title his work, the paintings done in Basel, far more abstract in their reference, are often given such titles as *Between Space and Time, Interspersed, Multiple Moments in Space, Appearances in Time*, or *Drift*. Tobey still employed a marked variety of brushstrokes from painting to painting. Rather than any reference to the outside world, the particular handling of each evokes its subject. Where *Ghost Town* (cat. no. 56) is filled with calligraphic strokes and numbers that echo in a void, *Breathing City* (cat. no. 57) and *Coming and Going* (cat. no. 59) are densely filled canvases. In *Coming and Going*, the golden-brown ground falls back into indefinite depth, with layers of activity in front, compressed into shallow frontal planes, and this quality of compression adds to the energy of the painting. Green and two shades of red, yellow and black weave in and out, interspersed with smaller strokes of white and yellow tempera. The effect is very rich and epitomizes Tobey's desire to paint "thick space." *Coming and Going* presents the artist's ultimate distillation of the city theme, by reducing the subject to the pure activity that had inspired his first city paintings.

To the end, the city signified for Tobey the pulse of life. Although his work is full of recapitulations, he did not cease to ex-

Cat. no. 57. *Breathing City*, 1965, Estate of Dr. Victor Hasselblad. (Photo courtesy of **Galerie Beyeler, Basel**)

periment even in his last years. Yet the progression of his oeuvre is steady and consistent. In the paintings in this exhibition we see Tobey transform his vision of a particular city into a universal city. In doing so he brought not only the lessons of Oriental but also those of Western art to bear on his own, fashioning both traditions into his unique pictorial idiom. Perhaps no other artist of our time has invested brushstroke with the specificity of meaning that Tobey has. Yet his approach to content was never literal but poetic, philosophical, and musical. In pursuing the balance of his spiritual and artistic ideals, his progress from the particular to the universal was allied with his pictorial development from the representational to the abstract. Each period of his work reflects the mood and thought of the time. It is Tobey's energy and keen response to life that reverberates in his paintings of the city.

Cat. no. 59. *Coming and Going*, 1970, Albright- Knox Art Gallery, Buffalo, Charles Clifton Fund (color plate 9).

NOTES

TOBEY AND THE CITY AS A SOURCE

1. "Mystic Painters of the Northwest," *Life* (27 April 1953), 84.

2. Not long after he arrived at Dartington Hall, Tobey revealed his indifference to landscape, certainly to *living* in the midst of nothing but country, in a letter to Marshall Landgren: "There is nothing in Devon except the country and at present we are having a series of gales." (Undated letter, Landgren Papers, Archives of American Art, Smithsonian Institution.)

3. Belle Krasne, "A Tobey Profile," *The Art Digest* 26 (15 October 1951), 5.

4. *Art News* (Summer 1955), quoted in Rudi Blesh, *Modern Art U.S.A.* (Alfred A. Knopf, New York, 1956).

5. Yvonne Hagan, *The New York Herald Tribune* (June 1958). Colette Roberts Papers, Archives of American Art, Smithsonian Institution.

6. Alexander Watt, "Paris Letter: Mark Tobey," *Art in America* 49, no. 4 (1961), 112.

7. William Seitz, lecture on occasion of Mark Tobey exhibition at Museum of Modern Art, 1962 (Seitz Papers, Archives of American Art, Smithsonian Institution).

8. Dore Ashton, "New York Letter," *Das Kunstwerk* 16 (January 1963), 31.

9. Katharine Kuh, *The Artist's Voice* (Harper and Row, New York, 1962), 236.

10. Katharine Kuh, *Break-Up: The Core of Modern Art* (New York Graphic Society, Greenwich, Conn., 1965), 99.

EARLY YEARS

1. Biographical details from William Seitz, interview with Tobey, January 1962 (Archives of American Art, Smithsonian Institution); and from Seitz, *Mark Tobey* (New York, 1962).

2. Marie (Mrs. Albert) Sterner, who arranged Tobey's show at Knoedler's, directed many exhibitions at the Knoedler Gallery at this time, focusing on the younger, less established contemporary artists.

3. Arthur Dahl, conversation with Mark Tobey, 21 September 1963.

4. Kuh, *Artist's Voice*, 239-240.

5. Krasne, "Tobey Profile," 34.

6. Kuh, *Artist's Voice*, 236.

7. Mark Tobey, "Reminiscence and Reverie," *Magazine of Art* 44 (October 1951), 230.

8. For a Tobey retrospective at the Contemporary Arts Gallery in New York, 17 February-18 March 1931, Marsden Hartley wrote the introduction to the catalogue.

9. Kuh, *Artist's Voice*, 200.

10. Arthur Wesley Dow, *Composition*, 7th ed. (Doubleday, Page and Co., Garden City, New York, 1913), 7.

11. Emily Carr, *Hundreds and Thousands: The Journals of Emily Carr* (Clarke, Irwin and Co. Ltd., Toronto, Vancouver, 1966), 21.

12. Tobey, interview with William Seitz, 19, 20, 22 January 1962 (Archives of American Art, Smithsonian Institution).

13. Holger Cahill, *Max Weber* (The Downtown Gallery, New York, 1930), 32.

14. Bourgeois Galeries, Inc., located at 693 Fifth Avenue, not only exhibited American art (they gave a one-man show to Joseph Stella, 27 March 24 April 1920) but they also showed Chinese art on a regular basis (April 1921, November-December 1922, and March 1928). The foreword for the *Exhibition of American Art, 2-28 December, 1929,* included the following words: "There are methods which can be learned like all mechanical props, but the life spirit, as the Chinese call it, is born into an artist and cannot be instilled into a mind, if it is absent.

"In order to discover the artist we have therefore to find out if the life spirit is present in his work.

"Everybody can see . . . if a plant is alive or dead, if it has a tendency to seek light or love or food. . . . Real works of art are just like flowers or any form of living organism. They possess and express . . . a vital function . . . a continuous activity" (Archives of American Art, Smithsonian Institution).

THE TRIP TO THE ORIENT

1. Bernard Leach, *Beyond East and West* (New York, 1978), 171.

2. Tobey's notes from his trip to the Orient were studied by the author courtesy of Galerie Beyeler. Present whereabouts unknown.

3. Letter from Tobey to Dorothy Elmhirst, 3 May 1934, in which Tobey sent a sample of his own calligraphy from Shanghai to the Elmhirsts and explained, "my friend says belongs in 3 years practice grade" (Dartington Hall Archives, Dartington Hall Trust, Devon).

4. Tobey, interview with Seitz, 1962.

5. In Tobey's notes (the only place where the name or location of the monastery is recorded) it looks to be called Emperfuji, but the word is difficult to decipher with any certainty. In his interview with William Seitz, Tobey said he also practiced calligraphy while he was at the monastery in Japan.

6. Tobey travel notes, present whereabouts unknown.

7. The *Three Birds* is in the Seattle Art Museum; the *Toads* belongs to the Dartington Hall Trust, Devon.

8. Tobey did not, however, give Graves the idea of painting birds, for Graves had earlier exhibited his love of birds in works like *Moor Swan* (1933, Seattle Art Museum) among others. However, Tobey probably did give Graves the impetus to do them simply and directly, with as few strokes as possible and without concern for anatomical precision but rather for the spirit of the subject (as we find in Tobey's animals in the moonlight series, which were exhibited at the Seattle Art Museum later that year).

9. Dartington Hall Archives, Dartington Hall Trust, Devon.

WHITE WRITING AND PAINTINGS INSPIRED BY *BROADWAY*

1. See Tobey interview with William Seitz, 1962, as well as Seitz, *Mark Tobey,* where he states that Tobey "is positive that the three works were painted within a few nights of each other during the fall of 1935." Since *Broadway Norm* bears the date 1935 in two places, and *Broadway* was only dated some years later, after Tobey's return to Seattle, it seems likely that he might have made a mistake in dating *Broadway.*

2. A note in the catalogue of the Tobey one-man show at the Romany Marie Café Gallery (2-31 December) reads: "The French Surrealists in a special number of *Variétés*, drew up a map of the world and left out America, it being non-existent from their point of view. Mark Tobey is one of the very few who put us back on the map. Surrealism becomes apparent. It is working itself out as a reflex of its time. The question has been asked how relevant surrealism is to America. It is the relevant force for America, and not until we discover its magic will there be a cultural release."

3. Marin's work was exhibited at the Museum of Modern Art in *Modern Works of Art,* November 1934-January 1935; at the Whitney Museum of American Art in *Abstract Painting in America,* 12 February-22 March 1935; and in a one-man show at An American Place, October-15 December 1935 (extended to 1 January 1936). In his interview with Seitz, it is Tobey who brings up Marin, commenting on the calligraphic quality of his style and speculating on the possible influence of oriental art on his work.

4. *John Marin: Watercolors, Oil Paintings, Etchings* (Museum of Modern Art, New York, October 1936), 17.

5. Marin quoted in Sheldon Reich, *John Marin: A Stylistic Analysis,* Part I (Tucson, Arizona, 1970), 54.

6. E.M. Benson, "Phases of Calligraphy," *Magazine of Art* (June 1935), 359. In this article Marin's painting is referred to simply as *Broadway.* The catalogue raisonné of Marin's work (see footnote 5), however, lists this work as *Broadway Night.*

7. E.M. Benson, *John Marin* (The American Federation of Arts, Washington, 1935).

8. Tobey notes (estate of the artist), present whereabouts unknown.

9. Tobey, interview with Seitz, 1962.

10. Writings of Baha'U'llah, *Bahai World Faith,* 36.

11. Tobey, letter to Callahan, c.1935. Kenneth Callahan Papers, Archives of American Art, Smithsonian Institution.

12. A. Hyatt Mayor, "Writing and Painting in China," *Magazine of Art* 45 (February 1952), 76.

13. Mayor, "China," 77. Chiang Yee *(Chinese Calligraphy,* 2nd ed. [Methuen and Co., Ltd., London, 1954], 163) writes: "We have four terms to describe the quality of the strokes: Bone, Flesh, Muscle and Blood. For we look at strokes and characters from an animistic point of view."

14. D. Suzuki, "Zen and Art," *Art News Annual* (1957/1958).

15. Seitz, *Tobey,* 16.

16. Brooks Atkinson, *Broadway* (New York, 1970, 1974), 291.

17. Atkinson, *Broadway,* 178.

18. Tobey quoted in *Retrospective Exhibition of Paintings by Mark Tobey* [exh. cat., California Palace of the Legion of Honor] (San Francisco, 1951).

19. Tobey, interview with Seitz, 1962.

20. Kuh, *Artist's Voice,* 237.

21. Tobey, interview with Seitz, 1962.

22. According to Windsor Utley, owner of the painting, who was a good friend of Tobey, Tobey once told him that the painting was an impression of the winter circus in Paris. We do not know the origin or inspiration of Tobey's other circus paintings. But Ringling Brothers Barnum and Bailey Circus did come to Seattle and performed at the Coliseum on First Avenue North. The present building on the site replaces the one in which Tobey would have seen the circus in the twenties or thirties. Viola Patterson, who was a good friend of Tobey in Seattle, said that they all went to the circus, but she had no recollection of any special interest on Tobey's part.

23. Tobey, interview with Seitz, 1962.

24. Tobey, interview with Seitz, 1962.

25. Letter to the author from Charles Seliger, 15 March 1982.

26. Jack Lait, *The Broadway Melody,* novelized by Jack Lait from the scenario by Edmund Goulding (New York, Grosset and Dunlap, 1929).

SEATTLE

1. Tobey quoted in Helen Keen notebooks, Archives of American Art, Smithsonian Institution.

2. Tobey, interview with Seitz, 1962.

3. Mark Tobey, *The World of a Market* (University of Washington Press, Seattle, 1964), foreword.

4. We have no account of Tobey's discussion with Ozenfant, but we do know that Ozenfant visited Tobey's studio in May 1939. This visit is recorded in Ozenfant's *Memoirs.* We have only to compare Tobey's *Still Life with Egg* (1941, Seattle Art Museum) to Ozenfant's *Bottle, Pipe and Books* (1918, Galerie Katia Granoff, Paris). This was an exercise on Tobey's part, however, since his own work had already established an entirely different direction.

5. Colin Graham, *Mark Tobey in Victoria* (Art Gallery of Greater Victoria, 1957).

6. Tobey, in D. Davis, *Newsweek* (29 July 1974), 58.

7. Frederick S. Wight, *Morris Graves* (University of California Press, Berkeley and Los Angeles, 1956), 31.

8. Graves did paint one self-portrait (collection of Mrs. Max Weinstein, Seattle) and another painting of a man stretched out on a bed, probably also a self-portrait (collection of Mr. and Mrs. Marshall Hatch, Seattle).

9. See Ida Rubin, ed., *The Drawings of Morris Graves* (Boston, New York Graphic Society, 1974), 54-55.

10. Wesley Wehr, conversation with the author.

11. Tobey's work was reviewed (in the forties, in Seattle) as resembling, "the bottom of a child's cereal dish," "the cracked bottom of a dried-up paint can" (see Seitz, *Tobey,* 86).

12. Symposium on Tobey as teacher, held at the Cornish School, Seattle, 11 December 1978. Chaired by Virginia Barnett; participants: Viola Patterson, James Washington, George Tsutakawa, Virginia Banks, Clora Corea.

13. Tobey, quoted in "Tobey Talks of Seattle," *The Seattle Times,* Archives of American Art, Smithsonian Institution.

14. Another *Composition* by Torres-Garcia was illustrated in the article, "Phases of Calligraphy" in the *American Magazine of Art* (June 1935), 357.

15. Tobey was a packrat. In his small clapboard house on University Way in Seattle, just walking distance from the university campus and from his studio, he lived in disorganized fashion amidst objects and paintings from myriad cultures: Sung scrolls, an oriental screen of a stone rubbing, African masks, and Northwest Indian pieces.

16. Tobey, interview with Seitz, 1962.

17. Wesley Wehr, correspondence with the author. In 1939 Tobey met Pehr Hallsten, a Swede living in nearby Ballard and teaching French at the YMCA. Pehr was nearly destitute when they met. Tobey brought him home with him. He immediately felt protective toward him. Pehr had a gift for languages, and Tobey always had tremendous respect for anyone with that talent. Two of the other most important people in his life he met for the first time as language tutors, Bertha Poncy Jacobson, who subsequently taught him piano, and Otto Seligman, a Viennese, who later became his dealer and who gave Tobey French lessons.

18. *Seattle Post Intelligencer* (20 April 1951). Also see *Seattle Post Intelligencer* (24 March 1950): "Tobey pleads to save Seattle Public Market."

19. *Seattle Post Intelligencer* (20 April 1969).

20. Tobey, *The World of a Market,* foreword. Some years later, at the Western Round Table on Modern Art, in 1949, in a discussion of whether the artist profits from the words of his critic, the moderator, George Boas asked Tobey if he had ever learned anything from criticism. Tobey's reply was not only entirely in keeping with his attitude toward advertising, but also showed his sense of humor. He answered, yes, "According to this critic, my works looked like scraped billboards. I went to look at billboards and decided that more billboards should be scraped." (Western Round Table on Modern Art, sponsored by San Francisco Art Association, 8-10 April 1949, transcript, Museum of Modern Art Library.)

21. Benton, quoted in Barbara Rose, *American Art Since 1900* (London, 1967), 120.

ELIMINATION OF THE FIGURE

1. Tobey, interview with Seitz, 1962.

2. Rothko, quoted by Dore Ashton, "Art: Lecture by Rothko," *The New York Times* (October 1958), 26.

3. "Tobey Profile," *Art Digest* (1951), 34.

4. See Eliza Rathbone, "The Role of Music in the Development of Mark Tobey's Abstract Style," *Arts Magazine* (December 1983), 94-100.

5. Tobey, quoted in Seldon Rodman, *Conversations with Artists* (New York, 1961), 18.

6. The murals, originally painted for the Baillargeon house at 3801 East Prospect Street in Seattle, now belong to the Seattle Art Museum, given by Dr. and Mrs. Richard Fuller, who acquired the murals when they bought the house from Mrs. Baillargeon.

7. This sketch is reproduced in *Tobey's 80* [exh. cat., Seattle Art Museum] (University of Washington Press, 1970).

8. Tobey, quoted from his correspondence with the Whitney Museum of American Art, New York, on the occasion of the exhibition *Nature in Abstraction,* 14 January 1958 (Archives of American Art, Smithsonian Institution, and Whitney Museum files).

9. Seitz, *Tobey,* 23. Tobey explained to William Seitz the scientific grounds that interested him in paintings like *Drift of Summer:* "Scientists say that space is just loaded. . . . There is no such thing as empty space, it's all loaded with life. . . . Spores and God knows what all." (Tobey, interview with Seitz, 1962.)

10. Letter from Tobey to Callahan, Kenneth Callahan Papers, Archives of American Art, Smithsonian Institution. During the years 1938-1945 there was at least one Klee exhibition a year in New York. Nierendorf showed Klee in 1938, 1941, and 1945.

11. Clement Greenberg, *Art and Culture* (Boston, Beacon Press, 1961), 232.

12. In a catalogue of a Klee exhibition, Julia and Lyonel Feininger compared Klee's work to "runic scratchings on copper plates, hieroglyphs on silk and canvas of figures and buildings. . . ." [exh. cat., Museum of Modern Art] (New York, 1941), 7. Harold Rosenberg wrote of Tobey's work: "throughout, Tobey's dominant tone is the chalky tan-gray of scratching on a slate or tablet of stone, as if he wished to fix his twentieth-century experience into a message brought down from the mountains." (Rosenberg, *The Anxious Object* [New York, Horizon Press, 1964], 35.)

13. Paul Klee, quoted in Herbert Read, "Paul Klee," *A Coat of Many Colours* (London, George Routledge and Sons, Ltd., 1945), 19.

14. Whitney Museum of American Art files, statement of 4 July 1957, on file at the Archives of American Art, Smithsonian Institution.

15. Tobey, interview with Seitz, 1962.

16. Klee's *In the Grass* was included in the Klee exhibition at the Museum of Modern Art in 1930, as well as in 1941, and it was reproduced in the 1945 edition of the Memorial exhibition catalogue. It was also exhibited in the Klee show at the Buchholz and Willard Galleries, 9 October-2 November 1940.

17. Jackson Pollock did a series of paintings in 1946 called *Sounds in the Grass*; all three paintings of Pollock's series picked up the idea of the correspondence between an intimate view of nature, so close up that it fills the visual field, and the allover treatment of the pictorial field. Despite their radical differences in approach to art, Pollock almost surely received a boost toward his own allover abstraction from seeing the work of Tobey. Both *In the Marsh* and *Drift of Summer* were included in Tobey's first show at the Willard Gallery in the spring of 1944. Marion Willard (in conversation with the author, 1977) remembers that Pollock did come to see the show. The artist, Charles Seliger, who, though much younger than the abstract expressionist group, was often shown with them, recalled in 1962 (at the Tobey-Seitz interview): "Howard [Putzel] who had a gallery was showing me and he was very close to Pollock. We used to go out a great deal, and he [Putzel] had stated to me and Pollock that we must go and see Tobey's show." Greenberg, who has maintained that Pollock did not see the show (in "American Type Painting," *Partisan Review* 22, no. 2 [spring 1955]) reviewed the show in *The Nation* in 1944 (see footnote 29), opening with the remark that the Tobey exhibition "deserved the most special notice." Even if Pollock had not gone to the show at the Willard Gallery, he almost certainly would have seen Tobey's work at the Mortimer Brandt Gallery in 1944 or at Howard Putzel's 67 Gallery in *40 American Moderns* in 1944, in group shows in which both artists were included.

18. Kuh, *Artist's Voice,* 243, 244.

19. Tobey, in "Tobey Profile," 26.

20. Tobey, interview with Seitz, 1962.

21. Tobey, letter to Marion Willard, September 1946, quoted in *Mark Tobey* (Musée des Arts Décoratifs, Paris, 1961).

22. This statement was made in reference to a painting *Threading Light* (1942) and is quoted by Sidney Janis in *Abstract and Surrealist Art in America* (New York, 1944), 87.

23. This new exploration of structure, most specifically stated in *Gothic,* might well have been inspired by the work of both Klee and Feininger. Not only were the clean, soaring lines of architecture recurrent in Feininger's work, but also the subject of the painting Feininger had entered in the Metropolitan Museum's *Artists for Victory* exhibition in 1942, where both Tobey and Feininger won prizes, was that of a church. If Tobey's own investigation of cubism underlies *City Radiance,* its similarities with works by Feininger, such as *Umferstedt,* point to another source of inspiration for the delicate structure on the surface that fades at the edges. Tobey also probably saw Nancy Wilson Ross' Klee (which she had bought from the artist before 1940) called *Kathedrale.*

24. *Writings of Abdul-Baha,* "This Radiant Century," in *Baha'i World Faith,* 228-231.

25. Feininger lived in Germany from 1887 to 1937, where he joined the Bauhaus in 1919 and the Blue Four in 1924. He was already highly regarded in Germany by 1929, the year of his first public showing in New York. But in New York his work was poorly received. By the late 1930s, however, he had gained considerable respect in the United States and executed murals for the New York World's Fair in 1939. In the Northwest his work was shown at the Henry Art Gallery in 1947 and 1949.

Feininger, who always kept a photograph of Tobey in the livingroom of his New York apartment, invited Tobey to visit in Stockbridge, Massachusetts, as well as in New York. Both enjoyed motoring into the Berkshires, though neither ever learned to drive a car. Charles Seliger was often along at the wheel, leaving the two older artists the leisure to watch the landscape unfold. In the house in Stockbridge, both would play the piano: Feininger, Bach; Tobey, Debussy (Letter to the author from Charles Seliger, 15 March 1982).

26. Telephone conversation between Charles Seliger and the author.

27. Clement Greenberg, "Art," *The Nation* 158 (22 April 1944), 495. By 1947, Greenberg had retracted some of his enthusiasm, and in an only partially favorable review (*Horizon* [October 1947]) he wrote, "Graves and Tobey have turned out to be so narrow as to cease even being interesting."

28. Julia and Lyonel Feininger for *Mark Tobey* (Portland Art Museum, 1945-1946).

29. Tobey, "Reminiscence and Reverie," 230.

30. Tobey, letter to Marion Willard, quoted in *Mark Tobey Retrospective* (Musée des Arts Décoratifs, Paris, 1961).

31. Lawrence Alloway, "Introduction" in *Mark Tobey* [exh. cat., Institute of Contemporary Arts] (London, 4 May-4 June, 1955).

THE UNIVERSAL CITY

1. Robert Motherwell, quoted in *Fourteen Americans* (Museum of Modern Art, New York, 1946), 34, 36.

2. Tobey, quoted in *Fourteen Americans,* 70.

3. Tobey, interview with Seitz, 1962.

4. *Writings of Abdul-Baha,* 244.

5. Tobey, letter to Marion Willard, June 1949, published in *Mark Tobey Retrospective* (Paris, 1961).

6. Alfred North Whitehead, *Science and the Modern World* (New York, The Macmillan Company, 1925), 3.

7. "Consider this contrast: when Darwin or Einstein proclaim theories which modify our ideas, it is a triumph for science. We do not go about saying that there is another defeat for science, because its old ideas have been abandoned. We know that another step of scientific insight has been gained.

Religion will not regain its old power until it can face change in the same spirit as does science. Its principles may be eternal, but the expression of those principles requires continual development. ... The great point to be kept in mind is that normally an advance in science will show that statements of various religious beliefs require some sort of modification." (Whitehead, *Science,* 234).

8. Whitehead, *Science,* 118.

9. Einstein, paraphrased by Maurice Nadeau, in *History of Surrealism*, trans. from the French by Richard Howard (Macmillan, New York, 1965), 50.

10. Whitehead, *Science,* 119, 125. It is fascinating to find that one reviewer of Tobey's work found a relationship to Whitehead with no knowledge of any actual association between the two: C. H. Waddington writes in *Studio International* 173 (March, 1967), 8: "I cannot prevent myself seeing a relation between Tobey and another major contributor to the way in which modern man sees the world — A. N. Whitehead. I have never noticed any reference by Tobey to Whitehead. But at the time, and in the surroundings (at Dartington) in which Tobey first came to maturity, Whitehead was certainly a strong background influence. His basic ideas — that 'things' are essentially enduring entities whose existence requires a certain lapse of time; that everything is involved with everything else, in fact that the individual character of an existent is just precisely the particular way in which it absorbs — or as he puts it 'prehends' — into itself all the other things surrounding it — if one called for a diagramatic illustration of what Whitehead was saying, the essential points could hardly be made better than they are in some of Tobey's paintings."

11. On 14 February 1953, Tobey wrote to Marion Willard: "Monday night I speak to 150 architectural students on just what I don't know. Anyway, the lecture has refound for me Gideon's [sic] remarkable 'Time and Space Architecture' [sic]. I shall never forget our lunch with him and his saying he wanted a *chair* in some university for 'Unrecognized History,' Wonderful to meet minds — this is really, as yet, the back woods." Quoted in *Mark Tobey Retrospective* (Paris, 1961).

12. Sigfried Giedion, *Space, Time and Architecture* (Harvard University Press, Cambridge, Mass., 1943), 7.

13. Giedion, *Space,* 352.

14. J. B. "Georgia O'Keeffe at the Whitney," *Arts* 45 (November 1970), 55.

15. Indeed Tobey had imagined the simplification made possible by a view from the air as early as 1936, in a painting called *Flight over Forms* (the same year that Arshile Gorky described such a concept with regard to his mural, *Aviation: Evolution of Forms under Aerodynamic Limitations*), but this was an isolated instance in his work at the time. Arshile Gorky, "Aviation: Evolution of Forms under Aerodynamic Limitations," quoted in Hershel B. Chipp, *Theories of Modern Art* (Berkeley, 1970), 534.

16. Tobey, letter to Otto Seligman, 12 February 1954, Tobey Papers, courtesy of Galerie Beyeler, Basel (1976). Present whereabouts unknown.

17. Donald Culross Peattie, *This Flowering Earth* (G. P. Putnam's Sons, New York, 1939), 45.

18. Diaries of Charles Seliger, Archives of American Art, Smithsonian Institution.

19. Tobey, commenting on his painting, *Extensions from Bagdad* (1944), on file, Willard Gallery, New York.

20. Tobey, quoted from "Excerpts from a Letter by Mark Tobey," *The Tiger's Eye* no. 3 (15 March 1948), 52.

21. Tobey often used an atomizer (like an air-brush) in this period. Conversation with Seattle artist, Neil Meitzler, 1974.

22. Charles Seliger Diaries, entry for 20 July 1956, Archives of American Art, Smithsonian Institution.

23. Correspondence with Wesley Wehr. Author's files.

24. *The Book of Tea* by Okakura Kakuzo was in its fifteenth edition by 1931 and continued to be republished in 1952 and 1954. Seliger Diaries, entry for 20 October 1956, Archives of American Art, Smithsonian Institution.

25. Tobey, letter to Ulfert Wilke, 1960, Archives of American Art, Smithsonian Institution.

26. Information from Wesley Wehr, who was one of the few Tobey allowed into his studio while he was painting. Correspondence with the author, 14 February 1975.

27. Yee, *Chinese Calligraphy*, 126, 130.

28. Seliger would visit Tobey on Irving Place and has recorded in his diaries finding him at work there at a table, "When I used to come up to Tobey's studio he'd be huddled in a corner. He used a table." Seliger Diaries, Archives of American Art, Smithsonian Institution.

29. Mark Tobey, "Japanese Traditions and American Art," *College Art Journal* 18 (Fall 1958), 24.

30. Tobey, in catalogue of Feininger exhibition, Curt Valentin Gallery, 1954.

31. Tobey correspondence with Otto Seligman, letter dated 16 January 1955. Tobey Papers, courtesy of Galerie Beyeler.

32. Tobey correspondence with Otto Seligman, letter dated 9 April 1955. Tobey Papers, courtesy of Galerie Beyeler.

33. Undated letter from Tobey to Seligman, from New York, probably summer 1955. Tobey Papers, courtesy of Galerie Beyeler.

34. Letter to Ulfert Wilke, early 1958, Archives of American Art, Smithsonian Institution.

35. Alfred Frankfurter, "European Speculations II: Modern Art and Marco Polo," *Art News* 53 (September 1954).

36. H. P. Bowie, *On the Laws of Japanese Painting* (Paul Elder and Co., San Francisco, 1911), 38.

37. Tobey, from a letter to Katharine Kuh, 9 November 1961, Basel, in Kuh, *Artist's Voice*, 245.

38. Tobey, letter to Arthur and Joyce Dahl, 23 April 1957, quoted in *Mark Tobey, Paintings from the Collection of Joyce and Arthur Dahl* (Stanford Art Gallery, Stanford University, 1967), 10.

39. Tobey, letter to Marion Willard, 24 March 1958, quoted in *Tobey Retrospective* (Paris, 1961).

40. Mark Tobey, statement by the artist, Portland Art Museum, 1945/1946.

41. Tobey, letter to Katharine Kuh, 28 October 1954, in Kuh, *Artist's Voice,* 244.

42. Conversation with Mark Ritter, Basel, 1976.

CATALOGUE

The following symbol, the Japanese character for brush, appears beside works that are included in the exhibition: 筆

We are very grateful to the artist Shunkin Takahashi for her contribution.

筆 **1**
Cirque d'hiver, 1933

pastel on paper
16⅞ x 21½ in. (42.9 x 54.6 cm.)
inscribed lower right· *Tobey '33*
Mr. and Mrs. Windsor Utley, Laguna Beach, California, acquired from the artist, 1948
color plate 1

According to Windsor Utley, the painting was signed and dated by Tobey in the sixties. Tobey's friend and fellow Northwest artist Guy Anderson was in possession of this painting for several years before Tobey asked for it back to sell it to the Utleys, who were interested in acquiring one of his early abstract works.

Exhibitions
Seattle 1959-1960, cat. no. 29.
New York 1962-1963, cat. no. 4, ill. 21.
Amsterdam 1966, Bern cat. no. 1; Düsseldorf cat. no. 1.
Dallas 1968, cat. no. 7.
New York: *The 1930s: Painting and Sculpture in America,* Whitney Museum of American Art, 15 October to 1 December 1968, cat. no. 101, ill.
Düsseldorf/Zurich/Brussels: *American Modern Art Between the Two World Wars, 1920-1940,* Städtische Kunsthalle, 10 June to 12 August; Kunsthaus, 23 August to 28 October 1979; Palais des Beaux-Arts, 10 November to 30 December 1979.

Literature
Schmied, *Tobey,* plate 27.
Russell, *Mark Tobey,* color plate 1, 16.

筆 **2**
Shop Front, Hong Kong, 1934

ink on paper
9⅜ x 6⅞ in. (23.9 x 17.5 cm.)
inscribed lower right: *Tobey '34 Hong Kong China*
Dr. Solomon Katz, Seattle, 1963-1964

Provenance
Otto Seligman Gallery, Seattle

Exhibitions
Seattle: *The Smith Family Collection,* Seattle Art Museum, 19 March to 4 May 1975.

3
China, 1934

black (and a little brown) ink on wet paper
approx. 9½ x 7⅛ in. (24.1 x 18.1 cm.)
(cut to drawn contour rather than original rectangular sheet) mounted on black silk scroll
31½ x 12½ in. (80 x 31.8 cm.)
inscribed lower right: *Tobey 34 China*
Private collection

The work was mounted on a scroll by Ujii Abe for Mr. and Mrs. Weinstein in the late fifties. At that time its "rough edges" were trimmed. The Weinsteins decided to mount *China* without consulting Tobey. He did see it mounted, however, and didn't object to it.

Provenance
Mr. and Mrs. Max Weinstein, Seattle, late 1940s

Exhibitions
Seattle: Otto Seligman Gallery, 1956.
Seattle 1959-1960, cat. no. 33, ill. (traveled with reduced exhibition in 1960 as cat. no. 19).
Paris 1961-1962, cat. no. 10, ill. plate 1.
Dallas 1968, cat. no. 9.

Literature
Quadrum 13 (1962), ill. 29.

筆 **4**
San Francisco Street, 1934

opaque watercolor on paper
15 x 11 in. (38.1 x 27.9 cm.)
Henry Art Gallery, University of Washington, Seattle, Margaret Callahan Memorial Collection, Gift of Brian T. Callahan, 1963-1966.

Provenance
Kenneth Callahan, Long Beach, Washington

Exhibitions
Washington/Seattle/Portland: *Art of the Pacific Northwest,* National Collection of Fine Arts, 8 February to 5 May; Seattle Art Museum, 12 July to 25 August; Portland Art Museum, 17 September to 15 October 1974, cat. no. 117, fig. 42.

筆 **5**
Seattle in the Snow, 1935

tempera on gesso cardboard
11½ x 15½ in. (29.2 x 39.4 cm.)
inscribed lower right: *Tobey '35*
Mr. and Mrs. John M. Cooper, 1942

Exhibitions
Seattle: *28th Annual Exhibition of Northwest Artists,* Seattle Art Museum, 7 October to 8 November 1942.
San Francisco 1951, ill. 4.

Literature
Seitz, *Abstract Expressionist Painting*, fig. 237.

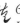
6
Broadway Norm, 1935

tempera on cardboard
13¼ x 9⅜ in. (33.3 x 23.5 cm.)
inscribed lower left: *35;* and lower right: *Tobey 35*
Carol Ely Harper

There is a self-portrait on the verso of the painting, according to its owner, Mrs. Harper, but it is not visible in its present heavy traveling frame which the Museum of Modern Art put on it.

Exhibitions
New York 1944.
Portland 1945-1946, cat. no. 1.
San Francisco 1951.
Venice 1958, cat. no. 37.
Seattle 1959-1960, cat. no. 22. ill.
Paris 1961-1962, cat. no. 12, plate 3.
Washington 1962, cat. no. 1.
New York 1962-1963, cat. no. 8, ill. 51.
Washington: *The New Tradition: Modern Americans Before 1940,* The Corcoran Gallery of Art, 26 April to 3 June 1963, cat. no. 99, ill.
Amsterdam 1966, Bern cat. no. 5; Düsseldorf cat. no. 5.
Dallas 1968, cat. no. 12.
New York: *The 1930s: Painting and Sculpture in America,* Whitney Museum of American Art, 15 October to 1 December 1968, cat. no. 102, ill.

Literature
Art News 61 (September 1962), ill. 39.
Stuart Preston, "Mystical Modern Artist," *The New York Times* (Sunday, 16 September 1962), ill.
Tillim, "Review," ill. 51.
Andrew Kagan, "Paul Klee's Influence on American Painting: New York School," *Arts* 49 (June 1975), ill. 58.
Artforum 17 (April 1979), 25, 27, ill. 24.
Coates, "Galleries," 98.
Seitz, *Abstract Expressionist Painting*, fig. 238.

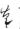
7
Broadway, 1935

tempera on fiberboard
26 x 19¼ in. (66 x 48.9 cm.)
inscribed lower right: *Tobey 36*
The Metropolitan Museum of Art, New York, Arthur Hoppock Hearn Fund, 1942

Provenance
Marion Willard, New York, 1939

Exhibitions
New York: *Artists for Victory,* The Metropolitan Museum of Art, 7 December 1942 to 22 February 1943.
London: *American Paintings from the 18th Century to the Present Day,* The Tate Gallery, 1 April to 1 October 1946.
Venice: *Venice Biennale d'Arte,* 15 June to 30 September 1948.
San Francisco 1951, ill.
Chicago: *Mark Tobey,* Gallery of Art Interpretation, Art Institute of Chicago, 21 January to 15 March 1955.
Houston 1956.
San Francisco: San Francisco Museum, 28 October to 1 December 1957.
Washington: *Mark Tobey,* Saint Alban's School, 20 May to 3 June 1959, cat. no. 57.
Paris 1961-1962, cat. no. 14, plate 4.
New York 1962-1963, cat. no. 7, color ill. 17.
Washington 1963, cat. no. 100.
New York: *Three Centuries of American Painting,* The Metropolitan Museum of Art, 1965.
Amsterdam 1966, Bern cat. no. 4, ill.; Düsseldorf cat. no. 4, ill.
Dallas 1968, cat. no. 13, ill.
Baltimore: *From El Greco to Pollock: Early and Late Works by European and American Artists,* Baltimore Museum of Art, 22 October to 8 December 1968.
Birmingham/Mobile: *American Watercolors: 1850-1972,* Birmingham Museum of Art, 16 January to 13 February 1972; Mobile Art Gallery, 22 February to 31 March 1972 (cosponsored by the Alabama Watercolor Society).
Allentown: *The City in American Painting,* Allentown Art Museum, 20 January to 4 March 1973, ill. 33.
San Juan: *Twentieth-Century Art: U.S.A. from the Metropolitan Museum of Art,* Institute of Puerto Rican Culture, 19 April to 2 June 1974, cat. no. 17, 47-48, ill. 47.
Washington 1974-1975, cat. no. 1, ill.
Southampton: *Twentieth-Century American Painting from The Metropolitan Museum of Art,* The Parrish Art Museum, 25 September to 31 December 1977, cat. no. 18, ill. 24.
Brussels: *La peinture americaine au 20e siècle de la collection du Metropolitan Museum of Art,* Palais des Beaux-Arts, 28 June to 23 August 1978, cat. no. 17, ill.
The Hague/Zurich/Munich: Gemeentemuseum, 19 November 1977 to 31 January 1978; Kunsthaus, February to March 1978; Haus der Kunst, March to April 1978.
Düsseldorf/Zurich/Brussels: *American Modern Art between Two World Wars, 1920-1940,* Städtische Kunsthalle, 10 June to 12 August; Kunsthaus, 23 August to 28 October 1979; Palais des Beaux-Arts, 10 November to 30 December 1979.
Albany: *Twelve Americans,* State Senate, 5 May to 20 June 1980.

Literature
Magazine of Art 35 (December 1942), 274.
Art News 41 (January 1943), 12, ill. 8.
Art News 47 (September 1948), 25.

Baur, *New Art,* ill. 193.
Kuh, *Artist's Voice,* plate 111, 238.
Geldzahler, *American Painting,* 162, ill. 162.
Schmied, *Tobey,* 8, plate 18.
Dore Ashton, *XXe Siècle* 28 (May 1966), 71.
Russell, *Tobey,* cat. no. 2, color ill.
Apollo 97 (April 1973), ill. 433.
John Russell, "Painter Tobey, at 83, Still Has a Way with a Line," *Smithsonian* 5 (June 1974), 62, color ill. 58.
Art in America 62 (September 1974), 119.
H. H. Arnason, *History of Modern Art* (New York, 1977), 524, ill. 525.
Oberlin College Bulletin 35 (1977-1978), 72, ill.
Art Forum 17 (April 1979), ill. 24.

8
San Francisco Street (Chinatown), 1941

tempera on laminated board
27¼ x 13 in. (69.2 x 33 cm.)
inscribed lower right: *Tobey 41*
The Detroit Institute of Arts

Exhibitions
San Francisco 1951 (as *San Francisco [Chinatown]*).
Venice: *XXVIII Biennale,* 1956 ("American Artists Paint the City," organized by Katharine Kuh, Art Institute, Chicago), 46, plate 32, 40.
New York 1962-1963, cat. no. 13.

Literature
Detroit Institute Bulletin 24 (1945), 49.
Time 67 (18 June 1956), 81.
Chicago Art Institute Quarterly 51 (February 1957), 12.
Kuh, *Artist's Voice,* plate 114, 242.
Devree, "Artist's Growth."

9
Two Men, 1941

tempera
11½ x 9 in. (29.2 x 22.9 cm.)
inscribed lower right: *Tobey 41*
Portland Art Museum, Helen Thurston Ayer Fund, 1945

Provenance
Willard Gallery, New York

Exhibitions
New York 1944.
Portland 1945-1946, cat. no. 4, ill.
Andover/Utica: *Ten Painters of the Pacific Northwest,* Addison Gallery of American Art; Munson-Williams-Proctor Institute, October 1947 to March 1948, cat. no. 41.
San Francisco 1951.
Europe and Asia: *Eight American Artists,* organized by the United States Information Agency, 1957-1958.

Seattle 1959-1960.
Paris 1961-1962, cat. no. 19. Traveled to London and Brussels.
New York 1962-1963, cat. no. 11.
Dallas 1968.
Tacoma: Tacoma Art Museum, 1-31 October 1972.
Coral Gables: *The American Prophets,* The Lowe Art Museum, University of Miami, 22 February to 25 March 1973.

Literature
Roberts, *Mark Tobey,*.47.
Kochnitzky, "Mark Tobey," 20, ill. 20.

10
Broadway Boogie, 1942

tempera on composition board
31⅜ x 24⅜ in. (79.7 x 61.9 cm.)
inscribed upper right: *Tobey 42*
Mrs. Max Weinstein, Seattle

Provenance
Pepsi Cola Company, New York, 1944
Mr. and Mrs. Max Weinstein, Seattle, 1946

Exhibitions
New York: *Portrait of America Exhibition and Competition, Artists for Victory, Inc.,* sponsored by the Pepsi Cola Company, The Metropolitan Museum of Art, opening October 1944, and subsequently on tour in the United States until January 1946.
Seattle 1959-1960, cat. no. 75, ill.
Paris 1961-1962, cat. no. 24, plate 7.
New York 1962-1963, cat. no. 19, color ill, 26,
Washington 1962, cat. no. 7.
New York: *About New York, Night and Day, 1915-1965,* The Gallery of Modern Art, 19 October to 15 November 1965.
Amsterdam 1966, Amsterdam cat. no. 10; Düsseldorf cat. no. 10.

Literature
Art Digest 20 (15 November 1945), 39.
Art News 61 (September 1962), ill. 39.
Schmied, *Tobey,* plate 23.
Ammann, "Mark Tobey," 496.
Russell, *Tobey,* cat. no. 5, color ill.
Seitz, *Abstract Expressionist Painting,* fig. 246.
Mondrian did a painting called *Broadway Boogie Woogie* (1942-1943, Museum of Modern Art, New York), which is almost exctly contemporaneous with Tobey's *Broadway Boogie,* but finished the following year.

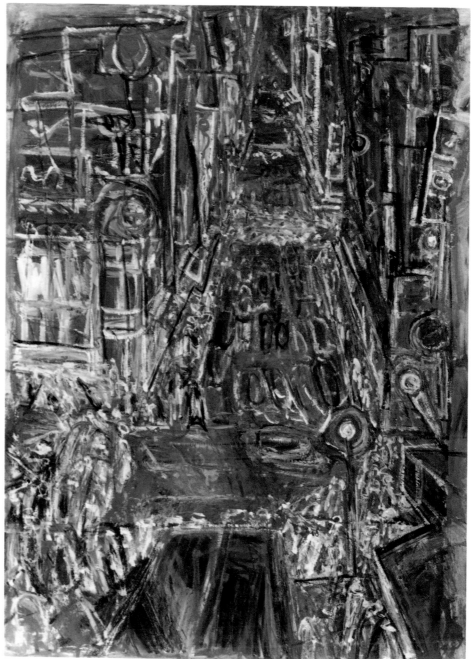

11.

11
City Street (Pike Street), 1942

tempera
26 x 21¼ in. (66 x 54 cm.)
inscribed lower right: *Tobey '42*
Private collection

Exhibitions
New York 1944.
San Francisco 1951.
Seattle 1959-1960, cat. no. 76.
Paris 1961-1962, cat. no. 22.

12
White Night, 1942

tempera on cardboard, mounted on hardboard
22 1/3 x 14 in. (56.5 x 35.6 cm.) inscribed lower
right: *Tobey 42*
The Seattle Art Museum, Gift of
Mrs. Berthe Poncy Jacobson, 1962

Provenance
Mrs. Berthe Poncy Jacobson

Exhibitions
Portland 1945-1946, cat. no. 10.
San Francisco 1951, ill. on cover.
Houston 1956.
Seattle 1959-1960, cat. no. 85.
Seattle: *Seattle Art Museum Mark Tobey
Exhibition,* Seattle World's Fair, Fine Arts
Pavilion, 1962.
Spokane: *Mark Tobey Retrospective,* Cheney
Cowles Memorial Museum, 8 March to 7 April
1968.
Seattle: *Mark Tobey, Paintings from Private
Northwest Collections,* The Bon Marché, 1969.
Seattle 1970-1971, cat. no. 44, ill.
Washington 1974-1975, cat. no. 4, ill.
Miami: *Mark Tobey,* Miami-Dade Community
College, 1 December 1975 to 29 January 1976.
Seattle: *Northwest Traditions,* Seattle Art
Museum, 29 June to 10 December 1978, ill. 20.
Boston: *Northwest Visionaries,* Institute of
Contemporary Art, 7 July to 6 September 1981.
Osaka: *Pacific Northwest Artists and Japan,*
National Museum of Art, 2 October to 28
November 1982.
Seattle: *Pacific Northwest Artists and Japan,* The
Pavilion (organized by the Seattle Art Museum),
27 January to 27 February 1983.

Literature
Chevalier, "Une journée," ill. 4.

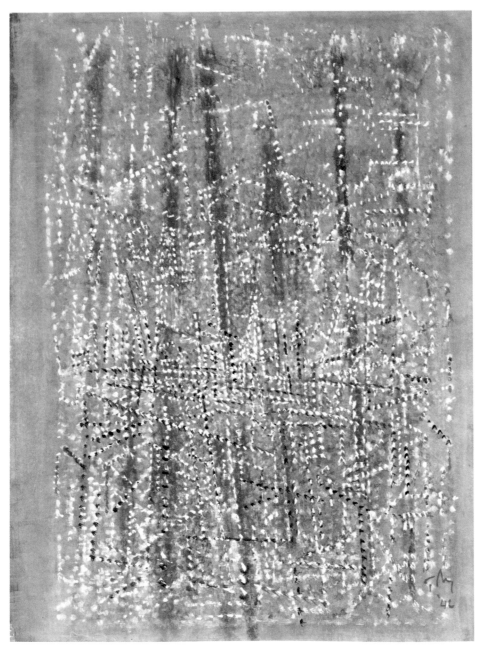

13. (Photo by Adolph Studley)

13
Electric City, 1942

tempera
size unrecorded
inscribed lower right: *Tobey 42*
Location unknown

14
E Pluribus Unum, 1942-1943

tempera on paper, mounted on board
20½ x 24½ in. (52.1 x 62.2 cm.)
inscribed upper right: *Tobey '42*
The Seattle Art Museum, Gift of Mrs. Thomas D. Stimson, 1943

Although *E Pluribus Unum* is dated 1942, in the upper right corner, Seitz dated it 1942 (or 1943?), and it seems likely that it was finished in 1943. Two other paintings of the subject, *Sale* (Whitney Museum of American Art, New York) and *The Gathering* (Galerie Beyeler, Basel) are both dated 1943.

Provenance
Willard Gallery, New York
Mrs. Thomas D. Stimson, Seattle, 1943

Exhibitions
New York 1944.
Portland 1945-1946, cat. no. 11.
New York: *Fourteen Americans,* Museum of Modern Art, 10 September to 8 December 1946, cat. no. 159.
Andover/Utica: *Ten Painters of the Pacific Northwest,* Addison Gallery of American Art; Munson-Williams-Proctor Institute, October 1947 to March 1948, cat. no. 42, ill.
San Francisco/Tacoma/Los Angeles/Portland/Vancouver, B.C.: *Trio,* Western Association of Art Museums, Palace of the Legion of Honor, San Francisco.
San Francisco 1951.
Buffalo: *Expressionism in American Painting,* Albright Art Gallery, 10 May to 29 June 1952, ill. fig. 44, 44.
Chicago: *Mark Tobey,* Gallery of Art Interpretation, Art Institute of Chicago, 21 January to 15 March 1955.
Seattle 1959-1960, cat. no. 77, ill. frontispiece.
Paris 1961-1962, cat. no. 25, plate 9.
London 1962.
Washington 1962, cat. no. 6.
New York 1962-1963, cat. no. 20, color ill. 32.
Amsterdam 1966, Amsterdam ill.; Hannover ill.; Düsseldorf cat. no. 8.
Spokane: *Mark Tobey Retrospective,* Cheney Cowles Memorial Museum, 8 March to 7 April 1968.
Chicago: *The Crowd,* The Arts Club of Chicago, 28 October to 29 November 1969.
Seattle 1970-1971, cat. no. 43, color ill.
Washington 1974-1975, cat. no. 2, ill.
Miami: *Mark Tobey,* Miami-Dade Community College, 1 December 1975 to 29 January 1976.

Literature
Art News 43 (15 April 1944), ill. 25.
Art News 44 (1 March 1945), ill. 28.
Art News 45 (July 1946), ill. 24.
Coates, "Galleries," 98.
Kochnitzky, "Mark Tobey," 19, ill.

"A Seattle Painter Wins Top European Prize," *Life* 45 (21 July 1958), color ill. 50.
Leslie Judd Ahlander, "Tobey's 'White Writing' at the Phillips," *The Washington Post* (Sunday, 13 May 1962).
Art Digest 18 (1 April 1974), 19.
John Russell, "Other Worldliness and a Penetrating Eye," *St. Louis Post-Dispatch* (Sunday, 2 May 1976).

15
Flow of the Night, 1943

tempera on wood pulp panel
19¾ x 14 in. (50.2 x 35.6 cm.)
20¾ x 15½ in. (52.7 x 39.4 cm.), framed
painting itself: 19¾ x 14 in.
inscribed lower right: *Tobey 43*
Portland Art Museum, Helen Thurston Ayer Fund, 1945

Provenance
Willard Gallery, New York

Exhibitions
New York: *Romantic Painting in America,* Museum of Modern Art, 17 November 1943 to 6 February 1944, cat. no. 194.
New York: *Seven American Painters,* Museum of Modern Art, 1944.
Portland 1945-1946, cat. no. 14.
Colorado Springs: *New Accessions, U.S.A.* 1946, Colorado Springs Fine Arts Center, 15 July to 2 September 1946.
San Francisco 1951.
Europe and Asia: *Eight American Artists,* organized by the United States Information Agency, 1957-1958.
Seattle 1959-1960, cat. no. 88 (traveled 1960, cat. no. 43).
Eugene: The Museum of Art, University of Oregon, 19 January to 13 March 1959.
Paris 1961-1962, cat. no. 30, plate 8.
La Jolla: *Twentieth Anniversary Loan Exhibition: American Paintings from Pacific Coast Museums,* The Art Center, 13 April to 7 May 1961.
New York 1962-1963, cat. no. 21, ill. 61.
Amsterdam 1966, Amsterdam, Hannover, Bern cat. no. 14, ill.; Düsseldorf cat. no. 15.
Dallas 1968, cat. no. 24.
Chicago: *The Crowd,* The Arts Club of Chicago, 28 October to 29 November 1969.
Tacoma: Tacoma Art Museum, 1-31 October 1972.

Literature
Portland Art Museum Bulletin 8 (March/April 1951).
Devree, "Artist's Growth."
Ammann, "Tobey," ill. fig. 3, 496.

16
Mounted Policeman, 1943

tempera
9⅞ x 6½ in. (25.1 x 16.5 cm.)
inscribed lower right: *Tobey 43*
Private collection

Provenance
Zoe Dusanne Gallery, Seattle

Exhibitions
Paris 1961-1962, cat. no. 28.
London 1962.

17
Market Scene, 1944

tempera on board
11¾ x 7½ in. (29.9 x 19.1 cm.)
inscribed lower right: *Tobey 44*
The Seattle Art Museum, Gift of Mrs. Albert Enders, 1979

Provenance
Mr. and Mrs. Ray M. Murray, Jr.
Mr. and Mrs. David Lewis, Seattle, 1959-1964.

Exhibitions
Seattle 1959-1960, cat. no. 98, ill.

Literature
Mark Tobey, *The World of a Market* (University of Washington Press, Seattle, 1964), color plate 3.

18
Crystallization, 1944

tempera on paper
18 x 13 in. (47.5 x 34.3 cm.)
Mrs. James H. Clark, Dallas

Provenance
Willard Gallery, New York
John Cage, New York, 1945
Willard Gallery bought back from Cage in November 1956
Mr. and Mrs. Benjamin Watson, Danbury, Connecticut, May 1957
Willard Gallery bought back from the Watsons in November 1965
Mr. and Mrs. James H. Clark, Dallas, March 1966

Exhibitions
Chicago: *Mark Tobey,* Arts Club of Chicago, 7 to 27 February 1946, cat. no. 3, as *Crystallized Forms.*
Bern: *Tendances Actuelles,* Kunsthalle, 29 January to 6 March 1955, cat. no. 78.
London: Institute of Contemporary Arts, 4 May to 4 June 1955, cat. no. 16, as *Crystallized* (exhibition from Paris: Galerie Jeanne Bucher, thus possibly shown there, but no record remains).
Paris 1961-1962, cat. no. 36, plate 15.
New York 1962-1963, cat. no. 34.
Dallas 1968, cat. no. 32.

19
New York, 1944

tempera on canvas on paper board
33 x 21 in. (83.3 x 53.3 cm.)
inscribed lower right: *Tobey/44*
National Gallery of Art, Gift of the Avalon
Foundation, 1976
cover illustration

Provenance
Dan and Marian Willard Johnson, New York, 1945

Exhibitions
New York: *Mark Tobey,* Willard Gallery, 13
November to 8 December 1945, cat. no. 8.
Portland 1945-1946, cat. no. 17.
New York: *Fourteen Americans,* Museum of
Modern Art, 10 September to 8 December 1946,
ill. 75.
Toronto: *Contemporary Paintings from Great
Britain, the U.S., and France,* The Art Gallery of
Toronto, October to December 1949.
New York: *The Intrasubjectives,* Samuel M. Kootz
Gallery, 14 September to 3 October 1949.
San Francisco 1951, cat. no. 38.
New York/Paris: *American Vanguard for Paris,*
Sidney Janis Gallery, December 1951; Galerie de
France, May 1952.
Europe and Asia: *Eight American Artists,*
organized by the United States Information Agency,
1957-1958 (shown at the Seattle Art Museum
1957).
Dallas: *Signposts of Twentieth-Century Art,* The
Dallas Museum for Contemporary Arts (now The
Dallas Museum of Fine Arts), 28 October to 7
December 1959, ill. 52.
Cleveland: *Paths of Abstract Art,* The Cleveland
Museum of Art, 5 October to 13 November 1960,
cat. no. 61, ill. 40.
Paris 1961-1962, cat. no. 51, plate 18, reference
in selected correspondence published in catalogue
(unpaginated).
Washington 1962, cat. no. 11, reference in
correspondence in catalogue (unpaginated).
New York 1962-1963, ill. 65.
New York: *Twenty-six Artists from the Museum's
and Friend's Collections of the Whitney Museum
of American Art,* 16 July to 8 September 1963.
Amsterdam 1966, cat. no. 18.
Melbourne/New South Wales/New York: *Two
Decades of American Painting,* International
Council of the Museum of Modern Art, exhibited
in Australia under the patronage of the United
States Ambassador and with the assistance of the
Commonwealth Government: National Gallery of
Victoria, 6 June to 9 July 1967; Art Gallery of
New South Wales, 26 July to 20 August 1967;
Museum of Modern Art, September to October
1967, cat. no. 87, ill.
Dallas 1968, cat. no. 30.
Washington: *American Art at Mid-Century I,*
National Gallery of Art, 28 October to 6 January
1974, ill.
Washington 1974-1975, cat. no. 7, ill.

Literature
Coates, "Galleries," 98.

William Seitz, "Spirit, Time, and Abstract
Expressionism," *Magazine of Art* 46 (February
1953), ill. 85.
Kuh, *Artist's Voice,* plate 113, 241.
Mark Tobey Retrospective [exh. cat., Musée des
Arts Décoratifs] (Paris, 1961) (see exhibitions
cited, unpaginated.)
Katharine Kuh, *Break-Up: The Core of Modern
Art* (New York Graphic Society, Greenwich,
Connecticut, 1955), plate 67, 98.
Mary King, "The White Writer: Tribute Show of
Mark Tobey," *St. Louis Post-Dispatch,* 1974.
Fred Hoffman, "Mark Tobey's Paintings of New
York," *Artforum* 17 (April 1979), ill. 26.
Art in America Since 1945 (Thames and Hudson
Ltd., London, 1981).
Seitz, *Abstract Expressionist Painting,* fig. 256.

20
City Radiance, 1944

tempera on paper
19 x 14 in. (48.2 x 35.6 cm.)
inscribed lower right: *Tobey 44*
Private collection, Zurich, 1972

Provenance
Willard Gallery, New York
Julia and Lyonel Feininger, New York, 1945
Julia Feininger, New York 1956
Julia Feininger Estate, 1970
Marlborough Gallery, New York

Exhibitions
New York: *Mark Tobey,* Willard Gallery, 13
November to 8 December 1945, cat. no. 9.
Portland 1945-1946, cat. no. 18, ill.
New York: *Fourteen Americans,* Museum of
Modern Art, April 1946, cat. no. 163.
Andover/Utica: *Ten Painters of the Pacific
Northwest,* Addison Gallery of American Art;
Munson-Williams-Proctor Institute, October 1947
to March 1948, cat. no. 43.
San Francisco 1951.
Japan: *Seven American Watercolorists,* The
Second International Art Exhibition, 2 May to
30 September 1953, cat. no. 169.
Venice: *XXVIII Biennale,* assembled by Katharine
Kuh, 1956, plate 21, 28.
Minneapolis: *American Paintings,* Minneapolis
Institute of Art, 18 June to 1 September 1957,
cat. no. 131.
Kassel: *Documenta II, Kunst nach 1945,
internationale Ausstellung,* 11 July to 11 October
1959, cat. no. 1, ill. 406, detail 407.
Paris 1961-1962, cat. no. 35, plate 16.
Washington 1962, cat. no. 8.
New York 1962-1963, cat. no. 32, ill. 64.
New York: *About New York, Night and Day,
1915-1965,* The Gallery of Modern Art, 19 October
to 15 November 1965.
Krefeld, Germany: *Marc Tobey: Rückblick auf
harmonische weltbilder,* Museum Haus Lange,
15 June to 3 August 1975, cat. no. 39.

Vevey, Switzerland: *Painters of Silence,* Museum,
Summer 1981.

Literature
Julia and Lyonel Feininger, "Comments by a Fellow
Artist," *Paintings by Mark Tobey* (Portland/
Detroit, 1945-1946).
Newsweek (10 September 1945), ill. 98.
Coates, "Galleries," 98.
Kenneth Rexroth, *Art News* 50 (May 1951), ill.
16, 61.
Katharine Kuh, *American Artists Paint the City,
XXVIII Biennale, Venice* (Chicago, 1956), plate
21, 28.
Quadrum 1 (1956), ill. 21.
Apollo 68 (December 1958), ill. 217.
Kuh, "Mark Tobey," 30.
Histoire de l'Art (20 January 1976), color ill.
Hoffman, "Tobey's Paintings," 25, ill. 26.
Seitz, *Abstract Expressionist Painting,* fig. 254.

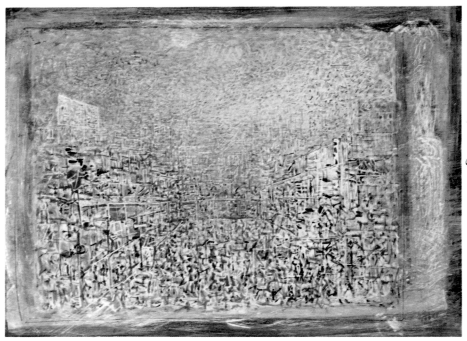

21. (Photo by Adolph Studley)

Miami: *Mark Tobey,* Miami-Dade Community College, 1 December 1975 to 29 January 1976.

Literature
Tobey, "Reminiscence," ill. 228.
"Mystic Painters of the Northwest," *Life* (27 April 1953), color ill. 85.
Tillim, "Review," 50, ill. 49.
Art in America 62 (September 1974), 119.

23
Times Square (New York Patterns), 1944/1948

tempera on wood
11 ¹¹⁄₁₆ x 11 ¹¹⁄₁₆ in. (29.7 x 29.7 cm.)
inscribed lower right: *Tobey '4Y(?)*
Private collection

Provenance
Bjarne Klaussen, Buffalo, New York, 1948
Sotheby Parke Bernet, New York, 1981
Private Collection, London, 1981
Christie's, London, December 1983

Exhibitions
Seattle: *Mark Tobey,* Henry Art Gallery, University of Washington, 20 May to 27 June 1951, as *New York Patterns.*

21
Western Town, 1944

tempera
12⅞ x 18¾ in. (32.7 x 47.6 cm.)
inscribed lower right: *Tobey*
Mr. and Mrs. Paul Feldenheimer, Portland, Oregon, 1946

Provenance
Willard Gallery, New York

Exhibitions
New York: *40 American Moderns,* 67 Gallery, 1944 (organized by Howard Putzel), cat. no. 39.
Portland: *Paintings,* 1945-1946, cat. no. 22, ill.
Andover/Utica: *Ten Painters of the Pacific Northwest,* Addison Gallery of American Art; Munson-Williams-Proctor Institute, October 1947 to March 1948, cat. no. 44.
San Francisco 1951.
Paris 1961-1962, cat. no. 33, plate 14.
New York 1962-1963, cat. no. 27, ill. 63.

Literature
Kochnitzky, "Mark Tobey," 15.

22
Electric Night, 1944

tempera on paper mounted on board
17½ x 13 in. (46 x 34.2 cm.)
inscribed lower right: *Tobey 44*
The Seattle Art Museum, Eugene Fuller Memorial Collection, 1944
color plate 2

Exhibitions
New York 1944.
Portland 1945-1946, cat. no. 28.
San Francisco: Special Exhibition in conjunction with the Western Round Table on Modern Art, San Francisco Museum of Art, 8 to 10 April 1949 ("lent by the artist," but in fact by Seattle Art Museum).
San Francisco 1951.
Houston 1956.
Europe: *American Painting, 1900-1955,* The American Federation of Arts for the United States Information Agency, 1956.
Europe and Asia: *Eight American Artists,* organized by the United States Information Agency, 1957-1958 (at the Institute of Contemporary Art, London, 8 November to 7 December 1957, cat. no. 25).
Seattle 1959-1960, cat. no. 96 (traveling exhibition, cat. no. 45).
Paris 1961-1962, cat. no. 41.
London 1962.
New York 1962-1963, cat. no. 35.

24
Partitions of the City, 1945

opaque watercolor on hardboard
30½ x 23⅞ in. (77.5 x 60.6 cm.)
inscribed lower right: *Tobey 45*
Munson-Williams-Proctor Institute, Utica, New York, Edward W. Root Bequest, 1957

Provenance
Edward W. Root, 1951

Exhibitions
New York: *Mark Tobey,* Willard Gallery, 13 November to 8 December 1945, cat. no. 10.
New York: *1946 Annual Exhibition of Contemporary American Painting,* Whitney Museum of American Art, 10 December 1946 to 16 January 1947, cat. no. 157.
Seattle: *Retrospective,* Henry Art Gallery, 1951, cat. no. 72.
New York 1953.
Paris 1961-1962, cat. no. 43 (traveled to London, Brussels).
Utica/Sacramento: *American Drawings and Watercolors from the Munson-Williams-Proctor Institute,* E. B. Crocker Gallery, Sacramento, 25 October to 24 November 1974, no. 61.

Literature
New York Sun (24 November 1945).
Limited Edition (December 1945).

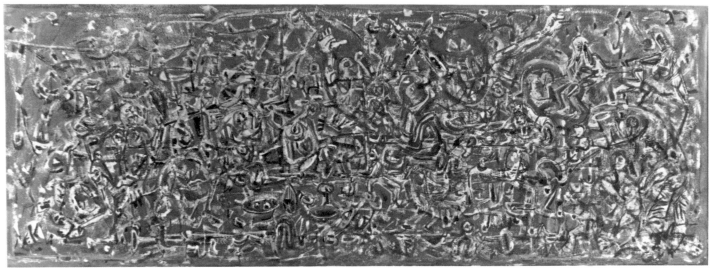

26.

ち 25
Broadway Melody, 1945

tempera on hardboard
24 x 17 in. (61 x 43.2 cm.)
inscribed lower left: *Tobey 45*
The University of Michigan Museum of Art, Ann
Arbor, Gift of Mr. and Mrs. Roger L. Stevens, 1949

Provenance
Willard Gallery, New York

Exhibitions
Chicago: *Mark Tobey,* The Arts Club of Chicago,
7 to 27 February 1946, cat. no. 10.
San Francisco 1951.

26
Celebration, 1945

tempera
7 ⅜ x 18 ½ in. (18.7 x 47 cm.)
inscribed lower right: *Tobey 1945*
Private collection, Little Rock, Arkansas,
November 1979

Provenance
Willard Gallery, New York
Dr. Steven van Riper, Detroit, March 1947
Willard Gallery, New York, December 1977

Exhibitions
Chicago: *Mark Tobey,* The Arts Club of Chicago,
7 to 27 February 1946, cat. no. 9.
Minneapolis: *1946 Purchase Show,* Walker Art
Center, 1946.

ち 27
Lines of the City, 1945

tempera on paper
18 ⅛ x 22 ¾ in. (46 x 57.8 cm.)
inscribed lower right: *Tobey 45*
Addison Gallery of American Art, Phillips
Academy, Andover, Massachusetts, Bequest of
Edward Wales Root, 1957

Provenance
Willard Gallery, New York
Edward W. Root, 1946

Exhibitions
New York: *Mark Tobey,* Willard Gallery, 13
November to 8 December 1945, cat. no. 5.
San Francisco 1951.
Burlington: *Four Pictures and a Bronze,* The
Fourth Annual Festival of Fine Arts, Robert Hull
Fleming Museum, University of Vermont, 6 April
to 7 May 1959.
Paris 1961-1962, cat. no. 59, plate 12.
New York 1962-1963, cat. no. 42, ill. 64.
Amsterdam 1966, Amsterdam cat. no. 21; Bern
cat. no. 21; Düsseldorf cat. no. 22.
Dallas 1968, cat. no. 37, ill.
Boston: *Northwest Visionaries,* Institute of
Contemporary Art, 7 July to 6 September 1981.

Literature
Burlington Free Press, Burlington, Vermont
(6 April 1959).
Artforum 17 (April 1979), ill. 28.
Seitz, *Abstract Expressionist Painting,* fig. 260.

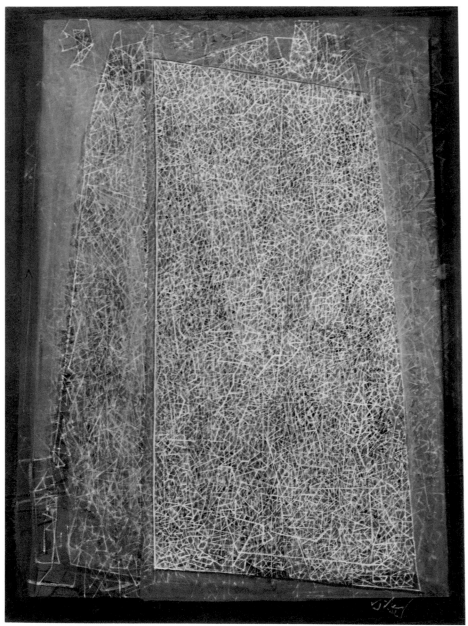

28.

San Francisco 1951.

New York 1953.

Bern: *Tendances Actuelles,* Kunsthalle, 29 January to 6 March 1955, cat. no. 80.

London: *Mark Tobey,* Institute of Contemporary Arts, 4 May to 4 June 1955, cat. no. 17.

Venice 1958, cat. no. 46.

20th Century American Paintings from the Edward W. Root Collection, Smithsonian Institution traveling exhibition, July 1959 to July 1960.

Paris 1961-1962, cat. no. 52 (traveled to London and Brussels).

Washington 1962, cat. no. 12.

New York 1962-1963, cat. no. 47, ill. 25.

New York: *About New York, Night and Day 1915-1965,* The Gallery of Modern Art, 19 October to 15 November 1965.

Amsterdam 1966, Amsterdam, Hannover, Bern cat. no. 22; Düsseldorf cat. no. 24.

Dallas 1968, cat. no. 40.

Washington 1974-1975, cat. no. 12, ill.

Boston: *Northwest Visionaries,* Institute of Contemporary Art, 7 July to 6 September 1981.

Literature

Tiger's Eye 3 (15 March 1948), 77, ill.

Coates, "Galleries," 98.

Robert Beverly Hale, "The Growth of a Collection," *The Metropolitan Museum of Art Bulletin* 11 (February 1953), ill. 161.

Julien Alvard, "Tobey," *Cimaise* (1955), ill.

Schmied, *Tobey,* fig. 28.

Seitz, *Abstract Expressionist Painting,* fig. 261.

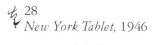

29
Transcontinental, 1946

tempera on paper, mounted on cardboard
27¾ x 20⅞ in. (70.5 x 53 cm.)
Private collection, Europe

Provenance

Willard Gallery, New York

William Elmhirst, Devon, England, 1955 (moved to Potomac, Maryland)

Sotheby Parke Bernet, New York, May 1976

Gustaf Douglas, Stockholm, Sweden, 1976

Exhibitions

New York: *Mark Tobey,* Willard Gallery, 4 to 29 November 1947, cat. no. 3.

Chicago: The Renaissance Society at the University of Chicago, 18 April to 14 May 1952, cat. no. 8.

London: *Mark Tobey,* Institute of Contemporary Arts, 4 May to 4 June 1955.

28
New York Tablet, 1946

tempera and chalk on paper on wood panel
24⅞ x 19 in. (63.2 x 48.3 cm.)
inscribed lower right: *Tobey '46*
Munson-Williams-Proctor Institute, Utica, New York, Edward W. Root Bequest, 1957

Provenance

Willard Gallery, New York

Edward W. Root, 1947

Exhibitions

New York 1947, cat. no. 4.

Utica: *Current Trends in British and American Painting,* Munson-Williams-Proctor Institute, 3 to 31 December 1950, cat. no. 30.

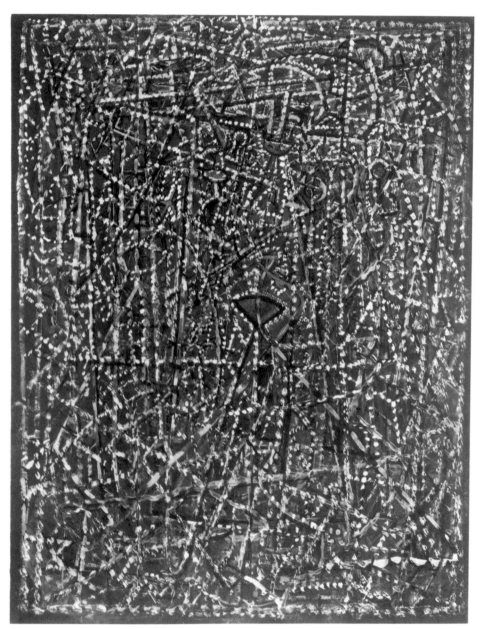

31. (Photo courtesy of Willard Gallery, New York)

30
Electric Tablet (Electric Night), 1947

tempera
15½ x 11⅜ in. (39.4 x 28.9 cm.)
inscribed lower left: *Tobey 47*
Private collection, Santa Rosa, California

Provenance
Windsor Utley, Seattle
Robert Aichele, Carmichael, California, 1968

Exhibitions
San Francisco: *Tobey,* Eliane Ganz Gallery, 16 March to 1 May 1976.
Los Angeles: *Tobey,* Ruth S. Schaffner Gallery, 11 May to 19 June 1976.
Seattle: *Mark Tobey,* Foster/White Gallery, July to August 1978.

31
Blaze of the Century, 1947

tempera
26 x 16 in. (66 x 40.6 cm.)
Location unknown

Provenance
Willard Gallery, New York
Mr. and Mrs. Walter Ross, New York, November 1957

Exhibitions
St. Louis: *Contemporary American Painting,* City Art Museum of St. Louis, 12 November to 10 December 1951.
Boston: Margaret Brown Gallery, June to October 1952.
New York: *Ten American Abstract Painters,* Rose Fried Gallery, 24 March to 10 April 1952 or 1953.
Middletown, Connecticut: *Paintings by John Marin and Mark Tobey,* Davison Art Center, Wesleyan University, 15 May to 2 June 1953.
Lynchburg, Virginia: *46th Annual Exhibition,* Randolph Macon Women's College, Department of Art, 28 April to 4 June 1957, cat. no. 22.

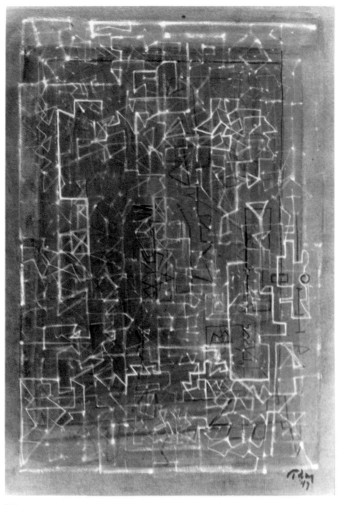

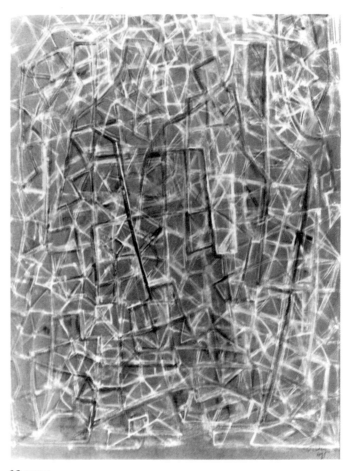

32.

32. verso

 32
Plan of a City, 1947

tempera
22¹³⁄₁₆ x 15¾ in. (58 x 40 cm.)
inscription lower right: *Tobey* 47
Galerie Beyeler, Basel, 1974

This work has an unfinished painting on the
verso that is also inscribed *Tobey 47.*

Provenance
Foster/White Gallery, Seattle

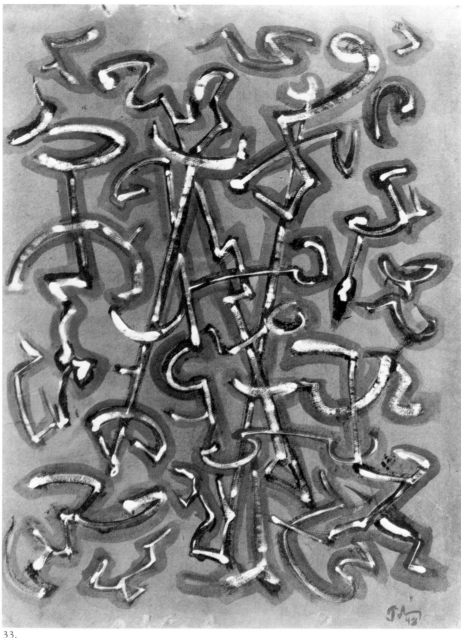

33.

San Francisco 1951, ill.

Washington: *Mark Tobey,* St. Alban's School, 20 May to 3 June 1959, cat. no. 64.

Paris 1961-1962, cat. no. 68, plate 25.

New York 1962-1963, cat. no. 56 (exhibited in New York only).

New York: *Three Centuries of American Painting,* The Metropolitan Museum of Art, 1965.

Dallas 1968, cat. no. 44, ill.

Allentown, Pennsylvania: Allentown Art Museum (on long term loan), October 1975 to October 1976.

Osaka: *Pacific Northwest Artists and Japan,* National Museum of Art, 2 October to 28 November 1982.

Literature

New York Sun (4 November 1949).

Robert Beverly Hale, *100 American Painters of the 20th Century: Works selected from The Metropolitan Museum of Art,* 1950, xxii, plate 104.

Tobey, "Reminiscence," ill. 229.

Life (27 April 1953), ill. 84 in the background of a photograph of Tobey.

Time (13 February 1956), color ill. 62.

Baur, *New Art,* ill. 194.

Geldzahler, *American Painting,* 163, ill. 163.

Apollo 84 (August 1966), ill. 157 (upside down).

A. T. Gardner, *History of Watercolor Painting in America* (New York, 1966), 124, plate 119.

Seitz, *Abstract Expressionist Painting,* fig. 265.

34
Awakening Night, 1949

tempera on fiberboard
20 x 27¼ in. (50.8 x 69.2 cm.)
inscribed lower right: *Tobey 49*
Munson-Williams-Proctor Institute, Utica, New York, Edward W. Root Bequest, 1957
color plate 3

Provenance

Willard Gallery, New York

Edward W. Root, 1949

Exhibitions

New York: *Mark Tobey,* Willard Gallery, 1 to 26 November 1949, cat. no. 7, ill.

Utica: *Current Trends in British and American Painting,* Munson-Williams-Proctor Institute, 3 to 31 December 1950, cat. no. 32.

San Francisco 1951, cat. no. 55.

New York 1953.

Venice 1958, cat. no. 50.

Schenectady: *Five Decades of American Painting,* Union College, September to October 1959.

Paris 1961-1962, cat. no. 73, fig. 73 (traveled to London and Brussels).

Washington 1962, cat. no. 17, cover ill.

New York 1962-1963, cat. no. 61.

Amsterdam 1966, Amsterdam, Hannover, Bern cat. no. 26; Düsseldorf cat. no. 28.

Dallas 1968, cat. no. 48.

Washington 1974-1975, cat. no. 14, ill.

33
Transit, 1948

tempera, ink, wash, chalk on paper
24½ x 19 in. (62.2 x 48.3 cm.)
inscribed lower right: *Tobey 48*
The Metropolitan Museum of Art, New York, George A. Hearn Fund, 1949

Provenance

Willard Gallery, New York

Exhibitions

New York: *Mark Tobey,* Willard Gallery, 1 to 26 November, 1949.

New York: *100 American Painters of the 20th Century,* The Metropolitan Museum of Art, 1950, plate 104.

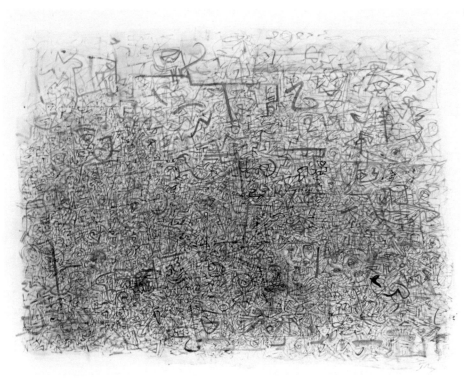

35. (Photo by E. Irving Blomstrann)

Katonah, New York: *American Painting 1900-1976: The American Scene and New Forms of Modernism, 1935-1954,* The Katonah Gallery, 17 January to 14 March 1976, cat. no. 65, ill.
Boston: *Northwest Visionaries,* Institute of Contemporary Art, 7 July to 6 September 1981.

Literature
Janet Flanner, "Tobey, Mystique Errant," *L'Oeil* 6 (15 June 1955), ill.
Life (21 July 1958), color ill.
Roberts, *Tobey* (Paris, 1959), color ill. 21; (New York, 1960), color ill.
Russell, *Tobey,* cat. no. 10, color ill.

35
Broadway Afternoon, 1950

watercolor on paper
18¾ x 25 in. (47.6 x 63.5 cm.)
inscribed lower right: *Tobey 50*
Wadsworth Atheneum, Hartford, The Ella Gallup Sumner and Mary Catlin Sumner Collection
color plate 4

Provenance
Willard Gallery, New York

Exhibitions
New York: *Whitney Museum of American Art Annual, Contemporary Sculpture, Watercolors, and Drawings,* 17 March to 6 May 1951, cat. no. 134.
London: *Mark Tobey,* Institute of Contemporary Arts, 4 May to 4 June 1955, cat. no. 24.
Venice 1958, cat. no. 51.
Paris 1961-1962, cat. no. 81.
New York 1962-1963, cat. no. 64.
Amsterdam 1966, Amsterdam, Hannover, Bern cat. no. 27; Düsseldorf cat. no. 29.
Washington 1974-1975, cat. no. 16, ill.

36
Written Over the Plains, 1950

oil and tempera on hardboard
30⅛ x 40 in. (76.7 x 101.7 cm.)
inscribed lower left: *Tobey 50*
San Francisco Museum of Modern Art, Gift of Mr. and Mrs. Ferdinand C. Smith, 1951
color plate 5

Exhibitions
San Francisco 1951.
Sao Paulo: *III Biennial of the Museum of Modern Art of Sao Paulo,* Museum of Modern Art of Sao Paulo, June to October 1955.
San Francisco/Cincinnati/Colorado Springs/Minneapolis: *Pacific Coast Art: United States' Representation at the 3rd Biennial of Sao Paulo,* 1956.
San Francisco: *Art in Asia and the West,* San Francisco Museum of Art, 28 October to 1 December 1957, cat. no. 280.
Venice 1958, cat. no. 52.
Seattle 1959-1960 (exhibited only at de Young Museum, San Francisco, 24 March to April, not listed in catalogue).
Auckland, New Zealand: *Paintings from the Pacific Northwest,* Auckland City Art Gallery, May 1961, cat. no. 51.
Milwaukee: *Ten Americans,* Milwaukee Art Center, 21 September to 5 November 1961.
New York 1962-1963, cat. no. 63, ill. 71.
Dallas 1968, cat. no. 51.
Washington/Seattle/Portland: *Art of the Pacific Northwest,* National Collection of Fine Arts, 8 February to 5 May; Seattle Art Museum, 12 July to 25 August; Portland Art Museum, 17 September to 13 October, 1974, cat. no. 119, fig. 48, 60.

Literature
San Francisco Museum of Modern Art Quarterly Bulletin, series II, 4 (1955), ill. 41; series II, 5 (1956), ill. 18.
Edmund Feldman, *Art as Image and Idea* (Prentice Hall, 1966), ill. 492.
Norbert Lynton, *Landmarks of the World's Art: The Modern World* (McGraw Hill Book Company, New York, 1965), color ill. no. 91, 45.
Seitz, *Abstract Expressionist Painting,* fig. 274.

37
Aerial City, 1950

watercolor on paper
16⅛ x 18¾ in. (42.5 x 55.3 cm.)
inscribed lower right: *Tobey 50*
Private collection

In 1962 Tobey wrote to Marion Willard: "You may be interested to hear some of dear Feininger's letters about my show, '. . . dear Mark, we saw your latest show, showing chiefly linear expressions, which has always been the vehicle of your especial gift, that of calligraphy. We reacted at

once strongly and happily to your delineating of aerial presentation of vast terrestrial expanses. We feel that with one great stride you have achieved a spatial vision which is at once satisfactory and at the same time convincingly logical, and which I should place far and beyond anything I have knowledge of by contemporary painters. At the same time, they are breathtakingly expressive and beautiful.'" (Quoted in *Tobey,* Phillips Collection, 1962.)

Provenance
Mr. and Mrs. Lyonel Feininger, New York, 1951
Mrs. Lyonel Feininger, New York, 1956

Exhibitions
Boston: Margaret Brown Gallery, 7 to 26 May 1951 (not confirmed).
Milwaukee: Milwaukee Art Institute, early August to late September 1951 (not confirmed).
Europe and Asia: *Eight American Artists,* organized by the United States Information Agency 1957 to 1958 (London, Institute of Contemporary Arts, 8 November to 7 December 1957, cat. no. 27, ill.).
Paris 1961-1962, cat. no. 75, plate 31, traveled to London and Brussels.
London 1962.
New York 1962-1963, cat. no. 66, ill. 70.

Literature
Chevalier, "Une journée," ill. 8.

38
Universal City, 1951

watercolor on paper on hardboard
37½ x 25 in. (95.3 x 63.5 cm.)
The Seattle Art Museum, Gift of Mr. and Mrs. Dan Johnson, 1970

Provenance
Mr. and Mrs. Dan R. Johnson, New York

Exhibitions
New York: *American Vanguards for Paris,* The American Federation of Arts, 1953.
New York: *Exhibition of Works by Newly Elected Members* (of the National Institute of Arts and Letters), American Academy of Arts and Letters, 4 May to 24 June 1956.
Washington: *Mark Tobey,* St. Alban's School, 20 May to 3 June 1959, cat. no. 67.
New York 1962-1963, cat. no. 68, color ill. 29.
St. Louis: *200 Years of American Painting, Bicentennial,* City Art Museum of St. Louis, 1964.
Montreal: *Man and his World,* International Fine Arts Exhibition, Expo 67, organized by National Gallery of Canada, 28 April to 27 October 1967, cat. no. 108.
Dallas 1968, cat. no. 52.
Seattle 1970-1971, cat. no. 58, ill.
Washington 1974-1975, cat. no. 18, color.

Literature
St. Louis Museum Bulletin 48 (1964), ill. 52.

Art News 69 (December 1970), 44, ill. 44.
Art News 73 (September 1974), color ill. 95.
Seitz, *Abstract Expressionist Painting,* color fig. 278.

39
Festival, 1953

tempera and oil on cardboard
39½ x 29½ in. (101 x 75 cm.)
inscribed lower right: *Tobey 53*
The Seattle Art Museum, Gift of Mr. and Mrs. Bagley Wright, 1962

Provenance
Willard Gallery, New York
Miss Virginia Bloedel, 1953

Exhibitions
New York: *Mark Tobey,* Willard Gallery, 1 April to 2 May 1953, cat. no. 9.
Europe and Asia: *Eight American Artists,* organized by the United States Information Agency 1957 to 1958 (London, Institute of Contemporary Art, 8 November to 7 December 1957, cat. no. 28).
Kassel, Germany: *Documenta II, Kunst nach 1945 internationale Ausstellung,* 11 July to 11 October 1959, cat. no. 3.
Seattle: *Seattle Art Museum Mark Tobey Exhibition,* Seattle World's Fair, Fine Arts Pavilion, 1962.
Portland, Oregon: *20th-Century American and European Paintings and Sculpture, Collection of Mr. and Mrs. Bagley Wright,* Portland Art Museum, 1964.
Osaka: *Pacific Northwest Artists and Japan,* National Museum of Art, 2 October to 28 November 1982, cat. no. 123, ill.

40
The Avenue, 1954

tempera on paper board
40 x 30¼ in. (101.6 x 76.8 cm.)
inscribed lower right: *Tobey 54*
Norton Gallery and School of Art, West Palm Beach, June 1958
color plate 7

Provenance
Willard Gallery, New York

Exhibitions
New York: Manufacturers Trust, September to October 1954 (not confirmed).
Collectors Choice, American Federation of Arts, June 1955 to October 1956.
Des Moines: Des Moines Art Center, April 1957 to August 1957.
Venice 1958, cat. no. 57.
New York 1962-1963, cat. no. 871, ill. 74.
New York: *Between the Fairs: 25 Years of American Art 1939 to 1964,* The Whitney Museum of American Art, 24 June to 23 September 1964, cat. no. 129.

41
Traffic I, 1954

tempera on paper
17 x 10½ in. (43 x 27 cm.)
inscribed lower right: *Tobey 54*
Kunstmuseum, Kupferstichkabinett, Basel, 1960
color plate 6

Provenance
Willard Gallery, New York
Mr. Doetch-Benziger, Basel, 1954

Exhibitions
New York: *Mark Tobey,* Willard Gallery, 3 to 27 November 1954.
Bern: *Tendances Actuelles,* Kunsthalle, 29 January to 6 March 1955, cat. no. 92.
Basel: *Sammlung Richard Doetch-Benzinger, Malerei, Zeichnung, und Plastik, des 19 und 20 Jahrhundrets,* Kunstmuseum, 9 June to 8 July 1956, cat. no. 247.
Krefeld, Germany: *Marc Tobey, Rückblick auf harmonische Weltbilder,* Museum Haus Lange, 15 June to 3 August 1975, cat. no. 4.

Literature
Russell, *Tobey,* cat. no. 13, color ill. 39.

42
City Patterns, 1954

tempera
17¾ x 11¾ in. (45 x 30 cm.)
inscribed lower right: *Tobey 54*
Private collection, Brussels

Provenance
Galerie Beyeler, Basel

Exhibitions
Basel: *Mark Tobey,* Galerie Basel, May to June 1961, cat. no. 3, color ill.

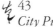
43
City Punctuation, 1954

tempera on paper
17⅜ x 11 in. (44 x 28 cm.)
inscribed lower right: *Tobey 54*
Galerie Jeanne Bucher, Paris, 1958

Provenance
Willard Gallery, New York

Exhibitions
Cincinnati: The Contemporary Arts Gallery, Cincinnati Art Museum, 1958, cat. no. 138.

44.

Provenance

Mr. and Mrs. Leonard K. Elmhirst, 1962/1964

Exhibitions

Amsterdam 1966, Amsterdam, Bern cat. no. 40; Düsseldorf cat. no. 44.

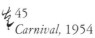

45
Carnival, 1954

tempera

12½ x 17¼ in. (31.8 x 18.4 cm.)

inscribed lower right: *Tobey 54*

Mrs. Joyce Lyon Dahl

Provenance

Joyce and Arthur Dahl Collection, 1955

Exhibitions

San Francisco: Gump's Gallery, 1955.

Carmel: American Federation of Arts Galleries, 1963.

Fresno: Fresno Arts Center, 1965.

Stanford/Lincoln/Chicago/Santa Barbara: *Mark Tobey, Paintings from the Collection of Joyce and Arthur Dahl,* Stanford Art Gallery, Stanford University, 27 June to 20 August 1967; University of Nebraska Art Galleries, 5 September to 1 October 1967; Roosevelt University, 4 to 25 October 1967; The Art Gallery, University of California, 4 to 31 January 1968; cat. no. 18, plate 13.

Dallas 1968, cat. no. 63.

Honolulu: *Mark Tobey, Paintings from the Collection of Joyce and Arthur Dahl,* Honolulu Academy of Arts, 1 February to 29 March 1970.

Portland: Portland Art Museum, 1971.

Seattle: Henry Art Gallery, University of Washington, December 1970 to January 1971.

Seattle: *Mark Tobey,* Foster/White Gallery, 9 to 27 January 1974.

New York: *Tobey,* M. Knoedler & Co., Inc., 10 April to 1 May 1976.

Seattle: *Mark Tobey,* Foster/White Gallery, 6 July to 31 August 1978, cat. no. 36.

Literature

Arts Magazine 49 (December 1974), ill. 16.

Paris: *Tobey,* Galerie Jeanne Bucher, December 1959 to January 1960.

Mannheim: *Mark Tobey,* Kunsthalle, 17 December 1960 to 22 January 1961, cat. no. 17.

Paris 1961-1962, cat. no. 113, plate 5.

Amsterdam 1966, Amsterdam, cover ill.; Hannover cat. no. 35; Bern cat. no. 35; Düsseldorf cat. no. 39.

The paper has yellowed since this work was painted, heightening the contrast with the painted patches of white.

44
Multiple Mansions, 1954

tempera

16½ x 13⅜ in. (42 x 34 cm.)

inscribed lower right: *Tobey '54*

The Dartington Hall Trust, 1965

This work was called *Painting in Pink and Yellow* in an exhibition at Dartington Hall in 1964, but by 1966, when it was exhibited in the Tobey retrospective it was titled *Multiple Man-*

46
Intersection, 1954

tempera on paper

9¹/₁₆ x 11¹³/₁₆ in. (23 x 30 cm.)

inscribed lower right: *Tobey '54*

Private collection, New York, c. 1970?

Provenance

Galerie Jeanne Bucher, Paris

47.

Exhibitions
Paris: *Mark Tobey,* Galerie Jeanne Bucher, 27
November 1959 to 16 January 1960.
Mannheim: *Mark Tobey,* Kunsthalle, 17 December
1960 to 22 January 1961, cat. no. 8.
Paris 1961-1962, cat. no. 110.
Amsterdam 1966, Bern cat. no. 32; Düsseldorf
cat. no. 36.

Literature
Roberts, *Mark Tobey,* Paris, color ill.

47
Golden City, 1956

tempera on paper
24 x 36 in. (61 x 91.5 cm.)
inscribed lower left: *Tobey*
Private collection, Zurich, 1961

Tobey told the current owner that everyone
thought the title *Golden City* referred to San
Francisco, but in reality it was Victoria. He gave
him the impression, moreover, that the painting
had been done in Victoria, British Columbia.

Provenance
Willard Gallery, New York
Galerie Beyeler, Basel, December 1958

Exhibitions
Lynchburg, Virginia: *46th Annual Exhibition,*
Randolph Macon Women's College Department of
Art, 28 April to 4 June 1957, cat. no. 23.

Mexico City: *The First Inter-American Biennale
Exposition of Painting and Graphic Arts,* Museo
Nacional des Artes Plasticas, sponsored by the
Instituto Nacional de Belles Artes, 6 June to 24
August 1958.

Mannheim: *Mark Tobey,* Kunsthalle, 17 December
1960 to 22 January 1961, cat. no. 26, color ill.

Paris 1961-1962, cat. no. 144, plate 39.

Basel: *Mark Tobey,* Galerie Beyeler, May to June
1961, cat. no. 9, color ill.

Amsterdam 1966, Amsterdam cat. no. 52; Bern
cat. no. 53; Düsseldorf cat. no. 58.

Krefeld, Germany: *Marc Tobey, Rückblick auf
harmonische Weltbilder,* Museum Haus Lange,
15 June to 3 August 1975, cat. no. 6.

Literature
Chevalier, "Une journée," ill. 9.

48
Battle of the Lights, 1956

gouache on paper
44½ x 35½ in. (113 x 90.2 cm.)
inscribed lower right: *Tobey 56*
Winston-Malbin Collection, New York

It is interesting to note that Joseph Stella did a painting by the same title of Coney Island. Similarly dense in execution, it reflects, however, a very different sensibility. I have come across no record of Tobey's deliberately borrowing the title from Stella.

Provenance
Willard Gallery, New York
Harry and Lydia Winston Collection, Detroit, November 1958

Exhibitions
Paris: Musée National d'Art Moderne, 28 November to 15 December 1956.
New York: *Guggenheim International Awards,* The Solomon R. Guggenheim Museum, 26 March to 7 June 1957.
Minneapolis: The Walker Art Center, Summer 1957, on loan (not confirmed).
Mexico City: *The First Inter-American Biennale Exposition of Painting and Graphic Arts,* Museo Nacional des Artes Plasticas, sponsored by the Instituto Nacional de Bellas Artes, 6 June to 24 August 1958.
Brooklyn: Brooklyn Museum, Fall 1958.
Detroit: *American Paintings and Drawings from Michigan Collections,* The Detroit Institute of Arts, 10 April to 6 May 1962, cat. no. 195, 11, ill. 30.
New York 1962-1963, cat. no. 94.
New York: *Futurism, A Modern Focus,* The Solomon R. Guggenheim Museum, 1973, cat. no. 109, 200, ill. 201.

Literature
Mark Tobey Retrospective, Musée des Arts Décoratifs (Paris 1961), cat. no. 120, painting never sent to exhibition.
Tillim, "Review," ill. 51.
Kuh, "Mark Tobey," 30.
Gene Baro, "Collector Lydia Winston," *Art in America* (September/October 1967), ill. in photograph of Malbin house interior, 75.

49
Rive Gauche I, 1956

tempera on paper
24½ x 36 in. (61 x 91.4 cm.)
inscribed lower right: *Tobey 56*
Mrs. James H. Clark, Dallas

A painting titled *Rive Gauche* belongs to the Galerie Jeanne Bucher in Paris, and one called *Rive Gauche II* is the most densely painted of the three (present whereabouts unknown).

Provenance
Willard Gallery, New York
Mr. and Mrs. James H. Clark, Dallas

Exhibitions
Venice 1958, cat. no. 63.
Kassel, Germany: *Documenta II, Kunst nach 1945 internationale Ausstellung,* 11 July to 11 October 1959, cat. no. 4.
Dallas 1968, cat. no. 73.
Brooklyn: *Trends in Watercolors Today,* 9 April to 26 May 1957.

50
Suburban Hill, 1957

sumi ink
21¼ x 29⁹⁄₁₆ in. (54 x 75 cm.)
inscribed lower right: *Tobey 57*
Private collection, Zurich, 1959

Provenance
Willard Gallery, New York
Galerie Beyeler, Basel, December 1958

Exhibitions
New York: *Tobey, Sumi Paintings,* Willard Gallery, 12 November to 7 December 1957.
Charlottesville: University of Virginia Art Museum, October to December 1958 (not confirmed).
Basel: *Panorama,* Galerie Beyeler, October to November 1959.
Krefeld, Germany: *Marc Tobey: Rückblick auf harmonishche Weltbilder,* Museum Haus Lange, 8 June to 3 August 1975, cat. no. 64.

51
New York Night, 1957

tempera on paper
36¼ x 24⅜ in. (92.1 x 61.9 cm.)
inscribed lower right: *Tobey '57*
Private collection, New York

Provenance
Willard Gallery, New York
Mr. and Mrs. Hans Arnold, New York, 1957

Exhibitions
Venice 1958, cat. no. 65.

Washington: *Mark Tobey,* St. Alban's School, 20 May to 3 June 1959, cat. no. 74.
New York 1962-1963, cat. no. 101.
Amsterdam 1966, Amsterdam cat. no. 57; Bern cat. no. 59; Düsseldorf cat. no. 63.

52
Red, White, and Blue Town, 1957

tempera on paper
44 x 28 in. (112 x 71 cm.)
inscribed lower left: *Tobey*
Private collection, Soleure/Solothurn, Switzerland, 1959

Provenance
Willard Gallery, New York
Galerie Beyeler, Basel, December 1958

Exhibitions
New York: *The Museum and Its Friends,* The Whitney Museum of American Art, 5 March to 12 April 1959.
St. Gallen, Switzerland/Darmstadt, Germany/ Göteborg, Sweden: *Modern American Painting,* organized by the United States Information Agency, Kunstmuseum; Hessisches Landesmuseum; Göteborgs Konstmuseum.
Basel: *Mark Tobey,* Galerie Basel, May to June 1961, cat. no. 12, ill.
Paris 1961-1962, cat. no. 153.

Literature
John Canaday, "Vibrant Space of Mark Tobey," *The New York Times Magazine,* section 6 (9 September 1962), 70.

53
Electric Dimensions, 1960

tempera
9⅜ x 6¾ in. (24.5 x 17 cm.)
inscribed lower left: *Tobey*
Location unknown

Provenance
Galerie Beyeler, Basel

Exhibitions
Basel: *Mark Tobey,* Galerie Beyeler, May to June 1961, cat. no. 38, color ill.
Paris 1961-1962, cat. no. 222, color plate 75.
Stockholm/Göteborg: *Tobey,* Konstsalongen Samlaren, 21 November to 15 December 1962; Göteborgs Konstmuseum, 11 January to 2 February 1963, cat. no. 20, color ill.
Amsterdam 1966, Bern cat. no. 94, color ill.; Düsseldorf cat. no. 99, color ill.
Basel: *Tobey,* Galerie Basel, December 1970 to February 1971, cat. no. 18.

Literature
C. H. Waddington, "The All-Round View," *Studio International* 173 (March 1967), color ill. 123.

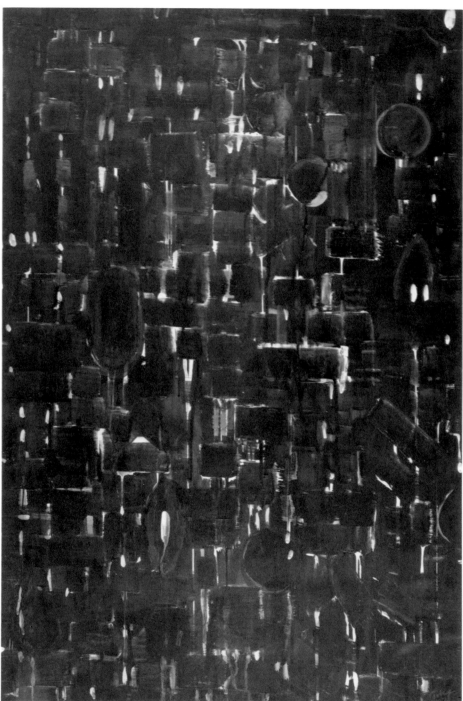

51. (Photo courtesy of Willard Gallery, New York)

54
New York Canyons, 1964

tempera
55¾ x 27½ in. (141.6 x 69.9 cm.)
inscribed: *Tobey 64, Bale*
Dallas Museum of Fine Arts, 1970

Provenance
Galerie Beyeler, Basel
Mr. and Mrs. James H. Clark, Dallas, 1964

Exhibitions
Basel: *Bilanz Internationale Malerei seit 1950,*
Kunsthalle, Summer 1964, no. 122.
Dallas 1968, cat. no. 110.

55
Echoes of Broadway, 1964

tempera
52½ x 25½ in. (133.4 x 64.8 cm.)
inscribed lower right: *Tobey 64*
Dallas Museum of Fine Arts, Gift of Mark Tobey

Exhibitions
Dallas 1968, cat. no. 112, color ill.

56
Ghost Town, 1965

oil on canvas
82¾ x 54 in. (210 x 134.5 cm.)
inscribed lower right: *Tobey*
Willard Gallery, New York

Provenance
Mr. and Mrs. Dan Johnson, New York

Exhibitions
Amsterdam 1966, Bern cat. no. 143; Düsseldorf
cat. no. 140.
Pittsburgh: *1967 Carnegie International,* 27
October 1967 to 7 January 1968.
Dallas 1968, cat. no. 123, ill.
Baltimore: *From El Greco to Pollock: Early and
Late Works by European and American Artists,*
Baltimore Museum of Art, 22 October to 8
December 1968.
St. Paul-de-Vence: *L'Art Vivant Americain,*
Fondation Maeght, 16 July to 30 September 1970.
New York: *146th Annual,* National Academy of
Design, 25 February to 21 March 1971.
Washington 1974-1975, cat. no. 48, color ill.

Literature
Andrei B. Nakov, "Les Americains à Saint-Paul-
de-Vence," *XXe Siecle* 35 (December 1970),
ill. 140.

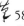 57
Breathing City, 1965

tempera
44 ⅞ x 34 ¼ in. (114 x 87 cm.)
inscribed lower right: *Tobey 65*
Estate of Dr. Victor Hasselblad

Provenance
Galerie Beyeler, Basel
Victor Hasselblad, Göteborg, Sweden

Exhibitions
Basel: *Tobey,* Galerie Beyeler, January to 10 March 1966, cat. no. 20.
Amsterdam 1966, Amsterdam, Hannover cat. no. 122; Düsseldorf cat. no. 133.

Literature
"Recent Paintings by Mark Tobey, an Exhibit at the Gallery Beyeler in Basel," *Stuttgarter Nachrichten* (11 February 1966).

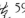 58
Celebration, 1965/1966

oil on canvas
54 ¾ x 35 ½ in. (139 x 90 cm.)
inscribed lower right: *Tobey 66*
Galerie Beyeler, Basel
color plate 8

Exhibitions
Basel: *Tobey,* Galerie Beyeler, January to 10 March 1966, cat. no. 46, color ill.
Amsterdam 1966, Amsterdam cat. no. 131; Bern cat. no. 142, color cover ill.; Düsseldorf cat. no. 142.
Dallas 1968, cat. no. 117.
New York: *Galerie Beyeler at Pace,* November to December 1971.
Düsseldorf/Baden-Baden: *Surrealitat-Bilderealitat,* Stadtische Kunsthalle, 8 December 1974 to 2 February 1975; Kunsthalle, 2 February to 13 April 1975, cat. no. 362, color ill. 29.
Krefeld, Germany: *Marc Tobey: Rückblick auf harmonische Weltbilder,* Museum Haus Lange, 15 June to 3 August 1975, cat. no. 2.
Basel: *Paysages,* Galerie Beyeler, September to November 1975, cat. no. 70, color ill.
Basel: *Lettres et chiffres,* Galerie Beyeler, March to May 1980, no. 92.

Literature
"Recent Paintings by Mark Tobey, an Exhibit at the Galerie Beyeler, in Basel," *Stuttgarter Nachrichten* (11 February 1966).
Russell, *Tobey,* cat. no. 38, color ill.

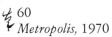 59
Coming and Going, 1970

tempera on cardboard
39 ½ x 27 ½ in. (100.3 x 69.9 cm.)
inscribed lower left: *Tobey 70*
Albright-Knox Art Gallery, Buffalo, Charles Clifton Fund, 1970
color plate 9

Provenance
Galerie Beyeler, Basel

Exhibitions
Buffalo: *Recent American Painting and Sculpture in the Albright-Knox Gallery,* 17 November to 31 December 1972.
Washington 1974, cat. no. 63, color ill.

Literature
John Russell, "Tobey at 80," *Art News* (December 1970) 43, ill. 45.
Tobey (December 1970 to February 1971), Galerie Beyeler, Basel, color plate 83.
Gazette des Beaux Arts (Extrait) 1237 (February 1972), Paris, 186.
Gallery Notes, Buffalo Fine Arts Academy 35 (1971), Albright-Knox Art Gallery, Buffalo, ill. 51.
John Russell, "Painter Tobey, at 83, Still Has a Way with a Line," *Smithsonian* 5 (June 1974), 56, color ill. 57.
American Art in Upstate New York (1974), 55.
"Tobey Tribute," *The Art Gallery* (June 1974), 79, color ill. 79.
Jean Lipman and Helen M. Franc, *Bright Stars, American Painting and Sculpture Since 1976* (E. P. Dutton, 1976), 152, color ill. 152.
Dialogue 10 (1977), United States Information Agency, Washington, D.C., color ill. 61.

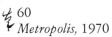 60
Metropolis, 1970

tempera on cardboard
39 ¼ x 27 ½ in. (99.5 x 70 cm.)
inscribed lower right: *Tobey 70*
Galerie Alice Pauli, Lausanne

Provenance
Galerie Beyeler, Basel

60.

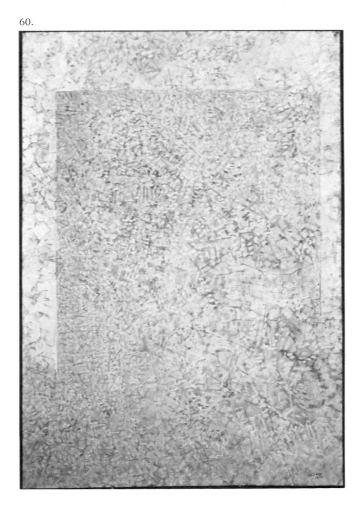

Morris Graves, Mark Tobey, Marion Willard, and Graves' dog, Edith, at the home of Graves, Woodway Park, Edmonds, Washington, August 1949.
(Photo by Mary Randlett)

1890 11 December, Mark George Tobey born, Centerville, Wisconsin, to George Baker Tobey (carpenter, house-builder, and farmer) and Emma Jane Cleveland Tobey. He is the youngest of four children; his two sisters, Crippa and Frances, are eight and six years older than he, and his one brother, Leon, is ten years older.

1893 Moves with family to Tennessee, near Jacksonville.

1894 Moves with family to Trempeauleau, Wisconsin, a village of about 600 inhabitants on the Mississippi River. The Tobey family are devout Congregationalists. One of Tobey's early memories is of a new pair of scissors, with which he wanted to cut out the animals his father drew. Tobey's father also carved animals out of red stone.

1906 The Tobey family moves to Hammond, Indiana. Tobey attends high school, where he is an excellent but erratic student and especially interested in sciences. Tobey's brother learns the building trade, eventually becomes a structural designer; but Tobey, not drawn to his father's profession, is sent to Chicago (twelve miles away) for Saturday classes at the Art Institute. He takes eight classes in watercolor, with Frank Zimmerer, and two in oil, with Professor Reynolds, who tells him he has "the American handling bug." Because his father is ill, Mark leaves high school after two years to look for work.

1909 The Tobey family moves to Chicago. Tobey works as a blueprint boy at Northern Steel Works and takes a course in mechanical drawing. He dreams of becoming a magazine illustrator. He has a series of unsuccessful jobs before finding work as an errand boy at a fashion studio, where he displays talent in drawing girls' faces and is asked to do them for catalogue illustrations. He starts collecting clippings of pictures by such illustrators as Harrison Fisher, Howard Chandler Christy, Charles Dana Gibson. Tobey frequents the Art Institute, where he is particularly impressed by the works of John Singer Sargent, Joaquin Sorolla, and Frans Hals.

1911 Tobey goes to New York, hoping to be a fashion artist. He lives at 21 West 16th Street (Greenwich Village) below Holger Cahill. He goes to work for *McCall's Magazine*. Later that year he returns to Chicago, where he continues to work as a fashion artist.

1913 Tobey sees the Armory Show at the Art Institute of Chicago but "the exhibition has little meaning for him" (Seitz, *Tobey*, 90).

1913- Tobey lives alternately in Chicago and New York. He
1917 starts making charcoal portraits.

1917 17-24 November, first one-man show at M. Knoedler and Co., organized by Marie Sterner.
 He paints walls, lamps, screens, "imitation tapestries," concentrating on interior decoration.
 He takes two private lessons from Kenneth Hayes Miller.

c.1918 At dinner at Marie Sterner's Tobey meets portrait painter, Juliet Thompson, who is a follower of the Bahai World Faith. She invites Tobey to visit her friend Harry Randall at Little Boar's Head, Maine. In nearby Greenacre Tobey is introduced to a gathering of Bahais and becomes deeply interested in this new

religion. Tobey stays three months in Maine before returning to New York, where he has a studio in Washington Square.

Tobey visits Marcel Duchamp.

1918 11 November, Tobey celebrates the armistice with Janet Flanner.

1919-
1920
Tobey begins seeking ways to get away from Renaissance space; wants to smash forms and break them up. He paints a work which he calls *Descent into Form* (now lost), which in some respects presumably adumbrates his painting to come.

1920s *An Exhibition of Portraits and Interpretative Paintings by Stewart Reinhart and Mark Tobey*, at St. Mark's Hall, St. Mark's-in-the-Bouwerie, includes ten works by Tobey.

Tobey remembers the twenties as a period of confusion and brillance.

He draws caricatures, particularly of theater personalities, some of which are published in the *New York Times*.

Tobey does three lithographs based on burlesque and Harlem dancers.

c.1920 Tobey participates in the Inje-Inje movement, which proposed a return to simplicity in art, founded by Holger Cahill. Alfred Maurer also joins.

Tobey marries, but the marriage lasts less than a year.

1922 Tobey draws burlesque, vaudeville, Harlem dancers, and prostitutes in New York.

Persuaded by a New York friend, George Brown, a native of Seattle, Tobey leaves New York and travels across the country by train to Seattle, to look for a job teaching art at the Cornish School, run by Miss Nellie Cornish.

In Seattle Tobey resides at the Marne Hotel.

1923-
1924
Tobey meets Teng Kuei (Kuei Dunn), a Chinese student at the University of Washington, who is himself an artist and introduces Tobey to Chinese brushwork.

Tobey is included in the *Ninth Annual Exhibition of the Seattle Fine Arts Society* (represented by four paintings).

1925 In June Tobey goes to Europe, settles in Paris on the rue de la Santé, meets Gertrude Stein, frequents the Louvre and the Musée des Arts Décoratifs, where he sees the Indian dancer, Rudi Shankar, perform in the evenings.

Tobey spends time in the winter with American friends, the Sanders, at their house near Chateaudun; he visits Chartres cathedral often.

1926 In January Tobey cruises with the Sanders in the Mediterranean, stopping at Barcelona, Greece, Constantinople, Beirut. He makes his first pilgrimage to Haifa, the International Bahai World Center, Mt. Carmel, and to the Bahai shrines at Acca and Sinai. He becomes interested in Persian and Arabic calligraphy. They stop in Cairo.

Tobey returns to Paris in February, where he lives on the rue Visconti.

1927 Tobey returns to Seattle.

Robert Bruce Inverarity studies with Tobey in Seattle; Tobey and Inverarity share a studio in the ballroom of a private house near the Cornish School. At this time Tobey is very interested in sculpture, and, inspired by a high school project of Inverarity (twenty years his junior), he carves about 100 pieces of soap sculpture, one of which is later cast in brass by Howard Putzel.

1927-
1929
Tobey lives in Seattle, but travels regularly to Chicago and New York where he spends a good deal of time. In New York he sees Teng Kuei again.

1928 Tobey and Mrs. Edgar Ames found the Free and Creative Art School in Seattle. In August Tobey and Inverarity go to Emily Carr's studio in Victoria to teach and stay about two to three weeks.

Tobey meets Howard Putzel.

24-31 December, *Paintings, Watercolors, and Drawings by Mark Tobey* at the Arts Club of Chicago.

1929 30 June, Tobey requests entry blanks for Carnegie International. He is living in Chicago at 61 Cedar Street and is very hard up for money.

2-31 December, Tobey one-man show at Romany Marie's Café Gallery (interior designed by Buckminster Fuller); thirty-one works by Tobey exhibited. Alfred Barr, Jr., selects pictures from the show for the Museum of Modern Art's *Paintng and Sculpture by Living Americans*.

Tobey returns to Seattle.

1930 Tobey one-man show at the Cornish School, Seattle.

Tobey leaves Cornish School to go to Dartington Hall in Devon, England, a school founded and run by Leonard and Dorothy Elmhirst. This switch was suggested to Tobey by Beatrice Straight (daughter of Dorothy Elmhirst by her first marriage), who was studying at

the Cornish School. He stops in New York along the way.

13 March-2 April, Paul Klee exhibition, Museum of Modern Art, New York.

In October, Muriel Draper writes the first article on Tobey ("Mark Tobey," *Creative Art 7,* sup. 42-44) in which she states, "The essential power of his work is in his control of form and his force of rhythm. When these combine, his painting emerges with full conviction. . . . This makes him, in spite of himself, an important painter, and one of the significant artists of America."

2 December-20 January, 1931, *Painting and Sculpture by Living Americans,* Museum of Modern Art, New York, includes three paintings by Tobey.

1931 17 February-18 March, Tobey one-man show, organized by Marshal Landgren, at the Contemporary Arts Gallery (directed by Emily Francis Jacob), 12 East 10th Street, New York. Marsden Hartley writes the introduction:

> Mark Tobey is a man who lives every moment, and by living is meant not only acting so much himself as letting life act every moment upon him. He visualizes every sensation plastically and gives the plastic sense of his encounter; and is not troubled as to how his pictures are, for he is not a repetitionist. . . . He is a searcher and a revealer of the inner condition.

21 February-14 March, Harvard Society for Contemporary Art, Cambridge, *Americans,* includes work by Tobey.

19 May-31 August, *Retrospective* at Contemporary Arts Gallery, New York, a group show of twenty-seven paintings, includes three by Tobey.

In June (?) Tobey departs from New York for England on the *Brittania*. Marshal Landgren and other friends see him off.

August, *Drawings and Watercolors by Mark Tobey* at Harry Hartman Bookstore Gallery, Seattle.

About 1 October, Tobey arrives at Dartington Hall, expecting to stay about ten months.

1932 Bernard Leach comes to live and teach at Dartington Hall, meets Tobey.

Spring to fall, Tobey goes to Mexico, sponsored by the Elmhirsts. Sees Marsden Hartley there, as well as Martha Graham. Also travels in Europe.

1933 Tobey does figure drawings on wet paper at Dartington Hall.

In June, Seattle Art Museum opens to the public.

Tobey paints frescos at Dartington Hall.

In the fall Bernard Leach is invited by the Japanese "craftsmen," including his friend from his childhood in Japan, Yanagi Soetsu, to revisit them the following spring. Two days later, the Elmhirsts ask Leach if he would like Tobey to go with him.

Tobey and Leach remain lifelong friends. A year after Tobey leaves Dartington Hall, Leach becomes a member of the Bahai faith, to which he was introduced by Tobey (letter to Arthur Dahl, Archives of American Art).

1934 In February Tobey rents a pianoforte from Bluthner & Co., Ltd. (Wigmore Street, London).

6-24 February, *Paintings and Drawings by Mark Tobey* at Beaux Arts Gallery, Bruton Place, London, consists of thirty-six oils and gouaches.

In early March Leach and Tobey set sail at Dover, cross the Channel to Calais, spend a few days in Paris, and continue to Rome. Tobey visits Pompeii, where the Villa of the Mysteries impresses him.

18 March, Leach and Tobey set sail from Naples, continuing, by way of Aden, to Colombo (where they go briefly ashore), thence on to Hong Kong. They spend a week in Hong Kong.

In April Tobey and Leach take a steamer from Hong Kong to Shanghai.

25 April, Tobey is staying with his friend Teng Kuei at 364 rue Lafayette in Shanghai. Leach leaves Tobey in Shanghai and goes on ahead of him to Japan.

June/July, Tobey spends a month in a Zen monastery outside Kyoto. An edition of thirty drawings on wet paper, executed in England, is published in Japan. The edition was confiscated and destroyed by Japanese authorities, and only a few sets remain in existence.

9 July, Tobey is in Kyoto (at the Kyoto Hotel).

Mid/late July, Tobey goes to San Francisco, where he takes a hotel room for a couple of months and paints a series of animals under moonlight and a watercolor called *San Francisco Street.* (In his interview with William Seitz in 1962, Tobey states that he arrived in San Francisco in June 1934. This is not possible, however, since he wrote letters from the Kyoto Hotel in July, and we can assume it was not until mid to late July that he arrived in San Francisco.)

In late September, Tobey goes to Seattle.

15 October, Tobey's one-man show at the Paul Elder Gallery in San Francisco, arranged by Howard Putzel.

Tobey, however, was not there.

7 November to 9 December, Tobey show at Seattle Art Museum, including watercolors done in China and San Francisco and some portraits.

17 December, Tobey in Seattle.

1935 In February Tobey writes to Dorothy Elmhirst: "Japan stands out over all the rest."

January/February, Tobey in New York, hoping for a gallery, and living in a furnished room on 86th and Park Avenue.

In April, the dealer J. B. Neumann is encouraging.

5 June, Tobey is in Washington, D.C., and visits the Phillips Collection. Writes to Dorothy Elmhirst of his interest in Lawrence Binyon's *The Spirit of Man in Asian Art* of which Tobey notes: "just out and very inspiring."

By late June Tobey is in New York.

In July Tobey is in Jasper, Alberta.

In about October Tobey returns to Dartington Hall.

November to December, Tobey paints *Broadway Norm*, *Broadway*, and *Welcome Hero*.

25 November to 14 March, 1936, *International Exhibition of Chinese Art* at Burlington House, the Royal Academy, London, which Tobey saw and lectured about.

Tobey makes a trip to Haifa to the Bahai Shrines(?)

1936 The East River Gallery in New York becomes the Willard Gallery and gives Lyonel Feininger his first show in the United States.

Tobey returns to the U.S. in the summer for a few months to give art classes in Tacoma, Washington, at the instigation of Helen Keen and Mrs. Hooker.

In October, John Marin retrospective opens at Museum of Modern Art, New York.

1937 Tobey is back at Dartington Hall but returns to Seattle again in the summer to teach.

1938 In April Tobey goes to New York, and in late June or July to Seattle.

July/August, Amedée Ozenfant teaches at University of Washington, Seattle.

In August Tobey gives art classes to Helen Keen and others.

In mid-September Tobey goes back to New York, expecting to continue on to Dartington Hall, but is forced to stay in America due to mounting tensions in Europe.

In November Tobey is in Waterford, Connecticut, visiting a friend.

In mid-December Tobey is in New York City.

Willard Gallery becomes Willard-Neumann Gallery with addition of J. B. Neumann.

In mid-December Tobey is in New York.

In late December Tobey is back in Seattle and starts working on the WPA project, under the supervision of Robert Bruce Inverarity, state director of the Federal Art Project Administration.

1939 Tobey collects old *Asia* magazines, gathering articles on art.

Sometime early this year, Tobey's paintings and other possessions sent to him from Dartington Hall, arrive in Seattle.

10 May, Tobey shows his paintings to Ozenfant, who has returned to Seattle to teach.

Tobey is working on WPA. At this time he expresses interest in doing a mural project and submits a proposal for a mural for the front hall of the University of Washington's chemistry building. His proposal is rejected. Robert Bruce Inverarity later does the mural himself.

11 June (Sunday), picnic at Charles and Nancy Wilson Ross' on Hood Canal, with Ozenfants and Ambrose and Viola Patterson.

Later in June Tobey goes to Geyserville, California, to attend a Bahai summer school, where he spends the rest of June and July. He is absent from the WPA project longer than the time allowed, so Inverarity drops him.

In August Marion Willard visits Nancy Wilson Ross in Seattle. Miss Willard sees work by Tobey and Graves in a WPA exhibition and asks to meet them. Mrs. Ross takes her to each of their studios. At Tobey's, Miss Willard sees *Broadway* and other paintings of the *Modal Tide* type and buys *Broadway*.

1939-
1940 Tobey meets Pehr Hallsten, in Ballard, near Seattle, by enrolling in a YMCA French course that the Swede is teaching. They become friends, and Pehr subsequently shares a house with Tobey in Seattle and later in Basel.

In the winter Tobey paints murals (now in the Seattle Art Museum) for the music/living room of Mrs. John Baillargeon at 3801 Prospect Street, Seattle.

Tobey, on far left, picnicking with Charles and Nancy Wilson Ross, as well as Ambrose and Viola Patterson and Amedée and Madame Ozenfant, at the Ross' home on Hood Canal, Seattle, 1939. (Photo by Ambrose Patterson, courtesy of Viola Patterson)

1940 Tobey one-man show at Arts Club of Chicago.
 Wins Baker Memorial Award in *Northwest Annual Exhibition,* Seattle Art Museum, for *Modal Tide.*
 25 April-26 (?) May, Art Institute of Chicago, *19th International Exhibition of Watercolors* includes work by Tobey.
 In the fall teaches art classes to Helen Keen and others.

1941 1 October-2 November, *27th Annual Exhibition of Northwest Artists*, Seattle Art Museum, includes three works by Tobey.
 In December Tobey begins piano and music theory lessons with Berthe Poncy Jacobson in Seattle.

1942 April/May, Tobey one-man show at Seattle Art Museum.
 In the summer meets Arthur and Joyce Dahl at the Bahai summer school in Geyserville. They become

great admirers and collectors of his work, at one time owning ninety works by Tobey.

Morris Graves is represented by nineteen works in *Americans 1942*, at the Museum of Modern Art, New York. (Tobey is not included in this exibition.)

7 October-8 November, *28th Annual Exhibition of Northwest Artists*, Seattle Art Museum, includes three paintings by Tobey.

3-28 November, Morris Graves show at Willard Gallery. (Marion Willard gives Graves a show before giving one to Tobey because she doesn't like Tobey's *Modal Tide* style.)

Tobey meets Windsor Utley, a painter and musician, with whom and for whom he later composes pieces for piano and flute.

7 December-22 February 1943, *Artists for Victory* at the Metropolitan Museum of Art in New York. Marion Willard enters Tobey's *Broadway*, and it wins

Tobey dressed up to look like the dowager empress of China, at the home of Charles and Nancy Wilson Ross, Seattle, 1939/1940.
(Photo courtesy of Viola Patterson)

sixth prize, a purchase prize whereby it becomes part of the Metropolitan Museum's collection. (Tobey is not in New York to see the exhibition.)

Elizabeth Bayley Willis begins to work at Willard Gallery where she stays for the next five years. She shows Tobey's work to Sidney Janis and interests him enough to write the foreword to the catalogue of

Tobey's first show at the Willard Gallery in 1944. She begins selling works by Tobey to Edward Root in 1943 from a back room in the gallery.

1943 January-February, Feininger show at Willard Gallery.

17 November-6 February 1944, *Romantic Painting in America* at the Museum of Modern Art includes Tobey, cat. no. 194, *Flow of the Night*, 1943. (The show also included four works by Morris Graves, all of which had been purchased by the museum.)

1944 11 January-5 February, *Morris Graves,* Willard Gallery, New York.

4-29 April, Tobey's first show at the Willard Gallery, New York, for which Sidney Janis writes an introduction, consists of nineteen paintings.

In the 1 April 1944 issue of *Art Digest,* Maude Riley reviews the show at Willard Gallery, using the term "white writing," the first appearance of this term in Tobey literature, a term by which his work eventually becomes known.

In *The Nation* (22 April 1944, 495), Clement Greenberg begins his art column, "The showing of Mark Tobey's latest paintings deserves the most special notice" and goes on to say that Tobey has "already made one of the few original contributions to contemporary American painting."

29 November-30 December, *Exhibition of Abstract and Surrealist Art in America*, Mortimer Brandt Gallery, New York, includes Tobey (in the surrealist group) represented by *Threading Light* (1942).

1945 March-April, Tobey is included in the *13th International Watercolor Exhibition* at the Brooklyn Museum, New York.

7 July-12 August, *Paintings by Mark Tobey,* thirty-one works, with catalogue essays by Julia and Lyonel Feininger and by Tobey, opens at the Portland (Oregon) Museum of Art, and travels to San Francisco, Chicago, and Detroit.

Jeanne Bucher, who eventually becomes Tobey's dealer in Paris, buys Tobey's *Animal Totem* and takes it back to France with her. It is probably the first mature work by Tobey to arrive in France.

3 October-4 November, *31st Annual Exhibition of Northwest Artists*, Seattle Art Museum, includes two paintings by Tobey.

November/December, Tobey's *Rummage* awarded 4th prize in the *2nd Annual Portrait of America Exhibition* (sponsored by Pepsi Cola), which opened at the

International Building at Rockefeller Center, New York, and circulated to eight cities in the U.S.

13 November-8 December, *Tobey Exhibition* at the Willard Gallery (catalogue introduction by Julia and Lyonel Feininger). Tobey's paintings are grouped as War, City, Indian, or Religious. *New York*, *City Radiance*, *Lines of the City*, and *Partitions of the City* are included in the show.

27 November-10 January 1946, *Whitney Museum Annual* includes works by Tobey.

1946 January-February, Feininger show at Willard Gallery.

January (or January 1947), in a warehouse fire in Montana, five works by Tobey are destroyed, including *The 1920s (Welcome Hero)* and *Transition to Forms*. (In Seitz [*Tobey*, 1962] the fire is dated 1947, whereas in the Willard Gallery files on the 1920s, it is dated January 1946.)

In January, Tobey included in *Modern Religious Paintings* at Durand-Ruel Galleries in New York.

7-27 February, *Mark Tobey* at Arts Club of Chicago, with eighteen works.

April, Tobey included in *Fourteen Americans* at Museum of Modern Art, New York, cat. nos. 156-169.

1947 4 March-15 April, Tobey included in the *9th Annual Exhibition of Paintings by Artists West of the Mississippi*, at the Colorado Springs Fine Arts Center.

1 October-2 November, Tobey is represented by two works in the *33rd Annual Exhibition of Northwest Artists*, Seattle Art Museum,

October-December, *Contemporary Paintings from Britain, U.S., and France*, Art Gallery of Toronto, includes Tobey.

4-29 November, *Tobey, Recent Paintings*, at Willard Gallery, New York, includes *Electric City*, *Transcontinental*, *New York Tablet*, and *Blaze of Our Century*.

October 1947-March 1948, *Ten Painters of the Pacific Northwest*, Munson-Williams-Proctor Institute (January-April, 1947) includes: cat. nos. 40. *Rummage*, 41. *Two Men*, 42. *E Pluribus Unum*, and catalogue reference to *City Radiance*, p. 4.

Exhibition traveled to Phillips Academy, Andover, Mass.; Albany Institute of History and Art; Albright-Knox Art Gallery, Buffalo; and Baltimore Museum of Art.

6 December-25 January 1948, *Whitney Annual of Contemporary American Painting* includes one work by Tobey.

1948 6-31 January, at Rotunda Gallery, San Francisco, Tobey included in group show with Guy Anderson, Kenneth Callahan, W. Isaacs Patterson, and Hassel Smith.

6 October-7 November, *34th Annual Exhibition of Northwest Artists*, Seattle Art Museum, includes two works by Tobey.

Sometime between January 1948 and April 1949, Tobey moves from 4213½ University Way, Seattle, to 4743 Brooklyn Avenue, Seattle.

Around this time Tobey begins to use a space over a hardware store as a studio. It was located on an alley between Brooklyn Avenue, N.E., and University Way (between N.E. 47th and 50th Streets). It had windows facing west, so Tobey usually painted in the morning, until mid-afternoon. The contents of his studio have been described, "Tobey kept a great collection of paintings, objects of art, books, American Indian artifacts, and interesting or amusing brickabrack. He loved the textures of sea-shells, of tree-bark, of ceramic pieces" (Arthur and Virginia Barnett papers, Archives of American Art).

He also kept a record player and a collection of records there. Tobey kept this studio even after he moved to Basel in 1960 and continued to use it on return visits to Seattle for several more years.

1949 8-10 April, Western Round Table on Modern Art, San Francisco, sponsored by the San Francisco Art Association: director, Douglas McAgy; chairman, Mrs. Lindner; moderator, Dr. George Boas; artists, Marcel Duchamp, Mark Tobey. Other participants, Andrew Ritchie, Gregory Bateson, Kenneth Burke, Alfred Frankenstein, Robert Goldwater, Frank Lloyd Wright, Darius Milhaud, and Arnold Schoenberg (not present). Abstract of the proceedings edited by Douglas McAgy, published by the San Francisco Museum of Art Association. Works exhibited during conference at San Francisco Museum of Art, where the conference was held, include Tobey's *Electric Night* and *Mockers No. 2*.

2 April-8 May, *Whitney Annual of Contemporary American Painting*, New York, includes one Tobey.

16 May-4 June, *Morris Graves . . . Mark Tobey*, Margaret Brown Gallery, 240-A Newberry Street, Boston. First Boston exhibition, courtesy of Willard Gallery, New York.

Toby at play, c. 1939. (Photo courtesy of Nancy Wilson Ross)

Toby at play, c. 1939. (Photo courtesy of Nancy Wilson Ross)

Jeanne Bucher offers Tobey a one-man show in Paris. In the summer Tobey meets Wesley Wehr, who tutors him in musical composition.

The Intrasubjectives at Samuel Kootz Gallery, New York, includes Tobey's *Geography of Fantasy* and Graves' *Joyous Young Pine*. Also included are Reinhardt, Baziotes, Gorky, de Kooning, Gottlieb, Hofmann, Rothko, Pollock, Motherwell, Tomlin.

1-26 November, *Tobey*, at Willard Gallery.

16 December-5 February 1950, *Whitney Annual of Contemporary American Painting*, New York.

1950 In the early 1950s Tobey meets Otto Seligman, a Viennese, who later becomes his dealer.

Tobey meets Charles Seliger.

Tobey's own musical compositions are publicly performed (and recorded) by Windsor Utley and Lochrem Johnson in Seattle.

12 May, Bernard Leach visits Tobey in Seattle.

14 September, Tobey is in San Francisco.

1951 Josef Albers, head of Yale University Art Department, invites Tobey to spend three months as guest critic for the graduate art students' work.

23 January-25 March, *Abstract Painting and Sculpture in America*, at the Museum of Modern Art, New York, includes Tobey's *Tundra*.

17 March-6 May, *Whitney Annual of Contemporary American Sculpture, Watercolors, and Drawings* includes Tobey, cat. no. 134, *Broadway Afternoon.*

31 March-6 May, *Retrospective Exhibition of Paintings by Mark Tobey*, California Palace of the Legion of Honor. Traveled to Seattle, Santa Barbara, and New York.

Film, *Mark Tobey: Artist,* with Tobey's own script and music as sound track, made by Orbit Films, Seattle, directed by Robert G. Gardener.

2 November, Tobey in New York, planning to return to Seattle in about a week.

1953 1 April-2 May, *Mark Tobey,* Willard Gallery, includes *The Street* and *Festival.*

9 April-29 May, Whitney Museum of American Art, *Annual Exhibition of Contemporary American Painting*.

21 April, Tobey in New York.

16-23 July, Tobey included in group exhibition at Galerie Craven, Paris.

Tobey reading Eugen Herrigel's *Zen in the Art of Archery*.

15 October-16 December, *Whitney Annual of Contemporary American Painting* includes Tobey.

Otto Seligman opens his gallery in Seattle.

Pehr paints his first picture, Tobey encourages him to continue.

1953-
1954 Claire Falkenstein tapes a conversation among herself, Michel Tapié, Yvonne Hagan, and Tobey, in Paris.

1954 In January, Tobey in Seattle.

From February to June Tobey lives on Irving Place in New York. This is a very productive period for Tobey. In March he begins working on his Meditation series. Sometime during 1954 Tobey does two numbered series of paintings, one called *New York,* the other called *Lights.*

In the summer *Abstract Japanese Calligraphy,* exhibition at Museum of Modern Art, New York.

From August to early September Tobey in Sweden with Pehr.

21 September-31 October, *Work in Progress: Paintings by Lee Milliken and Mark Tobey*, Detroit Institute of Arts. Tobey represented by six works.

In October Tobey goes to Paris, where he lives until June of the following year. There he paints intensively, doing small works because he is living in a small room in a pension without very good light. Tapié was supposed to arrange a studio for Tobey but never got around to it.

Tobey meets Georges Mathieu who becomes an enthusiastic promoter of his work.

3-27 November, *Mark Tobey, Recent Paintings*, at Willard Gallery (paintings from the spring of 1954, which Tobey spent in New York), includes six paintings by Tobey.

In November, Tobey's first one-man show at Otto Seligman Gallery, Seattle.

5-30 November, *Exposition Mathieu* at Galerie Rive Droite, for which Tobey wrote a short statement about Mathieu's work in the catalogue.

Tobey at the home of Graves, Woodway Park, Edmonds, Washington, August 1949. (Photo by Mary Randlett)

Marion Willard requests big paintings (and repeatedly thereafter).

In December Bernard Leach visits Tobey in Paris, stopping over one night on his way back to England from Haifa.

1955 From mid-January to mid-February, small retrospective exhibition of work by Tobey at the Art Institute of Chicago.

12 January-20 February, *Whitney Annual of Paintings, Sculpture and Drawings* includes Tobey.

29 January-6 March, *Tendances Actuelles,* Kunsthalle, Bern, includes Jackson Pollock, Georges Mathieu, Bryen, Wols, and Tobey. Tobey, cat. nos. 78-109, including *New York Tablet, Awakening Night, Broadway Afternoon, Traffic.*

16 January, Tobey writes from Paris to Otto Selig-

man, "I am trying to save a little money by painting Tapié some things but so far I haven't made anything big enough for him and he likes 'oil.'"

30 January, Tobey is in Basel and travels to Bern to see the *Tendances Actuelles* exhibition.

In February, Tobey goes to the south of France, stays in and around Nice, but is back in Paris by 14 March.

17 February-15 March, Tobey exhibition of paintings from 1954, organized by Seligman, at Gumps Gallery, San Francisco.

18 March-9 April, Jeanne Bucher, who had seen Tobey's paintings in America in 1945 and had offered him a show as early as 1949, finally introduces Tobey's work to Paris in his first one-man show there at her gallery on the Blvd. Mont Parnasse. The ensuing critical acclaim far exceeds any he has ever received in his own country.

During the spring Tobey feels well liked in Paris and is occasionally tempted to get an apartment and settle there. But he also feels lonely living there. Janet Flanner takes Tobey to visit Alice B. Toklas, who tells him he has "penetrated perspective," a comment he clearly appreciates as he later speaks of his efforts to "penetrate perspective" and "bring the far near."

25 April-20 May, *Recent Paintings by Mark Tobey* (courtesy of Otto Seligman Gallery), Paul Kantor Gallery, Los Angeles.

4 May-4 June, Tobey retrospective at Institute of Contemporary Art, London. From London, Patrick Heron writes for *Arts Digest* (1 July 1955): "Tobey's pioneering is obvious, the courage and orginality no less than the exquisite economy of his 'white writing' was greatly appreciated by many painters."

May-10 June, Tobey is in London; he also visits Bernard Leach at St. Ives, Cornwall.

10 June, Tobey returns briefly to Paris.

22 June, Tobey embarks on the *New Amsterdam* to return to America. Arrives in New York at the end of June.

In July Tobey visits the Feiningers in Stockbridge.

9 November-8 January 1956, *Whitney Annual of Contemporary American Painting* includes Tobey.

1956 In January Tobey returns to Seattle.

13 January, Lyonel Feininger dies in Manhattan at the age of eighty-four. This is a great loss for Tobey.

In March Tobey is included in an exhibition *American*

Painting at the Tate Gallery, London, with Rothko, Still, de Kooning, Pollock, Motherwell, and Kline. This was the first time the new American painting had a real impact in England.

In mid-April Tobey travels to Portland and San Francisco (where he stays with his sister).

18 April-10 June, *Whitney Annual of Sculpture, Watercolors, and Drawings* includes Tobey.

In May Tobey elected to National Institute of Arts and Letters. Receives Guggenheim International Award for *Battle of the Lights.*

28 May-20 June, Tobey exhibition at Margaret Brown Gallery, Boston.

9 July, Tobey arrives in New York. Pehr and Wesley Wehr are in New York with him. (Pehr has come from Europe.) They visit Charmion von Wiegand and Charles Seliger.

25 September, Tobey returns to Seattle.

16 June-31 October, *XXVIII Biennale,* Venice, U.S. representation: *American Artists Paint the City,* including Tobey's *Neon Thoroughfare,* 1953 (plate 5); *San Francisco Street,* 1941 (plate 32); *City Radiance,* 1944 (plate 21); *Inner City,* 1945.

14 November-6 January 1957, *Whitney Annual of Sculpture, Paintings, Watercolors, and Drawings* includes Tobey.

During the winter of 1956-1957, Tobey produces very little. In January, he is reading Suzuki on Zen and by spring is seeing a good deal of his Japanese friends in Seattle: a Zen master Takizaki, "a connoisseur of Japanese art, a wise and knowledgeable man with whom Tobey loved to talk" (Virginia Barnett, in Arthur and Virginia Barnett papers, Archives of American Art), and the artists Paul Horiuchi and George Tsutakawa. Horiuchi and Tsutakawa offer him sumi brushes and ink to try. In March and April Tobey does sumi flung ink painting, saving somewhere from fifty to ninety of them, and throwing away the rest. (Paul Horiuchi says he kept ninety altogether. I only know of fifty. By all accounts, he discarded as many as he saved.) Tobey does this type of sumi painting for only this brief period.

1957 In September Tobey goes to New York. He talks with Seliger about his astrologer and also about the telescope and the microscope and the new vision of today.

24 September, Seliger gives a farewell dinner for Pehr, who leaves for Europe the next day.

Tobey's studio, Seattle, 1970s. (Photo by Kevin Tomlinson, Mark Tobey Papers, Archives of American Art, Smithsonian Institution)

Tobey's studio, Seattle, 1970s. (Photo by Keven Tomlinson, Mark Tobey Papers, Archives of American Art, Smithsonian Institution)

27 September, Tobey's sumis are being framed.

3 October, Mathieu is in New York, and he and Tobey lunch together.

20 October, Tobey gives Seliger Okakura's *The Rook of Tea.*

12 November-7 December, *Sumi paintings by Mark Tobey* at the Willard Gallery.

In late November Tobey, with Pehr, who is recently back from Sweden, returns to Seattle.

In November Tobey presents a paper in San Francisco at the 6th National Conference of U.S. Commission for UNESCO. Entitled, "Japanese Traditions and American Art," it was subsequently published in the *College Art Journal* 18, no. 1 (Fall 1958) (also published in *Arts Review* 14, no. 3 [24 February 1962]).

20 November-12 January 1958, *Whitney Annual of Sculpture, Paintings, and Watercolors*, Tobey, cat. no. 173, *Pacific Circle.*

In November Tobey included in *Eight American Artists*, Institute of Contemporary Art, London, which also included Graves, Callahan, and Anderson (painters) and Rhys Caparn, David Hare, Seymour Lipton, and E. Martinelli (sculptors).

1958 In January Tobey complains of difficulty getting down to work.

Patrick Heron writes from London for *Arts* magazine:

The most considerable artist of the show was of course Mark Tobey. . . . Morris Graves' Oriental calligraphic touch is charming, but he nowhere elevates this personal calligraphy into plastic design—making of each touch of his elegant brush a palpable plastic fact, as does Tobey at his best. Graves remains illustrational. . . . No: Tobey it is whom one considers most seriously in this company, re-examining, for instance, the fact of his extreme historical significance. A case could be made out claiming that Tobey is one of the most influential painters now living: he is the forerunner of Pollock, for instance, in his "shallow depth" system, as in the extreme evenness of emphasis in his overall composition—two features of non-figurative pictorial expression which have spread first from Seattle to New York and thence all over the world.

Tobey plays the piano a lot, usually several hours first thing in the morning.

In March Tobey is invited to paint a mural for the Washington State Library in Olympia.

14 June-19 October, at the *XXIX Biennale* in Venice, where the United States is represented by Seymour Lipton, David Smith, Mark Rothko, and Tobey, Tobey wins first prize.

In July Tobey goes to New York, and from there on to Paris. After some time in Paris with Otto Seligman, they continue on in late July to Brussels. There, they go to the World's Fair, whence Tobey reports *White Journey* looks spectacular.

From 25-29 July, Tobey attends the Bahai Intercontinental Conference in Messegeland, Frankfurt am Main, Germany.

In August, Tobey and Otto Seligman travel to Lugano, and to Kitzbuhl in early September. In the course of their travels, Tobey writes "have seen hundreds of Klees and all doors opened" (Tobey to Wesley Wehr, from Lugano, Archives of American Art).

He returns to New York in October.

Tobey wins first *Art in America* award (of $1,000) for an outstanding contribution to American art.

6 November-7 December, *44th Annual Exhibition of Northwest Artists*, Seattle Art Museum, includes Tobey, cat. no. 142, *Figure of a Woman* (sumi ink).

Tobey goes to New York for Christmas.

1959 By 20 January, Tobey has completed the mural for the library in Olympia, which is dedicated on 7 June. He remains in New York until March or April, when he returns to Seattle.

Tobey is back in New York in June, and in early July he goes to Paris.

11 September, *Mark Tobey, a Retrospective from Northwest Collections* opens at the Seattle Art Museum (224 paintings, 95 of which traveled to Portland, Colorado Springs, Pasadena, and San Francisco).

1 October, from Freudenstadt, Tobey writes of the superiority of French art criticism.

7 October, Tobey and Pehr sail on the *Bremen* to New York, where they arrive on 13 October and stay a week.

On 20 October, Tobey leaves for Seattle to see his retrospective which closes there 1 November.

1960 14 February, *The Los Angeles Times* states: "Tobey has become the most famous of all living Pacific Coast painters."

From May until at least 15 June, Tobey is staying in New York at the Manger Windsor Hotel (100 West 58th Street). In May he is elected a member of the American Academy of Arts and Sciences but turns it down.

In late June Tobey sails to Europe, to go, via Paris, to Basel, where he has rented a house for a year. This is the house, at 69 Saint Albanvorstadt, in which he spends the rest of his life. Tobey starts working on a poster for his show to be held at the Louvre in 1961.

27 July, Tobey is settling into his new house in Basel; Pehr and Mark Ritter share the house with him. He has already acquired a piano. However, he keeps his studio in Seattle and returns there every summer for the next seven (or eight) years.

24-28 September, Tobey represents the United States on the East-West panel at the Congress of the International Association of the Plastic Arts, held at the Palffy Palace, Vienna.

17 December-22 January 1961, Tobey Retrospective at the Kunsthalle, Mannheim. In the exhibition catalogue, Tobey is called the "old master of the Young American Painting."

1961 Tobey wins first prize at the Carnegie Institute's *Pittsburgh International Exhibition of Contemporary Painting and Sculpture.*

Tobey is in Seattle for a few months in the summer and fall, staying at the house of Ambrose and Viola Patterson, while they are away.

18 October-1 December, *Tobey Retrospective* at Musée des Arts Décoratifs, Paris.

3-28 October, *Mark Tobey, Paintings (1933-1961)*, Royal S. Marks Gallery, 21 East 66th Street, New York.

9 November-3 December, *47th Annual Exhibition of Northwest Artists,* Seattle Art Museum, includes Tobey.

16 December, Tobey writes from Basel, "I have not lifted a brush for months and have no inclination to do so" (Letter to Wesley Wehr, Archives of American Art).

1962 Tobey interview with William Seitz in New York in January. Charles Seliger participates some of the time.

Tobey to New York with Pehr in February.

In March Tobey to Seattle. Mr. and Mrs. John Hauberg of Seattle commission Tobey to paint a mural for the Seattle Opera House.

9 May-31 July, Tobey exhibition at Otto Seligman Gallery, Seattle.

6 May-6 July, Tobey exhibition at the Phillips Collection, Washington, D.C.

In June Tobey paints in his Seattle studio.

21 April-21 October, *Art Since 1950* and *Northwest Art Today*, at Seattle World's Fair, Fine Arts Exhibition. In *Art Since 1950*: Tobey, cat. nos. 69, *Harvest,* 1958 and 70, *Serpentine,* 1955. In *Northwest Art Today*: Tobey, cat. no. 78, *Les Signes,* 1962.

12 September, Mark Tobey retrospective opens at the Museum of Modern Art, New York (exhibition traveled to Cleveland and Chicago).

25 September-20 October, Willard Gallery, *Recent Paintings by Mark Tobey.*

Tobey doesn't paint at all between August and Christmas.

28 November-6 January 1963, *48th Annual Exhibition of Northwest Artists,* Tobey, cat. no. 182, *Night Space* (tempera).

1963 9 August, *Seattle Post-Intelligencer*, "Mr. Tobey arrived in Seattle a week ago."

1964 Tobey's Opera House mural (*Journey of the Opera*

Pehr Hallsten, Tobey, and Wesley Wehr, Seattle, April 1962. (Photo by George Uchida, Historical Photography Collection, University of Washington Libraries)

Star) is finished and installed. It is his largest work, at 12 x 7 feet.

Tobey gives twelve small paintings (dating from 1954 to 1964) to the Bahai World Faith to sell, raising $40,000.

Clifford Wright refers to Tobey as "rightly the most celebrated artist in Europe" (*Studio*168 [July 1964], 24).

1965 1 September, Tobey debarks in Europe.

2 November-4 December, *Recent Paintings by Mark Tobey,* Willard Gallery.

Pehr dies in December. This is a great loss for Tobey. Soon after, he paints *Unknown Journey* (Musée Nationale d'Art Moderne, Centre Georges Pompidou, Paris)—a reflection on the death of his dear friend.

Winter 1965-1966, Tobey goes to Paris.

6 December-4 January 1966, *Mark Tobey, Recent Works, 1961-65,* at the Otto Seligman Gallery, Seattle.

1966 In May Tobey and Mark Ritter go with Charmion von Wiegand to Venice; Tobey and Ritter continue by boat to Haifa and Akka, visiting the Bahai shrines. Tobey feels a need to strengthen his faith after the deaths of Pehr and Otto Seligman.

Tobey and Ritter go to Seattle.

1967 Tobey and Ritter go to Seattle again in the summer, and in August to Victoria (Tobey liked the museum there).

27 June-20 August, *Paintings by Mark Tobey from the Collection of Joyce and Arthur Dahl* at Stanford Art Gallery, Stanford University.

1968 May-June, *Mark Tobey, Paintings, Gouaches, Monotypes* at Hannover Gallery, London.

7 May, Tobey receives the "Commandent de l'Ordre des Arts et Lettres" in Paris. Mathieu delivers a speech honoring Tobey.

Tobey and Mark Ritter go to New York (but don't go to Seattle on this trip to the United States). From New York, they travel to Madrid, where Tobey visits the Prado for the first time (though he had sent Pehr there many times). From Madrid they continue to Barcelona.

1970 In November (?), Tobey included in exhibition of American painting at St. Paul de Vence (Tobey's *Ghost Town* exhibited).

3 December-31 January 1971, *Tobey's 80: A Retrospective* is held at Seattle Art Museum (eighty works).

December-February 1971, *Mark Tobey* at Galerie Beyeler, Basel.

1971 Wins the Skowhegan School of Painting and Sculpture Award.

1 September-31 October, *Mark Tobey Prints*, Whitney Museum of American Art, New York.

26 October-27 November, *Mark Tobey, Paintings, 1969-1970,* Willard Gallery.

1971-
1973 Robert Gardner visits Tobey in Basel, makes film of Tobey.

1972 Bernard Leach visits Tobey in Basel.

In July Humboldt Gallery in New York (Sam Figert), shows Tobey.

10 September-27 November, *Mark Tobey, a Decade of Print Making*, Cincinnati Art Museum.

6 October-31 October, *Mark Tobey, Paintings, Drawings, Prints*, Tacoma Art Museum.

1974 23 April-25 May, *Tobey, Sumi Paintings, 1957*, Willard Gallery, New York.

In June Tobey exhibition at European Gallery, 3450 Sacramento Street, San Francisco, California.

7 June-8 September, *Tribute to Mark Tobey*, National Collection of Fine Arts, Washington (seventy paintings).

15 October-16 November, *Mark Tobey, A Selection from the Collection of Mr. and Mrs. Arthur L. Dahl*, Willard Gallery, New York.

1975 Film *Northwest Visionaries*, including Tobey, produced and directed by Kenneth Mark Levine.

15 June-3 August, *Tobey Rückblick auf harmonische Weltbilder*, Museum Haus Lange, Krefeld, Germany (ninety-three works).

22 October-23 November, *Paintings and Drawings by Mark Tobey*, Humboldt Galleries, New York.

1976 10 April-1 May, Tobey Retrospective exhibition at M. Knoedler and Co., Inc., New York (fifty-eight works).

24 April, Tobey dies, Basel, at eighty-five years.

28 April, Tobey's funeral held at St. Alban's Church, Basel.

May-June, Tobey, one-man show at Ruth Schaffner Gallery (small works and prints).

Summer, *Mark Tobey* at Eliane Ganz Gallery, San Francisco.

Tobey in his studio at 69 Saint
Albanvorstadt, Basel, 1970.
(Photo by Kurt Wyss, Basel)

ABBREVIATIONS FOR LITERATURE

Ammann, "Mark Tobey"
Ammann, Jean-Christophe. "Mark Tobey." *Werk* 53 (December 1966).

Baur, *New Art*
Baur, John I.H. *New Art in America*. Frederick A. Praeger, New York, 1957.

Chevalier, "Une journée"
Chevalier, Denys. "Une journée avec Mark Tobey." *Aujourd'hui* 33 (October 1961).

Coates, "Galleries"
Coates, Robert. "The Art Galleries." *The New Yorker* (13 October 1951).

Devree, "Artist's Growth"
Devree, Howard. "An Artist's Growth." *The New York Times* (Sunday, 7 October 1951).

Geldzahler, *American Painting*
Geldzahler, Henry. *American Painting in the Twentieth Century*. Metropolitan Museum of Art, New York, 1965.

Hoffman, "Tobey's Paintings"
Hoffman, Fred. "Mark Tobey's Paintings." *Artforum* 17 (April 1979).

Kochnitzky, "Mark Tobey"
Kochnitzky, Leon. "Mark Tobey." *Quadrum* 4 (1957).

Kuh, *Artist's Voice*
Kuh, Katharine. *The Artist's Voice*. Harper and Row, New York, 1960.

Kuh, "Mark Tobey"
Kuh, Katharine. "Mark Tobey, A Moving Encounter." *Saturday Review* (1962).

Roberts, *Mark Tobey*
Roberts, Collette. *Mark Tobey*. Evergreen Gallery Book 4, Grove Press Inc., New York, 1960.

Russell, *Tobey*
Russell, John. intro. *Mark Tobey*. Editions Beyler, Basel, 1971.

Schmied, *Tobey*
Schmied, Wieland. *Tobey*. Harry N. Abrams, Publishers, Inc., New York, 1966.

Seitz, *Tobey*
Seitz, William. *Mark Tobey*. Museum of Modern Art, New York, 1962.

Seitz, *Abstract Expressionist Painting*
Seitz, William. *Abstract Expressionist Painting in America*. Published for the National Gallery of Art, Washington, by Harvard University Press, Cambridge, Massachusetts, and London, England, 1983.

Tillim, "Review"
Tillim, Sidney. "Month in Review." *Arts* 37 (October 1962).

Tobey, "Reminiscence"
Tobey, Mark. "Reminiscence and Reverie." *American Magazine of Art* 44 (October 1951).

ABBREVIATIONS FOR EXHIBITIONS

New York 1944
New York: *Mark Tobey*, Willard Gallery, 4 to 29 April 1944.

Portland 1945-1946
Portland/San Francisco/Chicago/Detroit: *Paintings by Mark Tobey*, Portland Art Museum, 7 July to 12 August 1945; San Francisco Museum of Modern Art, 8 to 30 September 1945; Arts Club of Chicago, 7 to 27 February 1946; Alger House, Detroit Institute of Arts, March 1946.

San Francisco 1951
San Francisco/Seattle/Santa Barbara/New York: *Mark Tobey Retrospective*, California Palace of the Legion of Honor, 31 March to 6 May; Henry Art Gallery, University of Washington, 20 May to 27 June; Santa Barbara Museum of Art, 16 August to 9 September; Whitney Museum of American Art (modified from the original exhibition), 4 October to 4 November 1951.

New York 1953
New York: *The Edward Root Collection*, The Metropolitan Museum of Art, 12 February to 12 April 1953.

Houston 1956
Houston: *Contemporary Calligraphers—John Marin, Mark Tobey, Morris Graves*, Contemporary Arts Museum, 12 April to 13 May 1956.

Venice 1958
Venice: *XXIX Biennale d'Arte,* Museo d'Arte Moderna, 14 June to 19 October 1958.

Seattle 1959-1960
Seattle/Portland/Colorado Springs/Pasadena/San Francisco: *Mark Tobey, A Retrospective Exhibition from Northwest Collections*, Seattle Art Museum, 11 September to 1 November 1959; Portland Art Museum, December 1959 to January 1960; Colorado Springs Fine Arts Center, January to February 1960; Pasadena Art Center, February to March 1960; M.H. de Young Memorial Museum, March to April 1960.

Paris 1961-1962
Paris/London/Brussels: *Mark Tobey Retrospective*, Musée des Arts Decoratifs, 18 October to 1 December 1961; Whitechapel Art Gallery, 31 January to 4 March 1962; Brussels, 1962 (modified from the original exhibition).

London 1962
London/Brussels: *Mark Tobey*, The Whitechapel Art Gallery, 31 January to 4 March; Palais des Beaux Arts, 1962.

Washington 1962
Washington: *Mark Tobey*, The Phillips Collection, 6 May to 6 June (extended to 6 July) 1962.

New York 1962-1963
New York/Cleveland/Chicago: *Mark Tobey*, The Museum of Modern Art, 12 September to 4 November 1962; The Cleveland Museum of Art, 11 December 1962 to 13 January 1963; Art Institute of Chicago, 22 February to 24 March 1963.

Amsterdam 1966
Amsterdam/Hannover/Bern/Düsseldorf: *Mark Tobey, Werke, 1933-1966,* Stededijk Museum, 19 March to 8 May; Kestner-Gesellschaft, 19 May to 26 June; Kunsthalle, 9 July to 4 September; Kunstverein fur die Rheinlands und Westfalen Düsseldorf Kunsthalle, 16 September to 23 October 1966.

Dallas 1968
Dallas: *Mark Tobey Retrospective*, Dallas Museum of Fine Arts, 20 March to 21 April 1968.

Seattle 1970-1971
Seattle: *Tobey's 80, A Retrospective*, Seattle Art Museum, 3 December 1970 to 31 January 1971.

Washington 1974-1975
Washington/Seattle/St. Louis: *Tribute to Mark Tobey*, National Collection of Fine Arts, 7 June to 8 September; Seattle Art Museum, 27 September to November; St. Louis City Art Museum, 7 December 1974 to 12 January 1975.

ACKNOWLEDGMENTS

This exhibition and catalogue would not have been possible without the time and effort of many people. I would like to thank Miani Johnson of the Willard Gallery and Claudia Neugebauer of Galerie Beyeler for their patience in answering questions and for allowing me to use their gallery files and photographs. Paula Wolf at the Seattle Art Museum willingly provided answers to numerous queries of date and exhibition history. Garnett McCoy and Colleen Hennessey of the Archives of American Art were helpful with archival information. Donald Foster of the Foster/White Gallery guided me to collectors of Tobey's work in Seattle. Mrs. M. B. Nicholson and Robert Johnson generously allowed me to study the Tobey papers and works by Tobey at Dartington Hall.

To many who shared their reminiscences of Tobey, I am very grateful, especially: Marion Willard, Charles Seliger, Arthur Dahl, Guy Anderson, the late Mark Ritter, Francine Seders, Katharine Kuh, Carol Ely Harper, Joanna Eckstein, Robert Gardner, Nancy Wilson Ross, Marchal Landgren, Claire Falkenstein, Georges Mathieu, John Cage, Arthur and Virginia Barnett, the late Berthe Poncy Jacobson, and Viola Patterson. Wesley Wehr has been my guide to Seattle and its Tobey friends and collectors, as well as the source of numerous anecdotes and documents about the artist. Mary Randlett, Viola Patterson, and Nancy Wilson Ross contributed their photographs of Tobey himself, an invaluable record of his life and personality.

I would also like to thank Katharine Kuh and Sydney Freedberg for their very helpful and conscientious critical readings of the catalogue manuscript, Paula Smiley for her painstaking editing, and Susan Lehmann for her artful design of the catalogue.

A considerable contribution to Tobey literature was made by the late William Seitz, who had the perspicacity to interview Tobey at length in preparation for the exhibition at the Museum of Modern Art in 1962. This interview and Mr. Seitz' catalogue remain important sources of information about Tobey's life and work.

I would particularly like to thank John Golding and Adelyn Breeskin for their continuing interest in my study of Tobey's art.

To every phase of this endeavor, my family and my husband, Andrew Hamilton, have given their enthusiastic and invaluable support.

Eliza E. Rathbone